# WEDDING PHOTOGRAPHER'S HANDBOOK

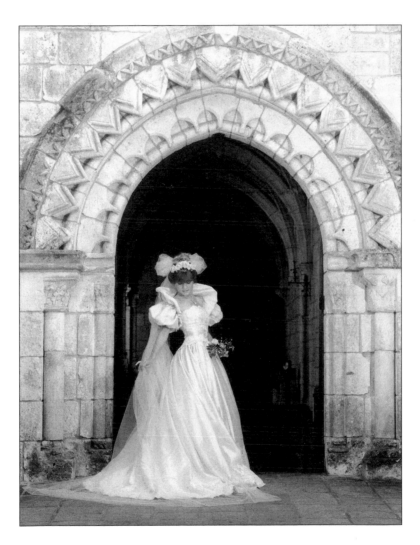

## THE COMPLETE GUIDE ✿ ROBERT & SHEILA HURTH

AMHERST MEDIA, INC. ■ AMHERST, NEW YORK

*Notice of disclaimer:* The information contained in this book is based on the author's experience and opinions. The author and publisher will not be held liable for the use or misuse of the information in this book

Published by:
Amherst Media Inc.
P.O Box 586
Amherst, NY 14226
Fax: 716-874-4508

Publisher: Craig Alesse
Editor/Designer: Richard Lynch
Associate Editor: Frances J. Hagen
Editorial Consultant: Dan Schwartz, J.D., Ph.D.
All photos by: Robert and Sheila Hurth

ISBN: 0-936262-44-3
Library of Congress Catalog Card Number: 95-80948

Printed in the United States of America
10 9 8 7 6 5 4 3 2 1

# TABLE OF CONTENTS

## Shooter's Log: Making Your First Million

Although we have been involved in photography for over 20 years, until about 11 years ago we had photographed only a hand-full of small weddings. These early attempts were not very successful. Then we purchased our first studio, and one of our first bookings was a wedding; a rather sizable affair with 200 guests, 14 in the bridal party, dozens of family members, three location sites to work in, and so on. The whole thing lasted eight hours, and by the session's end we were mentally and physically exhausted.

That wedding was no more successful than our earlier attempts. We did not have the experience to deal with situations properly: equipment failed, we didn't take charge, and we were unfamiliar with posing and lighting techniques. We didn't even realize that wedding photography should follow an orderly progression. As a result of this fiasco, we decided we had to learn all we could about wedding photography if we were going to continue booking weddings.

We began by studying with known wedding photographers. We also became active in local, state, and national photographic associations. After spending long hours and lots of money, we finally learned the "do's and don'ts" of wedding photography. Putting this into practice, we became quite successful.

We shoot an average of 250 weddings per year and recently grossed over $1,000,000. We have eight full-time and three part-time employees and we're still growing. Although we do other forms of photography, we owe a great part of our success to wedding photography. It introduces us to a lot of people and leads us to other photographic assignments.

# INTRODUCTION

Not many years ago, the wedding photographer was not a specialist. Photographers considered weddings a sideline business and paid little attention to the subtleties of the wedding day. It was common to shoot only two or three dozen shots of an entire wedding event, capturing just the highlights. A bridal couple received a photo album containing only 12 to 24 photos. Worse, the photographs were usually of only moderate quality. Hardly an investment or achievement for the photographer!

Today, brides and their families are more knowledgeable and demanding when it comes to photography; they expect more. To survive in the wedding business, a photographer must be a wedding specialist.

Some amateurs may think that all you have to do is have a camera of any kind, set it to automatic, follow the bridal couple around for a few hours, shoot a few rolls of film, produce a few candid shots, and collect the easy money. That is wrong; it is necessary to invest time, effort and money to succeed in wedding photography.

When a person represents him or herself as a wedding photographer, it implies competence and knowledge in all phases of wedding photography. This means that the photographer knows what to do, how to do it, and has all of the equipment needed. Competent wedding photography is involved. This book will show how to do it, and do it right.

We wrote this book for those who wish to enter this fabulous field. It will save time, effort, money, and embarrassment. It will also help bring you success and satisfaction in the business. We can promise you one thing: wedding photography is a great field. So, read on!

**"THIS BOOK WILL SHOW HOW TO DO IT, AND DO IT RIGHT."**

**READER'S NOTE:** Whenever you come across this camera symbol in the book, check a sidebar such as this one for additional discussion and information.

# CHAPTER ONE

# WEDDING PHOTOGRAPHY: AN OVERVIEW

The evidence of a wedding photographer's success or failure is longer lived than the relative successes of: the music, the food, or the flowers. To ensure his or her success, the photographer has a lot to consider before loading the camera.

The photographer must be thoroughly familiar with all the phases of the event. He must know what photos to take, and must keep the role of each in mind.

This information appears here as part of three distinct sections: Anatomy of a Wedding (a list of the parts, or phases, of a wedding), Photographic Categories for Wedding Phases (a list of important photos for each phase), and Anatomy of a Wedding Photographer (the role and involvement of a photographer in the wedding event).

## ANATOMY OF A WEDDING

The personal and emotional interaction between bride, groom, family, and friends makes the wedding day a special event.

Weddings can and do differ. Religious considerations, time of day or year, location and so on, all factor into how events proceed. To simplify the event, a photographer should think of the wedding as a series of segments or phases. This will help him or her shoot the wedding in an organized, manageable fashion, and will reduce or eliminate the possibility of missing anything important.

### The Seven Photo Phases of a Wedding

1. Formal and casual portrait photography of the bride and groom before the wedding day.

2. Wedding day pre-ceremony photos of the bride and members of the wedding party.

3. Photography before, during and after the ceremony.

4. Altar returns: formal photography immediately after the service at the altar.

5. Photos of the wedding couple exiting the wedding site.

6. Wedding day romantic photographs of the bridal couple in a special and scenic location.

7. Photographs taken during the cocktail hour and reception.

**1-1:** Wedding photography is very involved. A successful photographer should be familiar with all phases of a wedding.

## THE SEVEN PHOTO PHASES:

1. Pre wedding-day.
2. Pre-ceremony.
3. The ceremony.
4. Altar returns.
5. Wedding site exit.
6. Post-ceremony romantics.
7. Cocktail hour/reception.

## PHOTOGRAPHIC CATEGORIES FOR WEDDING PHASES

Thinking in a framework will help organize the photos you must, should or might take during a wedding. The following list defines the four major categories: command, must-get, suggested, and frosting photographs.

### Command Photographs

Photographs selected from the Wedding Candid Checklist (on page 14) should be a primary consideration. This list is available so shots can be selected by the bride, groom, or family prior to the event. Do everything within your power and ability to make certain that none are missed or overlooked.

### Must-Get Photographs

The wedding album should be comprised of photos which show a complete wedding story, in a logical fashion. The selections made for command photos may not reflect those images which are necessary to adequately illustrate a wedding. Must-get photos are those not already selected that you must take to properly record the whole event. Take these whether they have been requested or not. If you fail to capture them, you may have difficulties with the bridal couple or their families later on.

### Suggested Photographs

Throughout a typical wedding day, the bride, groom, members of their families or close friends will suggest photographs for you to take. Respond to their requests promptly. Recording these images will often increase your sales.

### Frosting Photographs

This category includes all the other photographs. They are like the frosting on a cake. These images can help round out a bridal album so that it tells a more complete and interesting story. For example, you may photograph a young ring-bearer curled up and asleep in one of the church pews, the bride consoling her mother moments before the service is to start, or the bride making funny faces at the groom during the reception. Many frosting situations arise during the course of a wedding event. They will enhance the bridal album and will increase sales.

### Wedding Photography

A *photographic style* is how a photo is composed: using hard or soft light, using umbrellas rather then soft boxes, using varying amounts of soft focus diffusion, using high or low f-stop settings for controlling depth-of-field, and so on.

Styles come and go and have changed drastically over the years. They even differ by region. By contrast, *photographic categories* are quite stable and transcend time: they seldom change dramatically. For example, the bride and groom kissing at the altar immediately after being pronounced man and wife, is as important to capture today as it was 30 years ago.

A dedicated photographer must keep abreast of changes and trends. The best way to do this is to become familiar with the wedding photography of accomplished, modern photographers. Avoid gimmicky photos, such as a bride and groom apparently located inside a brandy glass. Some elements of good wedding photography and style don't change.

### Missed Photos

A photographer can get by if he or she misses some photos from categories 3 or 4 (suggested and frosting photos). However, he or she is likely to face some severe consequences if missing any of the shots from categories 1 or 2 (command and must-get photos). This may reflect in a loss of sales, a decline in future wedding business, and even a lawsuit from the bridal couple.

In the event that you miss important category 1 or 2 shots, you may be able to re-enact or re-create them. Whatever you

## FOUR PHOTOGRAPHIC CATEGORIES:

1. Command Photographs
2. Must-Get Photographs
3. Suggested Photographs
4. Frosting Photographs

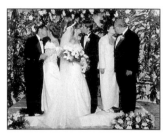

**1-2:** On the wedding candid checklist, a bride may specify a certain shot she would like taken during the wedding day. This photo would be called a "command photograph."

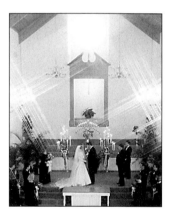

**1-3:** Must-get photos are those not specifically selected by the bride on the wedding candid checklist, but need to be taken to properly record the whole event.

do, don't ignore the missed shots. Address yourself to the problem and solve it as soon as possible.

### Summary

To ensure success, you must include photographs from categories 1 and 2 (command and must-get photos) and should get photographs from categories 3 and 4 (suggested and frosting photos).

In each phase of a wedding, ask yourself how the shots you consider fit together as being representative of the wedding day. If a shot is pretty, but not representative of a phase, you may be better off moving on to something else. For example, taking a photo of the front of the church where the bridal couple were married is not likely to have much appeal. However, if you take a romantic shot of the bridal couple in front of that church, you'll almost certainly have a winning photograph.

## ANATOMY OF A WEDDING PHOTOGRAPHER

A wedding photographer is assigned a job that can be done once, and once only. He is relied upon to record, as creatively as possible, a few of the most important hours in the lives of a couple. There's no chance for a reshoot.

A properly equipped, trained and competent wedding photographer knows what to do and then does it! He or she must:

- take charge
- photograph emotions
- be dedicated
- be technically competent
- control photo competition
- know which shots to take

### The Photographer Takes Charge

A photographer must be good at dealing with and directing people. This is no easy task, and often places a photographer in the position of being a pivotal person in making the events of the day come together.

Although the photographer must direct, he can not be pushy, overbearing, or rude. He must direct people in a firm, assertive, but pleasant, manner without antagonizing anyone. He must keep a low profile and work smoothly, methodically, efficiently, and quietly.

Even if the caterer, the band, the florist, the bridal party, the photographer, and so on, may perform their roles exactly as planned, things don't always run smoothly. Often it is the wedding photographer who must intervene.

For example, if the band leader forgets to invite the bride to dance with her father, the photographer must arrange it. If the caterer places the bridal couple at the cake table in a way that is not conducive to good photography, the photographer must re-arrange the positioning of the couple. If, at the end of the reception, the bridal couple had not planned for a formal exit, the photographer may have to stage a simplified version of this event in order to photograph it. These are but a few of the situations which a photographer must be prepared to orchestrate.

### Take charge, but don't force.

Guests should not be forced to do anything which they don't want to do just for the sake of capturing good photos. You should advise them of your intentions. Tell them what you would like to do and why you want to do it. If they refuse, do not press the issue. You don't want to create a scene.

### Photograph Emotions

Photographing emotions at a wedding really involves capturing special photos of two groups of people: the bridal couple and other guests.

During most weddings, emotions run rampant; family members and friends

> **"A PROPERLY EQUIPPED, TRAINED AND COMPETENT WEDDING PHOTOGRAPHER KNOWS WHAT TO DO AND THEN DOES IT! "**

Once in a while you'll come across people who will not cooperate with you. Be cautious about how you handle such a situation. You cannot afford to create a scene or do anything which might embarrass you, the bride, the groom or their families. Take real problems to the bride and let her, or her family, solve them.

openly display emotions. Recording these events is relatively simple and straightforward. All can be captured with a single, on-camera flash. However, watch your timing. Take photos either the instant before an emotional moment, such as just before an embrace, or at the peak of action. Photographing emotions after the fact will be a complete waste of your time, effort and film.

You won't know which photos will be important to a bride, groom or their families, but film is your cheapest commodity. Shoot first and then worry about the importance of the photos later. We always follow a simple rule: when in doubt, photograph it twice!

A wedding photographer is hired to record the bridal couple displaying feelings of joy, love, tenderness and togetherness. You must anticipate these images and capture them on film. And, if the atmosphere you want is not present, you'll have to orchestrate some situations in order to generate it.

### Arrange Poses

Romantic photos should be reflections of the way the bridal couple truly feel about each other. A good photographer can make an obviously happy and involved couple look great. However, not all bridal couples will freely display their feelings towards each other in public. In such cases you'll have to arrange poses.

For example, stand the groom close to his bride, and have him cradle her face gently in his hands. Then have him lower his face to hers so that their lips almost touch. You are sure to get that special gleam you are after. Capture that type of emotion on film and you will surely have a winner.

### Gain the Groom's Confidence

Grooms often feel silly when posing for romantic photos; its not unusual to find a groom who resists the entire concept. In such a case, spend a few minutes

talking with him. Be friendly and assure him that the results will well be worth the inconvenience. With encouragement from you and the bride, even a hesitant groom will capitulate. By sessions end, you'll frequently find the groom enjoyed the experience and is anxious to be involved in more photo-taking later on.

### Shoot a lot of Romantics

The number of romantic shots you'll take will vary. It will depend on the amount of time the couple affords you, the locale you are working in, the couples involvement with each other, and even the time of day.

For example, if the wedding takes place in the evening, where the only place to take photos is in a small backyard, and you have only ten minutes to take photos, you'll be lucky if you capture six images.

By contrast, if the wedding takes place at a hotel where the grounds are stunning and the couple has committed one hour to you for photos, it would not be uncommon to expose two or more rolls of film. Take as many romantic shots as you can. These are very popular and are a great addition to any bridal album. However, don't bore the couple with this phase. Know what you want to do in advance and organize your shooting so that you take romantic photos during various phases of the wedding.

For example, take a few romantic shots of the couple at the conclusion of the ceremony, some before the reception starts, and additional ones at intervals during the reception. Work fast, going from one pose or situation to another.

Above all, show your own enthusiasm when taking such photographs. The couple will become enthused and the results will show in your photos and increased sales.

### Romantic Photos are in Vogue

Whether you think of romantic photos as must-gets or frosting photos is not

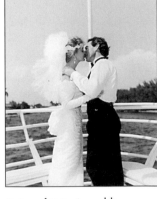

**1-4 and 1-5:** A wedding photographer is hired to record the joy, love and tenderness felt by the bridal couple on *their* day. Here are two romantic photo examples.

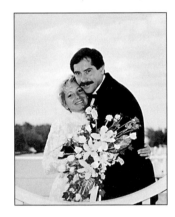

"...SHOW YOUR OWN ENTHUSIASM WHEN TAKING SUCH PHOTOGRAPHS. THE RESULTS WILL SHOW IN YOUR PHOTOS AND IN YOUR INCREASED SALES."

important; the experienced wedding photographer must provide a bridal couple with romantic shots. Take your time when setting up romantic photos. All the poses should *look* comfortable and not contrived; it might take several minutes to set up a shot to make it appear natural.

Romantic photos have far more appeal than mundane shots in which the bridal couple stands stiffly, staring into the camera. How do you know when a photo is romantic? As Justice Stewart said when asked to define pornography, "I'm not sure I can define it, but I know it when I see it." Key qualities which help define a romantic photo are displays of genuine love, togetherness and involvement. Capture these emotions on film, and you'll often have winners. Use soft light and a soft-focus lens attachment for

> *"ALL THE POSES SHOULD LOOK COMFORTABLE AND NOT CONTRIVED..."*

## Shooter's Log: Do the Business-Like Thing

Some years ago, Sheila and I were photographing a wedding held in a large hotel penthouse dining suite. Due to the large number of guests, space was cramped. There was hardly enough room to maneuver between the tables.

We began to take table shots which the bride had requested. Due to the size of the tables and the lack of space between them, photography was difficult. To complicate matters, at the center of each table was an extremely large floral arrangement. It was impossible to photograph all ten guests at one time; at least three or four of them were always blocked by the flowers. We couldn't move the guests, due to the limitation of space, so we had to temporarily remove the center piece. We did this for about three or four tables. Just as we were about to photograph another group, a man came up to me, looked me straight in the eye, and said, smiling, "I am the florist; I arranged those floral pieces. If you or your wife move one more of them, I shall have you both arrested and removed from the premises." I was shocked. My reaction was to take this fellow outside so that we might have a little 'talk.' However, Sheila immediately took charge: she placated the florist and went to the bride with the problem. The bride put the florist in his place and we continued, just as before. If I had followed my initial inclination, I would have caused a host of problems: disrupted the reception, tainted our reputation, caused ill feelings, and lost lots of future wedding business. Sheila had done the business-like thing.

romantic photos whenever possible. These add a dream-like quality to images.

### Be Creative

When taking romantic photos, you should let your creative juices run free: try soft focus, soft light, wide open f-stops for limited depth of field, different lens focal lengths for different effects, different poses, and so on. This will add variety to the shots and sessions.

### Be dedicated

Never be satisfied with your work. Strive to be better. One of the things that makes a photographer's work outstanding is his dedication. Commit to doing a good job with every wedding. Learn as you go and expect to do an even better job on future weddings.

Could you imagine a lawyer walking out in the middle of a trial because he was late for a social engagement, or a doctor walking out in the middle of surgery because he was due on the golf course? A professional photographer should not be held to any less of a professional standard. We have, however, heard accounts of photographers who do not perform their jobs in a manner we would consider professional.

### Competence is Required

When the wedding day is over, the bridal couple and their families depend on photos to document and remember that special day. A lack of photographic skill or competency is a poor excuse for not getting the expected results.

Wedding photography is not for the once-in-a-while photographer whose only concern is to make a few dollars on the side. Weddings are the domain of dedicated photographers who strive for professionalism in all aspects of their work.

To be considered competent, you must be completely familiar with the wedding event, your craft, and you must think and behave as a professional. The following is a list of points that will prepare you to become professional from your first shoot onward:

### Master Basic Wedding-Photo Techniques

Although there are many ways to shoot a wedding, there are certain basics that run throughout almost all weddings. Long before shooting your first wedding, learn these basics. When you're familiar with your craft, you can afford to break some rules and try new and different things.

### Don't Use Any New Equipment!

During the course of a paying photo session, never use equipment that you are not completely familiar with. The photo results may not be as expected, and you could fail to get important images or ruin shots that had great potential.

### Become Familiar with Wedding Ceremonies

Before shooting your first wedding, attend as many as you can, at least a dozen. You need not be acquainted with either a bride or groom; weddings are open to the public at most churches and temples. To find out when weddings are scheduled, seek out the official in charge of the church or temple and ask.

When attending, observe how individuals interact with each other and the photographer. Watch what the photographer does and how he handles each situation. Notice how he takes charge or fails to take charge of each phase.

Make notes of things which impressed you, as well as those that didn't. Use your observations as a tool for learning what you should and shouldn't do. Such information will prove invaluable when you are first getting started.

### Attend Some Receptions

Visit several of the better hotels or country clubs in your area. Inquire when

*"...THERE ARE CERTAIN BASICS THAT RUN THROUGHOUT ALMOST ALL WEDDINGS"*

*"WEDDINGS ARE THE DOMAIN OF DEDICATED PHOTOGRAPHERS WHO STRIVE FOR PROFESSIONALISM IN ALL ASPECTS OF THEIR WORK."*

wedding receptions are to take place and whether it might be possible to be present as an observer. Plan to watch about a dozen receptions. (Do not bring a camera.)

Make notes on the progression of the phases of a reception and the role the photographer plays. Again, make notes of the things you like and dislike for future reference.

### Assist a Wedding Photographer

Become an assistant without pay, if necessary, to a local wedding photographer. This firsthand experience will prove invaluable. Learn as much from him or her as you can. Some of their information will be good, some might be bad. In either case, sift through it and learn from the experience.

## Shooter's Log: Nothing Ever Goes as Planned

In one case we know of, a photographer was hired to photograph a wedding with a specific schedule. The bride indicated that the wedding service was to start promptly at noon and the reception promptly one hour later. The entire affair was to be concluded by 6 p.m..

On the day of the wedding, things did not go as planned. The ceremony did not start until 2 p.m., and the reception started at 5 p.m. because the caterer and band were late in arriving. Just before 6 p.m., the photographer approached the bride and announced, I'm sorry for all of the troubles and delays you've had today, however, I will be leaving in just a few minutes. You told me that it was all going to be over at 6 p.m. and I have a prior commitment.

The bride and groom were shocked! He left without capturing many of the important reception events: the toast, the cake cutting, the bouquet toss, and the like. He never even offered to stage these events before leaving.

You might have to charge clients for the extra time, but never leave a wedding until it's over (unless the bride and groom have instructed you otherwise).

## WEDDING CANDID CHECKLIST

WEDDING DATE: _____

BRIDE'S NAME: _____

On the list below, check off which special moments you would like to see in your Wedding Album.

❐ Bride in dress
❐ Bride with Mother
❐ Bride with Father
❐ Bride with both parents
❐ Bride with Honor Attendant
❐ Bride with Maids
❐ Bride touching up makeup, hair
❐ Bride & Father getting into car

❐ Bride at gift table
❐ Everyone getting flowers
❐ Bride leaving house
❐ Bride, Father getting into car
❐ Groom alone
❐ Groom with Best Man
❐ Groomsmen getting boutonnieres
❐ Other moments:

### AT THE CEREMONY:

❐ Guests outside church
❐ Bride & Father getting out of car
❐ Bride & Father going into church
❐ Ushers escorting guests
❐ Groom's parents being seated
❐ Bride's Mother being seated
❐ Soloist & organist
❐ Groom and groomsmen at alter
❐ Giving-away ceremony
❐ Altar or canopy during ceremony
❐ Bride and Groom exchanging vows
❐ Ring ceremony
❐ Bridesmaids coming down aisle

❐ Maid or matron of honor
❐ Flower girl and ring bearer
❐ Bride and Father
❐ Groom meeting Bride
❐ The Kiss
❐ Bride and Groom coming up aisle
❐ Bride and Groom on church steps
❐ Bride alone in the chapel
❐ Bride and Groom among guests
❐ Bride and Groom getting into car
❐ Bride and Groom in back seat of car
❐ Other ceremony moments:

### POSED SHOTS BEFORE THE RECEPTION:

❐ All Maids looking at Bride's ring
❐ Bride with her attendants
❐ Bride's and Groom's hands w/ rings
❐ Groom with his attendants
❐ Bride and Groom together
❐ Bride, Groom, all wedding party

❐ Bride with parents
❐ Bride, Groom with all parents
❐ Groom with parents
❐ Bride and Groom with children
❐ Bride and Groom with honor attendants
❐ Other people with Bride, Groom:

### AT THE RECEPTION:

❐ Bride and Groom arriving
❐ Bride, Groom cutting the cake
❐ Bride and Groom getting out of car
❐ Bride, Groom feeding each other cake
❐ Bride and Groom going into reception
❐ Bride, Groom toasting
❐ The receiving line
❐ Throwing & catching bouquet
❐ Buffet table
❐ Groom taking off Bride's garter
❐ Bride, Groom at bride's table
❐ Throwing, catching garter
❐ Parent's table
❐ Wedding party decorating car

❐ Bride & Groom ready to leave
❐ Bride & her Father dancing
❐ Guests throwing rice
❐ Groom, & his Mother dancing
❐ Bride & Groom getting into car
❐ The musicians
❐ Rear of car as it drives off
❐ Bride, Groom talking to guests
❐ Table shots (specify which tables)
❐ Bride & Groom's first dance
❐ Best Man (or other) making Toast to Bride & Groom
❐ The Cake Table
❐ Outside grounds (wedding party)
❐ Other special reception fun:_____

Photos NOT to take: _____
Any other special moments, such as awards or gifts to be presented _____

## Dress Appropriately

To be perceived as the competent professional, you must dress appropriately. If the wedding is a black tie affair, wear a tuxedo. If it is an evening affair that does not require black tie, then wear a dark suit, white shirt and solid, dark tie. For an afternoon wedding that is not black tie, a dark suit will usually be appropriate. For female photographers, a simple black dress or a black suit, black slacks and plain white blouse are appropriate. Avoid short skirts and plunging necklines.

Sometimes during the course of the affair, the photographer will remove his tuxedo jacket, his tie, unbutton his collar, roll up his shirt cuffs, and so on. It looks unprofessional. You might be hot, tired and very uncomfortable, but stay fully dressed.

## Maintain a Professional Attitude

When you start photographing weddings, maintain a professional attitude. Be courteous, considerate, attentive to the bridal couple and their families, and keep your mind on your work. It will make your job go more smoothly, effectively and efficiently. Above all, maintain a positive attitude.

## Become Involved in the Wedding Events

Don't merely attend a wedding as a spectator would. You may be a hired professional and an outsider, but you are also a very integral part of the event. You are someone on whom much of its success depends.

## Prepare a Photo Check List

Before photographing any wedding, get detailed information from the bride about the events she has planned, including whom she wants photographed and whom she does not. One of the ways we accomplish this is with our Wedding Candid Checklist (see opposite page).

At the time of booking, we supply the bride with such a wedding candid checklist. We ask her to complete it and set a meeting date at least two weeks before the wedding so that we can review the list in detail. This gives us a final opportunity to become well acquainted with the bride. In the process we can learn which photos are most important to her. It also enables us to determine any specific problems we may encounter, saving us time and embarrassment.

A bride may not know all the shots necessary to successfully tell her wedding story. In the chapters that follow, we offer checklists of common shots. You can use these and the checklist on the previous page as guides to what shots you should consider taking.

We are not suggesting that you take all these shots at every wedding. The lists are just guides. The number of shots will be determined by the size of the initial bridal package selected, the number of people attending, the amount of time afforded you for taking pictures, the cooperation of the principals involved, the nature of the locations, and so on. Learn to be selective with the shots you take, and work fast.

## Take Emergency Equipment

You should not photograph any wedding without having two distinct selections of emergency equipment: a fix-it bag and backup equipment:

*Fix it bag.* Your fix-it bag should include such helpful items as bobby pins, clothespins, safety pins, a few strips of Velcro, needle and thread, face powder, tissues, scissors, and hair spray. You might include makeup, and even smelling salts.

Such items can be very helpful — from adjusting rented clothing that doesn't fit quite right to adjusting a hairstyle or smudged makeup. You may even find yourself helping to revive a guest who has become overwhelmed by the whole event.

> **"BE COURTEOUS, CONSIDERATE, ATTENTIVE TO THE BRIDAL COUPLE AND THEIR FAMILIES, AND KEEP YOUR MIND ON YOUR WORK."**

*Backup equipment.* The second set of emergency equipment should include backups of all photographic tools. You cannot afford to be at a wedding with just one camera, one film back, one set of lights and so on. Be constantly aware of Murphy's Law: If something can go wrong, it will, and it will do so at the most inopportune time!

Therefore, make certain to have at least doubles of all pieces of equipment and have them all readily available. You may even bring triples of some items. Keep this equipment with you; spare parts or equipment in your car or back at your studio are of no value.

### Be Alert at All Times

You must know what is going to happen and when it is going to happen. Be prepared for the unexpected. For example, a bride dancing with an usher suddenly trips and falls, laughing all the while. Shoot it! They'll love it, and buy it!

### Work with an Assistant

If your inclination is to photograph a wedding without an assistant so that you can save a few dollars, don't. You should never attempt to work without help, especially at large weddings. At such an event, an assistant will help make your transitions from one photographic situation to another smooth and rapid.

### Show Self-Confidence

Take each photo decisively and without hesitation. Don't shoot the same situation five or six times; the subjects may equate your indecisiveness with a lack of skill and you may lose their confidence and cooperation. Even if you see several different ways of taking a particular shot, don't consider doing them all. You'll have to select the ones you feel will best serve the purpose.

Demonstrating self-confidence also means keeping your cool. You might be very nervous while you're doing your first few weddings, but give the appearance of knowing what you are doing even if you're really not sure. Eventually your confidence and expertise will build.

### Meet the Right People

When you arrive at the reception, introduce yourself to the master of ceremonies, the band leader or disc jockey, and others who might be able to help make your job run smoothly. Meeting the right people also helps in referrals. Becoming friendly with others involved in wedding services is a step in getting additional wedding business.

Eventually, you will be able to refer brides to those whom you think will do a good job. They will reciprocate. In the interim, during an actual wedding reception, never hesitate to take a couple of shots of the band and the food tables. Send a few 8x10 inch prints of these to the respective parties with your compliments. Great photos of them or their product will go a long way in having them remember you.

### Decline Drink or Food

A hired photographer should never consume alcoholic beverages when shooting a wedding. If you have even one drink and later show the bride and her family just one out-of-focus picture, they will swear that all of their wedding photos were ruined because their photographer was intoxicated.

In a like manner, do not sit at a partially vacant guest table at a reception unless the bride, groom, or her family have specifically asked you to. Even then, keep your camera close at hand and remain watchful for photos opportunities.

If we know that the wedding is going to last over five hours, we inform the bride, at the booking, that she is responsible for providing food for the photographic team. In most cases, the brides agree to provide food for our staff members.

"...MAKE CERTAIN TO HAVE AT LEAST DOUBLES OF ALL PIECES OF EQUIPMENT AND HAVE THEM ALL READILY AVAILABLE."

**1-6:** Be alert at all times! You never know what photo opportunities will come up during the wedding day. By catching some of these spontaneous shots, you'll increase you're sales.

### Never Leave Equipment Unattended

Not only is photographic equipment expensive to replace, but there is no way to successfully complete your job if your equipment has been stolen.

Be sensitive to possible theft and constantly be on guard. Don't assume that because you are at a wedding attended by seemingly good, honest people, you can afford to become relaxed about safeguarding your equipment.

When we work weddings, we like to place all our equipment in a central, convenient, out-of-the-way spot. We make sure that we can still keep an eye on it, and it's readily accessible. On those occasions when we know in advance that we will not be able to keep an eye on the equipment for the whole time, we will bring someone from our studio to guard it for the entire event. It is important to keep all equipment in a safe place.

## Shooter's Log: Photographic Sabotage

Be forewarned about the real possibility of photographic sabotage. There may be someone who will cause you problems simply because **you** are photographing the wedding, and not them.

About seven years ago, we were scheduled to shoot eight weddings in one day. In order to accomplish this, I had to shoot one of the weddings by myself — something I don't recommend doing. At the church I was approached by a young woman who said, "I am a friend of the bride. I have been studying photography for a year and I want to know if I could follow you around and shoot over your shoulder." I explained why I could not allow it. She gave me an angry look, and left.

Minutes later, as I was preparing to take some pre-ceremony photos, this same woman interrupted me as I was photographing the groom and the best man. No matter what I did, she was in my way. I turned to her and politely said, "The bride has hired me to photograph this wedding; please wait until I'm done and then you can photograph what you wish." She replied, "What's the matter, are you afraid of competition?" Realizing I was getting nowhere with the woman, I located the bride and told her of my problem. The bride talked to the woman, who left the altar area scowling at me. The bride apologized and asked me to continue photographing. I thanked her and gave no further thought to the situation.

Later, I noticed that two of my portable light units had been damaged and were not repairable in the field. Fortunately, my backup equipment allowed me to continue without delay.

Several days later I received a call at our studio. A woman's voice said, "I hope all of your photos from Saturday's wedding turned out all right." She laughed hysterically, and hung up.

## Handling Photographic Competition

Prepare yourself for photographic competition. At most affairs, family and friends of the bridal couple will shoot alongside of you. They are aware that you know your business and they'll want to photograph the poses you arrange. You usually need not take intruding happy snappers seriously, but don't go out of your way to help them either. Allowing five, six or ten people to take their shots while you wait will cost you more time than you can afford, especially when you're shooting at the church.

At the time of booking, make it clear to the bride that you do not want anyone shooting over your shoulder, as it could effect the quality of your work. Such a warning should help keep the nuisance to a minimum. But, whatever happens, conduct yourself in a truly professional manner.

Our policy is very simple: We do not permit others to shoot while we are photographing! If we observe someone photographing while we are shooting, we politely discourage them, and tell them they can shoot all they want when we have finished. This keeps happy snappers from interfering with us while we are shooting. Allowing others to fire flashes while you're shooting could lead to overexposure of some of your shots. You may underexpose because a flash triggers your slaved units before you shoot.

If you find it beyond your power to prevent others from shooting, you can either use remotely controlled slaved lights which won't be affected by other flashes (such as ultra sound or infrared slaves made by Venca or Wein ), or ask the bridal couple to intervene on your behalf. Whatever you do, don't ever have a confrontation with any guest.

## Potpourri

There is no single factor which will make you a great wedding photographer.

You must have knowledge of the entire event, proper equipment, and know what to do and then do it. To further broaden your base of knowledge of a wedding, we offer the following tips:

### The Time Factor

At the time a wedding is booked, discuss how much time the bride is prepared to allot you for photography at each phase (such as altar returns and romantics). Let the bride understand that you want to do as much for her as possible, but you'll need her cooperation to accomplish it.

As a general rule of thumb, if the number of people in the bridal party and immediate family members to be photographed is few, usually 15 to 20 minutes will be sufficient to do Altar Return photos. By contrast, if there are a large number of people in the bridal party (say 10 or more) and a lot of family members, then 45 to 60 minutes would be in order.

### Working Around The Time Factor

Even though you have been promised a certain amount of shooting time, you can't always depend on actually getting it. During an event, circumstances often change and this can cause your time to be cut, sometimes drastically. Here, again, is where your professionalism comes in; you must be prepared to graciously handle a change in schedule, work around limitations, and still produce fine photographs.

Complaining that the bride has changed the game plan will get you nowhere. Work fast, get all of the must-get photos, and let the bride know that you cannot do the things you had originally planned within the time constraints.

Often, when you present the situation to the bride in this fashion and she realizes that she will not get all the photos that she wanted at the time she booked her wedding, she will allot you more time for taking pictures.

> "OUR POLICY IS VERY SIMPLE: WE DO NOT PERMIT OTHERS TO SHOOT WHILE WE ARE PHOTOGRAPHING!"

### Photograph When the Opportunity Arises

Capture shots as they arise or they may be lost. Don't count on taking a shot later on in the evening if there's a possibility of not being able to take it at all. For example, if you want a romantic shot of the bridal couple embracing, you can take it at any time during the day.

However, if you're required to take a shot of Aunt Mary with the bridal couple and she is 90 years old, take it when the first opportunity arises. If you wait until later, you may find that she had become tired and left the reception very early. You'll have missed the needed shot.

### Quality Beats Quantity

When in doubt, shoot fewer shots of good quality, rather than simply shooting more shots.

For example, when doing Altar Return photography, you might assume you should take a lot of shots of each pose to ensure that all eyes are open, that expressions are good, that your flashes all fired, and so on.

However, repeating exposures takes time just as much as assuring you get the shot. Instead of exposing more film, take only two or three shots of each pose, arranging each carefully to ensure you capture the photos.

### The Secret of Wedding Photography

There are no real secrets to wedding photography. Everyone can take pictures, but few have the talent, knowledge, and skill to capture the emotions and the atmosphere of the wedding day.

The tools for success are very basic: a sound knowledge of craft, appropriate equipment, hard work, and sound preparation. A little talent doesn't hurt, either.

Attend every seminar you can, and read as much about the subject as possible. Then go out and practice, practice, practice.

## A Future With Wedding Photography

Wedding photography is a great business; one that can afford you recognition and financial security. It can help you develop your other photographic skills. Be proud of what you do and constantly strive to become better. Let's now move on to the more technical aspects of a wedding.

"WEDDING PHOTOGRAPHY IS A GREAT BUSINESS; ONE THAT CAN AFFORD YOU RECOGNITION AND FINANCIAL SECURITY."

# Chapter Two

# Equipment and Lighting

There is a certain amount of equipment you must take with you to any wedding. This chapter is devoted to giving you insight into what equipment to bring and how to use it.

Owning a lot of excellent and expensive equipment will not, in and of itself, guarantee fine results. If you take bad photos with inappropriate or mediocre equipment, you'll take bad photos with better equipment.

Knowing how to use what you have is the key. Learn how to operate all equipment, and understand specific uses or applications for wedding photography.

## Types of Wedding Photography

All weddings involve two distinctly different types of photography: formal and candid.

Although both areas encompass photography of individuals, couples and groups, they usually involve the use of different types of equipment.

### Formal Photographs

Formal photos often require the use of a substantial amount of equipment. You'll most often use one or more off-camera flash units, some props, a portable background, different lenses and filters, and so on. Formal photos also consume a fair amount of time; you must set up equipment, stylize poses, and adjust the lighting.

Studio-type equipment and lighting will usually take you longer to set up and tear down than portable equipment, but it will often give your photos a better look. However, being able to get a better result with studio-type equipment is not the criteria for selecting it.

As a general rule of thumb, the less time and help you have, and the more remote the area, the more you should favor using portable equipment.

Formal photos are planned and posed and require some extra effort. Because of this, they should only be taken in the studio or bride's home, days or weeks prior to the wedding day. On the wedding day, use portable equipment.

### Candid Photographs

Candid photographs are not posed nor planned, but are images made on the spur of the moment with minimal equipment. They are generally illuminated

> "**Learn how to operate all equipment, and understand specific uses or applications for wedding photography.**"

with a single, on-camera flash unit and take only seconds to execute. They are taken throughout the wedding day. What makes a wedding pro's candids different from the candids taken by a guest?

- film selection.
- knowing what candids to take.
- timing.
- consistent exposure.
- proper equipment.
- dependable equipment.

### Film Selection

The wedding pro knows which type of film to use for wedding photography and consistently uses the same type of film for every wedding photographed. Controlling this factor helps ensure more consistent photo results.

### Knowing What Candids to Take/ Timing

The pro knows from experience, education, and training, which candids must or should be taken, when to take them, and why to take them. He is constantly on his toes, waiting to photograph any moment. By contrast, the novice often just snaps away at anything which he or she thinks is a pretty picture.

### Consistent Exposure

Successful wedding pros know how to obtain consistently good film exposure for every frame of film they shoot, whatever the lighting conditions are.

The casual photographer often doesn't know what is meant by good film exposure, nor do they understand the efforts and equipment involved in attaining it.

### Proper Equipment

Casual photographers most often buy equipment basing their selections upon incomplete information, cost, the advice of a friend or salesperson, and advertisements. As a result, many are led to believe that only a minimal investment is needed for equipment that will last a lifetime.

They believe their limited equipment will enable them to photograph anything, anywhere, anytime. Pros don't follow such frivolous guidelines when it comes to selecting equipment; they select the proper tool for the job.

It is not uncommon for a pro to talk with a number of other professional photographers and seek their advice about equipment.

Many even go so far as to check equipment out on loan so they can test it prior to purchase.

### Dependability

A wedding photographer must be able to rely upon all pieces of his equipment. You cannot find yourself unable to photograph an important event or phase of a wedding because a piece of your equipment has failed or broken, and you have no backup equipment.

A wedding photographer simply cannot afford to use any piece of equipment which is not totally reliable and dependable.

All photographic equipment can be lumped into two major categories: consumer or professional grade. From a very general standpoint, consumer grade equipment will not withstand the use or abuse that professional equipment will. In addition, consumer equipment is usually inferior when compared to professional grade equipment.

Casual photographers may be content using consumer grade equipment since they only use it an occasional basis. Wedding pros, on the other hand, should not purchase any major piece of equipment unless it is of professional quality, or unless it can be modified to such a state.

*Backup equipment.* Even though you may own the best equipment that you can afford, do not relax your guard when it comes to equipment failure. You must assume that your equipment can and will fail, so always take backup equipment to all weddings.

**BETTER CANDID PHOTOS DEPEND ON:**
- film selection
- knowing what candids to take
- timing
- consistent exposure
- proper equipment
- dependable equipment

If you are in doubt as to how much equipment to take, take more than is necessary, just to be on the safe side. The advantages outweigh the inconveniences.

## Equipment

A single camera, lens, and set of lighting equipment will not serve you well for all types of photographic assignments. Equipment should be chosen based upon what and where you are going to photograph.

We may choose a particular brand of camera, lens and lighting to photograph a given situation; you may choose another. Just because you might admire a particular photographers work, don't rush right out and buy all the equipment that he or she might be using.

We assure you that a successful wedding photographer did not attain that status simply because of any particular choice in equipment. Accordingly, and until you establish your own favorites, use our suggestions as a guide. They'll save you some time, effort, and money.

### Portable Equipment

Some equipment, designed primarily for portability, can withstand the abuse associated with transporting. It's generally lightweight, compact, easy to maneuver and transport, and easy to set up or break-down. It often costs less too.

### Studio Equipment

This type of equipment is designed for stationary use; it can't take the abuse associated with frequent transporting. Accordingly, it is usually heavier, bulkier, less maneuverable, and more complex to set up and break down than portable equipment. It also costs a lot more. (See photo #2-2.)

A staple piece of our portable wedding equipment is a Vivitar flash unit, model #283. It's self-contained — comprising a lamp, housing and power source — weighs almost nothing, is extremely versatile, is portable and inexpensive. (See photo #2-1).

### Shooter's Log: In a Flash

When last in the market for additional portable flash equipment, our search boiled down to three different brands. Although we read all of the literature available from each manufacturer, talked with other pros and worked with each unit for a couple of days, we weren't sure our selection was correct. Then we talked with the service managers at five independent service-repair companies about all three brands. We got the same report from all of them: during any one given year, they serviced and repaired more of brands A and B units than they did of brand C, by ten to one. We purchased brand C units and have been thoroughly satisfied.

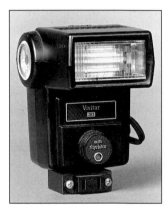

2-1: Although there are a number of small, portable, flash units on the market, it's hard to beat the Vivitar units, especially their #283 models.

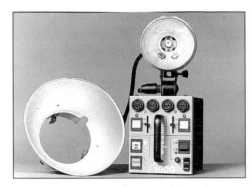

**2-2:** Here is just one of our simpler studio lighting setups: a Dynalite. Typically, three pieces comprise any studio lighting setup: a power pack, a lamphead, and a housing for the lamphead. The type of housing here is usually referred to as a bowl, or a bowl reflector.

If necessary, all phases of a wedding could be photographed with portable equipment, but not with studio equipment. Many studio pieces will be too awkward, too large, or too time consuming to employ.

## Cameras, Film, and Related Accessories

You must be prepared to make an investment in good photographic equipment if wedding photography is going to be a business for you, and not a sideline. Owning limited or bad equipment will put you and your business at a distinct disadvantage. The following tips and suggestions should help make your equipment selection easier.

### Cameras

Weddings are really the province of small and medium format cameras (35mm and 2-1/4 inch; See photo #2-3). Many successful wedding photographers use 35mm equipment. It is light, compact, and easy to use. With today's fine optics, there is no problem in making good enlargements. We prefer to use the 2-1/4- inch format for weddings for three main reasons:

1. *You cannot successfully retouch 35mm negative film because it is too small.* All

### Shooter's Log: Investing in Yourself

If wedding photography is going to be a business for you, and not a sideline, then you must be prepared to make an investment in good photographic equipment. This equipment includes cameras, film, and related accessories. Owning limited or bad equipment will surely contribute to your failure.

When it comes to cameras, we prefer and use medium format cameras, usually Hasselblads, for most of the weddings we photograph. The unique appearance of medium format cameras also makes you look more professional.

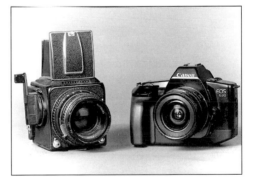

**2-3:** Although a wedding could be photographed by using a 35mm camera (such as the one on the right), we generally prefer and use medium format cameras (Hasselblads) at weddings (pictured on the left).

retouching must be done on the final prints and this is often not cost-effective.

2. *Most 35mm cameras will not synchronize with flash at all shutter speeds.* This limits your flexibility somewhat when taking certain shots.

3. *Medium format is more impressive; it bespeaks professionalism.* A number of people own 35mm cameras. Fewer own

> "WEDDINGS ARE REALLY THE PROVINCE OF SMALL AND MEDIUM FORMAT CAMERAS."

2-1/4-inch equipment. The public often thinks that the reason professional photographers get good results is because of the equipment they use.

### Lenses

Although you can do an entire wedding with only a standard-focal-length and a wide-angle lens, the more optical variety you use, the more varied the resulting images. Being able to offer more variety often increases your photo sales.

*Wide-angle lenses.* A wide-angle lens (see photo #2-4) is perfect for broad perspectives of the interior and exterior of a church or reception hall, and for groups of four or more people. It is sometimes the only choice when photographing a wedding or reception in a confined area, such as in a small restaurant, home, or apartment.

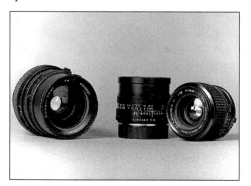

**2-4:** If we were restricted and could only use one lens to photograph an entire wedding, then we would often choose a slight wide angle lens: a 60mm for a medium format camera or a 35mm lens for a 35mm camera (both shown here). For extremely tight quarters, the 28mm lens for a 35mm camera (shown here) or 50mm lens for a medium format camera (not shown) is often the focal length of choice.

However, be cautious: faces and bodies may appear distorted if you are too close when taking photos. Keep the camera perfectly horizontal; do not get too close to subjects (no closer than six feet), and keep subjects well clear of the edge of the viewfinder frame.

*The standard lens.* This particular focal-length lens is an excellent lens to use when you wish in-camera cropping. It will permit you to get a closer, more intimate image of your subject. Because of its limited angle of view, unwanted details will be omitted from the photograph. The standard lens is ideal for capturing couples dancing at a reception, or for more intimate views of the bridal couple at the cake table.

*The portrait lens.* A medium telephoto is the perfect lens for portrait photography. Because this lens tends to compress and blur the background, its primary application is for intimate views: tight head, or head and shoulder shots.

An excellent time to use this lens is during the ceremony. Position yourself at the rear of the church and use the portrait lens to take some photographs of the bridal couple while they are at the altar.

Using only available light will enhance the natural appearance of the scene and produce very attractive prints. After making a few exposures with the portrait lens, switch over to the standard or wide-angle lens for a more expansive view of the proceedings.

*Zoom lenses.* A zoom lens places a myriad of focal-lengths at the photographers disposal. A 70mm-210mm zoom lens lets a photographer use any focal length between 70mm and 210mm without changing the lens. However, you will pay dearly for a zoom with good optical quality. You're frequently much better off buying three or four lenses of varied focal-lengths than you would be with one zoom lens. The separate lenses will be far superior to any zoom lens, and will result in better photographs.

### Filters

Used with discretion, filters can help add something extra to your wedding photographs (See photo #2-5). Not all filters are created equal. It makes no sense to buy an expensive lens and put a cheap filter on it. No matter which lenses you

> The following is a list of lens sizes we use in wedding photography:
>
> **Wide angle:** 28mm or 35mm for 35mm cameras, or 60mm for 2-1/4 inch.
>
> **Standard:** 50mm for a 35mm cameras or 80mm for 2-1/4 inch.
>
> **Portrait:** 100mm for a 35mm camera and 150mm for 2-1/4 inch.

might own, you cannot go wrong by buying the same brand filter. A manufacturer's filters will usually be designed to compliment their lenses. Good sources for filters are B&H, Harrison & Harrison, and Tiffen.

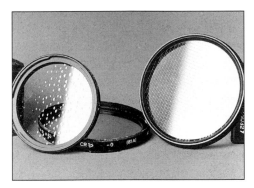

**2-5:** Many otherwise bland wedding photos could have been enhanced if some form of filtration had been used. The three shown here are the most popular types of filters to use: soft focus; 81A warming filer and a 4-point starburst filter. However, there is one word of caution regarding any filter. Do not over do! Use any filter sparingly and judiciously.

*Diffusion filter.* A soft-focus or diffusion filter will help give your photographs a dream-like look. Although diffusion filters are usually graded, unfortunately, there is no standard. The only way you can be certain of the results is to buy several different filter grades, take some photos, and see which you prefer.

Choosing a soft-focus filter to use for wedding photography is a subjective decision. Beware of using too strong a filter, or the resulting images may appear out of focus. When in doubt, go light. Like seasoning, a little will go a long way.

*Warming filter.* Add some color and sparkle to outdoor photographs executed on dull, overcast days by using a warming filter. An 81A, light balancing filter is generally ideal.

*Starburst filter.* When you are taking available-light shots from the rear of the church, the use of a starburst filter can add an ethereal look to your images. To

be effective, the photo scene must contain point light sources, such as candles or small electric lights. Although such a filter works best with available light as the only light source, it can also be used with a flash, but the flash must not overpower the point light sources.

The best times to use this filter is from the rear of the church during the ceremony, and at the reception site. Photographing the reception hall before the guests arrive with a wide angle lens and a starburst filter can yield dynamite photo results.

Starburst filters are two piece filters. The inner or back piece gets screwed onto the lens and remains fixed. The front or outer part of the filter rotates 360 degrees. As you turn the outer ring, the starburst effect rotates. For best results, do not allow the burst rays to invade a subject's face. A slight turn of the outer ring of the filter will relocate any offending ray into another part of the scene.

Filter companies which make and sell starburst filters (or star filters) frequently offer a variety: 2 point, 4 point, 6 point, and 8 point filters. A 2 point filter produces 2 rays of light from each point light source, 4 point filter produces 4 rays of light from each point light source, and so on. In our experience, we have found that a 2 point filter is not dramatic enough, while the 6 and 8 point filters are too busy; too many rays of light cloud the photo scene. A 4 point filter works best.

The following are filters we choose to use with Hasselblad cameras on wedding shoots:

**Diffusion:** Softar 1, Tiffen Black Net and Harrison & Harrison Black Dot.

**Warming:** Hasselblad C.R. 1.5 or 3.0 warming filter.

**Starburst:** B&H.

Don't overuse any filter, or its impact will be lost. We shot our first few weddings with soft-focus filters on all of our cameras. Without exception, every parent hated the photo results. To them, the resulting images looked out of focus. We learned to use soft-focus sparingly.

*Other filters.* There are many other special-effect filters which could be used at a wedding, including multiple or split-image filters, and two or three-tone filters. At best, all of these have limited application in wedding photography and tend to make photo results look dated.

## Exposure Meters

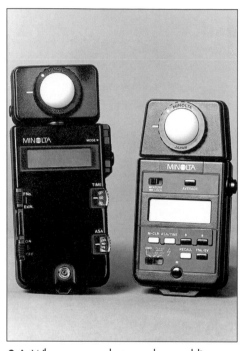

2-6: Whenever we photograph a wedding, we always carry two exposure meters with us. One is an ambient meter (shown on the right). We use this meter only in the ambient mode. Although the other meter, shown on the left, is capable of reading either flash or ambient light, we use this type of meter only in the flash mode.

Using a good exposure meter will help ensure photographic success. Throughout a wedding, you'll be photographing by ambient light, by flash, or both. For correct exposure, it's essential to have a light meter capable of making accurate readings, especially in low light situations.

We use the Minolta Auto 3F meter for ambient light readings and the Minolta Flash Meter for flash readings (See photo #2-6). We usually use both in the incident-light position. Using a light meter is only part of the answer for exposing film

properly. Exposure information gained from a meter should only be used as a guide. You must decide how you wish to expose your film. We like to overexpose our film by one full f-stop because we use color negative film. We do this to bring out full detail in shadowy areas.

## Tripods

A tripod has limited application in wedding photography. When one is called for, for formal portraits, available-light shots during the ceremony, and altar returns, it should be strong and easily maneuverable.

Most tripods have two or three handles or knobs which allow control over tilt, pan, and horizontal movements of the camera (See photo #2-7). Often these controls can get in the way, or may be awkward to use. To solve this problem, we modify all of our tripods with ball-and-socket heads (See photo #2-8). These heads allow tilt and pan control of the camera with one simple knob adjustment.

Using a ball-and-socket head may sometimes be impractical during a wedding: it might take too long to get your camera disengaged from the head and back onto a flash bracket for capturing candid photos.

In order to make a fast transition, we suggest that you purchase a quick release mount (See photo #2-9). The mount is affixed to the top of a tripod and the camera merely slips on and off. As with other pieces of photographic equipment, tripods come in two types: portable and studio.

*Portable tripods* vary in price, size, durability, weight, and extension capability. Some are collapsible, others not; some are as small as six inches high, and others are three to four feet and extend to eight. Some extend easily, others are more difficult. Some are very light in weight and flimsy, and others are built like tanks.

In choosing a portable tripod, you will really not know if you have chosen wisely

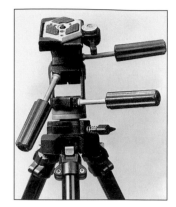

2-7: Tripod equipped with handles (or knobs).

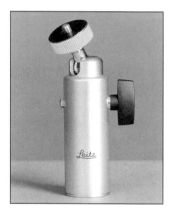

2-8: The Leitz ball-and-socket head.

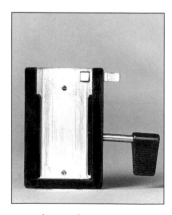

2-9: The quick (camera) release is a time-saving device.

until after you have used it on several photo assignments. A tip: Buy a sturdy one. We never buy a tripod unless it can support the weight of a larger camera than the one we intend to use.

For example, if we wanted a tripod to support a 35mm camera, we would buy a tripod which would support a medium format camera.

*Studio tripods* are heavier, bulkier and more expensive than portables. They are not made for ease of transportation, and they don't set-up or tear down easily. One of the very nice features of some studio tripods is that they sport wheels, and are extremely maneuverable.

In addition, they allow a mounted camera to be positioned anywhere from just inches above ground level to the full height of the tripod, all within fractions of a second and with little fuss.

### Flash Brackets

Whenever you're engaged in candid flash photography during the course of a wedding, you'll need an on-camera portable flash. Novice photographers typically mount such flash units directly onto their camera's hot-shoe. This is sometimes referred to as on-axis or in-line lighting, and is not desirable for professional-looking photos, even candids. When a flash is used on-axis, it can produce red eye. This looks unnatural and makes photos non-salable.

Mounting a portable flash above or off-axis to the left or right of the camera's lens will usually eliminate this condition. A flash bracket will hold the flash off-axis and still let it function as an on-camera flash. Ten years ago, flash brackets were few and far between. Today, they come in a myriad of configurations, with most of the better brackets being configured for specific camera types (See photo #2-12).

### Focusing Aids

Sometimes, during the course of a wedding, you'll experience difficulty with focusing; you won't be able to see well in the dim environment. If you cannot see well, your resulting photos will often be out of focus and undesirable. To help you see better, there are two aids which we suggest: bright screens and focusing lights.

*Bright screens.* If your camera has a removable focusing screen, replace it with a split image, bright focusing screen. Depending upon the manufacturer, a bright screen will increase brightness for focusing anywhere from 50 to 100 percent. Screens may seem costly, but they are well worth the investment.

*Focusing lights.* Before bright screens came into existence, photographers used a small video light mounted on flash brackets to illuminate scenes (See photo #2-10). Even though we use bright screens on all of our cameras, we still often use focusing lights. The 15-watt bulb produces enough illumination to focus even in the darkest areas.

2-10: During the course of many weddings, you will often find yourself photographing in low-light environments. Attempting to focus can be, at best, very difficult without the aid of some additional ambient illumination. Mounting a small video light, such as the one shown here, atop a flash (see photo #2-12), will give you just enough illumination to aid you with focusing.

On the negative side, focusing lights add more weight to an already heavy camera. They are also expensive to run. Replacement bulbs are relatively costly, and typically produce light for only about 20 minutes of continuous use.

We use Leitz ball-and-socket heads on most all of our tripods. They are versatile, easy to use, and serviceable. They are, however, expensive.

We use camera specific quick release mounts: one by Hasselblad and another by Mamiya.

Our portable tripods are Tilt-All and Bogen (model #'s: 3221, 3033, 3058 and 3068).

In the studio, we use a Monostand by Arkay (See photo #2-11).

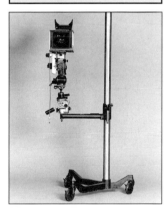

2-11: An Arkay monostand.

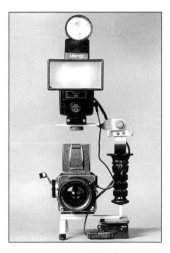

2-12: This type of flash bracket is ideal for wedding photography. This one is made by Armato Photo Services.

We turn a light just before we focus, then turn the light off and take our shot. At most, a light is only on for about three or four seconds at any time. Used in this fashion, a fully charged light will usually last an entire wedding.

### Film

There is a great selection of film to choose from. When choosing, follow these guidelines:

• The film size you need depends on the camera you'll use. If you use 35mm equipment, buy 36 exposure 35mm film. If you use a medium format camera, use 220 film size. You'll get more exposures from this size than with the 120 film size.

• When doing weddings professionally, always use film which is clearly marked professional film. Colors will saturate better, speed (I.S.O.) will be more consistent, and grain will often be finer than non-professional films.

• Film is manufactured in batches of thousands of rolls. Each batch is of a certain color dye-lot. Batches with different emulsion numbers may have slightly different colors than one another. Therefore, in order to have consistent color prints for an entire wedding, only use film of one emulsion number per wedding.

• Always shoot in color unless a client specifically requests otherwise. In all the years we have been doing weddings, we have only had two requests for black and white film, and only one request for slide film.

• For daylight and flash photography, use daylight film. If photos are to be taken solely by household bulbs, candles, and the like, use daylight or tungsten. Tungsten film will make such photos more natural looking, while daylight film will result in warmer photos.

• The lower the light level, the faster the film you should use. The brighter and stronger the light level, the slower the film you can use. Generally, we use I.S.O. 160 or 400 speed film.

• The brand of film used is an entirely subjective decision. Do some experimenting to determine what film best serves your purpose and taste. You'll get more consistent results if you always work with one film than if you skip from film to film.

• Always take more film than you'll need! Running out during an event is totally unprofessional. Typically, we carry at least one full brick (20 rolls of 220 film; 4 pro-packs) to an average wedding.

We most often use Kodak's Vericolor III or, occasionally, Fuji color 400. Both are professional negative films and give outstanding results.

## LIGHTING EQUIPMENT

To photograph any wedding, you must have some form of illumination: daylight, electronic flash, tungsten, or some combination of these. From a practical standpoint, most of your wedding photos will be captured by using flash, on or off-camera, or both. How you use flash units will separate your work from that of other photographers.

### Studio Flash

The power output, versatility, and durability of professional studio flash heads far exceeds portable flash units. Notwithstanding, each has its own area of application for wedding photography. In the studio flash category we use Balcar, Dynalite, Broncolor, and Norman lamp heads and power packs.

Our power packs range from 250 to 5,000 watt-seconds. This great versatility in lighting power allows us to use lights at varying distances, f-stop settings, and with various housings.

### Don't Mix and Match Equipment

Only use a brand power pack with the same brand lamp head. A manufacturer's power pack is specifically designed to compliment and work with their own

> **"ALWAYS TAKE MORE FILM THAN YOU'LL NEED!"**

flash heads for optimum performance. You may need more than one brand of equipment to obtain versatility and more complete light control. We have found that no single manufacturer offers the range of lighting equipment we need. For example, one of our brand A power packs has four, fixed power output settings: 400, 800, 1200 and 2,000 watt-seconds. If we needed a power setting in between any one of these, we cannot obtain it easily.

By contrast, with our brand D power packs, which are much more expensive and versatile than brand A, we have the ability and flexibility of changing the power output between 400 and 2,000 watt-seconds in increments of tenths of an f-stop.

### The Importance of Variable Power Output

Each time you double the power output of any flash, you gain one whole f-stop. By the same token, cutting the power output in half drops one whole f-stop.

For example, metering a subject 10 feet away from a flash connected to a power pack adjusted to emit 500 watt-seconds of power may indicate an f-stop of f-16.

By doubling the power to 1,000 watt-seconds, you would get a new meter reading of f-22, twice the light. By the same token, if you cut the power output to 250, you would now get a lower meter reading of f-11.

If you wanted a precise output of f-16.8, power pack A may not be able to accomplish it. You may have to move the lamp head to get the desired meter reading (which will often change the character or quality of the light), or change to a different brand flash.

### All Studio Flash Units are Not Created Equal

Manufacturers may claim performance standards, yet may perform better

or worse. Generally, the more expensive the unit, the more proficient the unit and the more faithful and accurate its power output.

*Power pack size.* This will frequently be based on what you can afford. Two things are for certain: the more powerful the power pack, the more expensive and versatile it will be.

We would suggest that at the minimum you start with 1,000 watt-second power packs and compatible lamp heads, but 2,000 watt-second packs are preferable, and offer more versatility.

### How Many Studio Power Packs should You Have?

This depends upon a number of factors, none the least of which is, again, available funds. We suggest that you start with a minimum of two power packs and at least four lamp heads.

Owning less will usually be too restrictive and can suppress creativity. As your business and needs develop, you can gradually add different brands of power packs and lamp heads to your equipment list.

## Portable Flash

By selecting a portable flash over a studio unit you will realize certain advantages and disadvantages. For example, portable units are often far less expensive than studio flash equipment. They're lighter, more compact, and easier to set up and tear down.

However, most have limited power capabilities. In spite of this, and for most wedding flash photography, portable flash equipment will be the type you'll use.

We have arbitrarily categorized portable flash equipment into two major types: type A and type B. The types are divided by two main factors: cost and power output. Each type offers certain advantages.

> "BY SELECTING A PORTABLE FLASH OVER A STUDIO UNIT YOU WILL REALIZE CERTAIN ADVANTAGES AND DISADVANTAGES."

## Type A Equipment

This type of portable flash equipment is usually inexpensive and has low power capabilities. In this category, we use the Vivitar Model 283 (See photo #2-1, page 22 ) for candid photography. Although its power output is only about 100 watt-seconds, and its cost is under $75, it's considered to be the workhorse of the wedding industry. There may be other brands on the market that function just as

well, but we haven't found one whose performance compares. Although the Model 283 can be used in manual mode, we almost always use ours on automatic. This eliminates the necessity of juggling f-stops, distances, and guide numbers when doing a fast-paced wedding.

## Type B Equipment

This type of portable flash equipment is expensive and has higher power capabilities. These units are more awkward

> **"THIS TYPE OF PORTABLE FLASH EQUIPMENT IS USUALLY INEXPENSIVE AND HAS LOW POWER CAPABILITIES."**

### Shooter's Log: Testing for Reliability

We are constantly on the outlook for type B flash equipment, preferably in excess of 400 watt-seconds of power. At one point we thought we had found a suitable unit. It's a portable flash unit with a separate power source and lamp head — a design similar to the Norman 400-B. It claimed to produce 100 to 800 flashes on one set of fully charged batteries at variable power settings up to 1200 watt-seconds of power. The unit was very expensive, but we thought that the added versatility would be well worth the money. Prior to buying the unit, we obtained the unit on loan to test. After fully charging the batteries, we set its power to 1200 watt-seconds and started shooting. Minutes later, after having exposed only 12 frames of film, the unit would produce no more flashes. Thinking that the unit or batteries were defective, we called the rep, who advised us to recharge the batteries and try again.

After recharging the unit, we went back to conduct another test, this time at half power. After 40 frames, the unit was again exhausted. This performance was totally unacceptable to us so we sent the unit back and again spoke with the rep about the problem. He assured us that he would check the problem and would get us another unit. We have heard nothing.

When spending money on wedding equipment, we want to make sure we will be able to rely upon it for any wedding. After testing the unit described above, we decided on another brand that proved more reliable.

and cumbersome to work with and are not as fast and easy to set up and tear down as Type A.

However, when you need more power output and can't use studio equipment, this is the only answer. For non-candid photos at a weddings, such as altar returns, or romantics of the bridal couple, we will often use this larger type of portable flash unit.

**2-13:** We like the Multiblitz for its versatility. However, there is one drawback – when the unit is configured for DC operation and connected to any 12 volt battery (optional item, not supplied with the unit), it becomes rather heavy and bulky. Notwithstanding, it's a great flash unit for non-candid wedding photos.

Our type B choice is the Multiblitz (See photo #2-13). Its cost varies depending upon the options you select. The power source and flash are contained in one unit. Its power can be adjusted to emit 100 or 200 watt-seconds, and it can be operated either by a portable 12-volt battery or with A/C power. One fully charged, 13 to 15 amp hour 12-volt battery will more than handle all of your photo needs at a wedding.

These units are extremely dependable: over a five year period we never had any of our six units repaired or serviced; we've never even had to replace a flash tube!

For those times when we need more than 200 watt-seconds of power, altar returns when the bridal party is ten or more people, or any time we need more

depth of field, we use Norman 400-B lights (See photo #2-14).

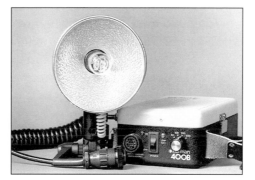

**2-14:** Compared to the Multiblitz, the Norman 400-B flash unit is even more versatile. Although the Multiblitz "looks" more professional than the Norman 400-B unit, don't be fooled. Between the two, the Norman is the better buy. It offers more power for the dollar and is just as serviceable.

Although their power sources and flash heads are separate, the 400-Bs are still considered portable. They are easy to set-up and tear down and produce 50, 100, 200 and 400 watt-seconds of power at the turn of a dial.

In addition, their self-contained batteries, work quite well. One fully charged set of batteries will produce hundreds of flashes before recharging becomes necessary, and recharging is fast. It's a great unit, but it is expensive.

### How Many Portable Units should You Own?

Have at least one type A unit for each camera you take to a wedding, plus one as a backup. The backup unit can also serve as an off-camera flash while your on-camera flash acts as a fill light.

This type of set up will yield better dimensional lighting compared with photos shot with simple on-camera flash. Since type B equipment will most often be used off-camera, a lot will depend upon the size of the groups you are photographing.

The greater the number of people, the more units you should use to ensure adequate lighting coverage.

*"THE GREATER THE NUMBER OF PEOPLE, THE MORE UNITS YOU SHOULD USE TO ENSURE ADEQUATE LIGHTING COVERAGE."*

At a minimum, you should take two to most weddings, and if you know in advance that the groups will be quite large, three or four units would be ideal. The most we have ever used is six units.

### Modifying the Portable Flash.

Type A portable flash units, such as the Vivitar 283, are usually designed to be powered by standard batteries. However, when doing a long photography session, such as a wedding, using standard batteries is impractical; these batteries become exhausted too quickly. At the first wedding we did, we used standard batteries. We not only had to change batteries quite often, it cost about $30 in batteries per light unit.

We now use gel-cell rechargeable batteries (See photo #2-15). These cost about $50 each. They easily attach to flash brackets, and they recycle the flash faster than any other units we have found, and they last about one year. One of these batteries, fully charged, will power one flash through an average wedding (18 to 20 roles of 220 film).

To use this type of battery with portable flash, the flash unit must be modified. To learn whether your flash can be adapted, contact a service company. You can also look into having your Type A units modified to increase the power output.

### Slaves for Portable Flash Units

Slaves are triggering devices that use electric eyes to set off remote flash units without any sync cords or other wire connections. They provide a way to trigger remote units conveniently and safely. An on-camera flash will yield flat, shadowless lighting. By moving a flash off-camera to the right or left, shadows will be added to give the subject dimension.

On location, a photographer can forget that directional lighting is possible with portable equipment. The flash on the camera can act as the fill light and a remote flash can act as the main light.

During a wedding you will not often have the time or space to arrange such dimensional lighting. However, whenever you have the opportunity to arrange it, do so.

### The Slaves We Use

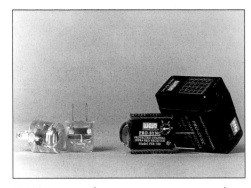

2-16: In our studio, we never use sync cords, we use slaves, such as the two types shown here: Norman SL2's (on the left) and the infrared slaves by Wein (right). A sync cord lying on the floor of a shoot-room is not only messy looking, it can be a hazard; someone could trip and fall over it.

In our studio we exclusively use the SL2 slaves by Norman and infrared slave units (transmitter/ receiver) by Wein (See photo #2-16). The Norman is relatively inexpensive. It's simple, efficient and reliable, especially useful for studio photography or on location inside a building. It's fast and easy to set up and take down. No transmitter is required, since an on-camera flash triggers the slaves.

However, slaves of this type must see a flash from another source. At weddings, this other source should be your on-camera flash, but any flash will trigger it. If someone happens to take a picture before you, your slaved lights will fire and you'll have to wait until your units have powered before you can attempt to shoot again. If you don't wait, you risk underexposure.

Although they are more expensive, Infrared Wein slaves solve part of this problem. These units involve at least two

2-15: Gel-cell battery. After use, the unit can be easily recharged and with care a gel-cell battery will typically last one year or more before it needs to be replaced.

pieces: an infrared transmitter and one receiver for each remotely connected flash. Although the infrared slaves still must see a source in order to fire a remotely connected flash unit, the infrared light coming from a transmitter trips the flash.

The Wein transmitter is connected to the cameras sync post, and a Wein receiver gets plugged into the remote flash. Every time you photograph, a pulse of infrared light gets sent from the camera, and the remote flash fires.

Since slaves like the SL2 and the Wein are dependent upon seeing a source, you cannot hide the units. If you position a bridal couple to one side of a pillar and you conceal a slaved light behind the pillar to act as the main light source, the slaved light may not fire.

In addition to this condition, there is also a further problem: daylight! Slaves of this type are definitely great when photographing indoors, such as in a studio or a church, but in the great outdoors their efficiency can suffer greatly. Strong daylight can cause the remote flash to fire randomly and erratically.

Obviously this condition is less severe on very cloudy days. The Wein company has infrared slaves which are designed to be used for outdoor work, but our experience has shown that even these outdoor models err in strong daylight. Because of this, we never use SL2 or Wein slaves units for outdoor location photography.

Ultrasound models are not dependent upon seeing anything. A transmitter is connected to the cameras sync post and a receiver is connected to units to be slaved. Your slaved flash units will not fire except when you take your photographs. You can put sound-activated units almost anywhere, even around a corner and up to about 100 feet from the transmitter. This makes them ideal for creative wedding photography. However, good ones are expensive. We have found less expensive brands to be less reliable.

When on location we sometimes use radio-controlled remote units by Tekno/Balcar, called Hawks, and infrared slave units by Wein. Most of the time we use radio-controlled slaves by Venca (See photo #2-17).

The Venca is better at handling sound interference. Although the Venca is susceptible, the sensitivity is easily remedied with a flick of a switch. Changing channels is a snap.

We also favor Venca slave units over Hawk units because of the Venca's superior electronic design. For some reason unknown to the technical reps at Tekno-Balcar, all of our Hawks trigger our Norman 400-Bs, but only certain Hawks work with particular Multiblitz units. Something inherent in the electrical wiring of the Multiblitzes, or the Hawks, prevents total compatibility.

2-17: When we are on location, we most always use radio-controlled slaves to trigger our flash units. And, the ones we presently use most often are those by Venca, shown above.

Several years ago, while photographing altar returns inside a church, our Hawk slaves picked up a pilot preparing to land at a nearby airport, engaged in conversation with the control tower. The following week, we heard a policeman talking with his dispatcher over a two-way radio.

We suggest that you test any slaves that you intend to buy with the specific pieces of flash equipment you intend to use them with.

### Flash Reflectors and Housings

When adding a reflector or housing to a flash, the quality of the light produced changes. As a result, reflectors and light housings are often referred to as light modifiers. Light modifiers include metal bowl reflectors, umbrella reflectors and soft boxes (See photo #2-18).

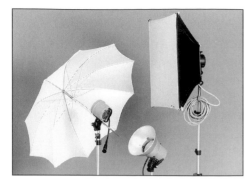

**2-18:** Shown above are three light modifiers: an umbrella (on left), a bowl reflector (center) and a soft box (on right). Each of these light modifiers will produce a different quality of light from the same, given flash source.

Each type and size of reflector or housing has its own, special application in photography. Small light sources, such as typical portable flash units (See photo #2-1, page 22) or a regular flash head in a 4 inch snoot reflector, yield hard light, with sharp and distinct shadows. Large sources, such as a flash reflected from a large umbrella or a light contained in a soft box, give softer light, with graduated shadows.

Though people look well in soft light, and wedding photography mainly involves pictures of people, it really isn't practical to photograph an entire wedding with large, soft light sources.

Due to the equipment needed for soft light photos, this type of photography is restricted to the studio and more formal scenes where time and space permit.

### Modifier Variables

Although there aren't too many different types of light modifiers, each type can have a number of variables: sizes, shapes, colors, fabrics and surfaces. These variables will have a special application and will produce different effects on the final images.

For example, a matte white reflecting surface on any type of reflector or housing will usually produce light that's softer than a silvered surface modifier.

## Reflector Boards, Cards and Circles

During a wedding, you may have time to use dimensional lighting. The flash on-camera can act as a fill light source while an off-camera, remote flash acts as a main light.

You can also use either an on or off-camera flash as a main light source and a reflector board, card, or circle as a fill source (See photo #2-19).

**2-19:** Most of the time you will use some sort of fill-light source to put light into the shadow area of your photo subjects. This can be accomplished one of two ways: a flash fill-light or a reflector. The large circular reflector shown above is silver on one side, white on the other, and collapses easily into a small bag (shown next to it).

The lighting method is your choice. However, keep in mind that any reflector will usually be less efficient as a fill source than as appropriate flash fill. Reflectors come in many sizes, shapes, surfaces and colors. Ready-made reflectors range from 6-inches square to over 4x8 feet.

They come in three shapes: rectangular, square, and round; and three reflecting surfaces: dull matte, regular reflective, and super reflective. Although they could be in any color you want, you will usually find them in white, silver, super silver, and gold.

### Sizes

A reflector should be at least as large as the subject you're photographing. If

In location photography, when space and time permit, we like to use a four-foot white soft box for formal head-and-shoulder photos of individuals or couples. When photographing a small group, we like to use two six-foot, silver-lined umbrellas. Umbrellas produce more light than the soft boxes, yielding a higher f-stop setting for greater depth of field. If time and space are factors, or if the group to be photographed is very large, we use silver-lined, 6-inch bowl reflectors on all of our lights. These produce harder light than the umbrellas, but they will also produce more light and thus allow us to work at still higher f-stop settings for even greater depth of field.

you are doing head and shoulder shots of an individual, a small 2x2-foot reflector will suffice. If you are doing full-length photographs of an individual or couple, a 4x6 or 4x8-foot reflector would be more appropriate.

If you are photographing a group of people, you might have to use many 4x8 foot reflectors to accomplish what one or two flash units could do. In any case, transporting such large cardboard reflectors to most weddings is often impractical. A viable alternative is a large, collapsible, circular reflector (See photo #2-19).

### Shapes

When doing fashion, still-life, or product photography, the shape of a reflector is often very important. However, when photographing people at a wedding, usually any shape reflector will suffice.

### Colors and Surfaces

The surface of a reflector will affect both the quantity and quality of light reflected from it. Of the four typical colors, white is the least efficient and has to be used fairly close to a subject, while super silver is the most light efficient and can be used at a further distance. However, a super-silvered reflector will produce much harder light than a regular silvered, gold, or white reflector will.

Whenever possible, we try a white reflector first. However, if it doesn't work, we try a silver, and finally a super silver reflector. If these efforts don't accomplish the result, we resort to using a flash as a fill source.

When shooting a wedding with color film, reflectors should always be white or silver. If you use any other color, the reflected light could cause an unwanted color shift.

The only exception is a gold reflector. In shade, the light is frequently blue and not very flattering. A gold reflector will give shadows and subjects a warmer glow than would occur with a white or silvered reflector.

### Make Your Own Card Reflectors

Although we own a number of the ready-made reflectors, we frequently make our own. We purchase 4x8-foot sheets of white foam-core board from hardware or art stores for about $10 per sheet, and cut them into 2x4-foot sections (See photo #2-20). We can either use the sections separately, or tape sections together to make a 4x8-foot collapsible reflector.

Sometimes we tape crumpled aluminum foil on one side of the reflector and leave the other side white. This gives us two reflective surfaces to choose from.

**2-20:** Ready-made reflectors can be somewhat expensive – the alternative is to make your own. What we do is purchase 4x8-foot sheets of white foam-core board, and then cut them into sizes that suit our needs. These sheets are constructed of pressed paper, about 1/8th inch in thickness. As a result, they cut very easily with an Xacto knife.

### Light Stands

For wedding photography, you'll need light stands that are easy to use and lightweight. Because you will sometimes encounter complications, you'll need a stand capable of holding portable or studio equipment securely up to at least eight feet. (Note! Norman and Bogen make stands which are ideal for this purpose. See photo #2-21.)

"WHEN SHOOTING A WEDDING WITH COLOR FILM, REFLECTORS SHOULD ALWAYS BE WHITE OR SILVER."

## THE FIVE LIGHTING CHOICES

There are five lighting choices which are available to you when photographing weddings. Using as many lighting choices as you can will add variety to photo results.

However, weddings will not always afford the opportunity to use all of the methods. Constraints on time and space, the time of day, and dictates of the bridal couple will work against you.

There is no single way to light a subject correctly, although there may be a lot of wrong ways. The one light that is essential in all photographic situations is a main light. Whether electronic flash, tungsten or daylight, you must learn how to work with it. Use the main light, and any other light, fill light, rim light and background light, thoughtfully. Never use a light anywhere unless you have a good reason for using it.

At any wedding, you will be confronted with a variety of lighting problems. You will not have much time to solve them, nor are you likely to have all types, nor quantities, of equipment needed for perfection.

For example, at a reception, the bridal couple may request a group shot of 40 or 50 people. If you had an hour, six 2,000-watt-second power packs, six 6-foot umbrellas, and a couple of assistants, you could probably handle the situation with ease. But, instead, you'll most likely have two portable flash units, no assistants and about three minutes to set up, pose the people, and to execute the shot.

Knowing the five lighting choices will make your decisions easier. No matter which you decide to employ, you must make certain that you expose film correctly and consistently.

### 1. Available Light

Available (or ambient) light photography involves taking photos using only available light sources: the sun, house-hold lamps, candles, and the like. Absolutely no flash is used.

When photographing by ambient light, the first step is to take a meter reading at the subject's position with an incident, ambient light meter directed at the light source. This is called metering the highlights. You should make certain that all subjects are lit equally. If not, one person will be brighter, and will stand out in the photograph.

Whenever you take photos by ambient light, the stronger portion of the ambient light is considered the main light, while the weaker portion is considered the fill light.

For example, if a subject is standing next to some candles, the portion of him/her which is closest to the candles can be considered lit by a main light. Metering the place farthest from the candles will give you the fill light.

### 2. Flash Only

Most wedding photography will fall into the flash only category. Photos are taken solely by electronic flash. The only problem with using this method, like photos taken solely by ambient light, is that there is no built-in safeguard. Since you have not considered nor compensated for any ambient light whatsoever, if your flash does not fire, your film will be totally underexposed.

Unless we note otherwise, all of our wedding candid photographs in this book were shot at one of two settings: flash on automatic to emit f-8 light, camera at f-5.6; or flash on automatic to emit f-5.6 light, camera at f-4. The shutter speed in each case was 1/60th second.

2-21: Although you might be tempted, you really should not skimp when it comes to purchasing light stands. You should use only stands that are well-built, durable, and serviceable. We have found two manufacturers, Norman and Bogen (shown above), produce excellent light stands.

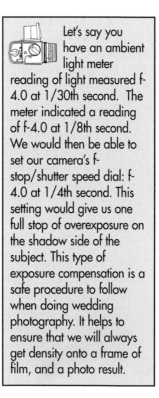

Let's say you have an ambient light meter reading of light measured f-4.0 at 1/30th second. The meter indicated a reading of f-4.0 at 1/8th second. We would then be able to set our camera's f-stop/shutter speed dial: f-4.0 at 1/4th second. This setting would give us one full stop of overexposure on the shadow side of the subject. This type of exposure compensation is a safe procedure to follow when doing wedding photography. It helps to ensure that we will always get density onto a frame of film, and a photo result.

## How to Work with Portable Flash

When photographing a wedding, you should concentrate on poses, expressions and actions without being overburdened by mechanical or technical aspects of photography. This is one of the reasons we set our portable Vivitar flash units on automatic for most of each wedding. We want to keep the operation simple.

If you are using color negative film, set a category A-type (see page 30) portable flash unit on automatic to emit f-8 light and adjust your camera to f-5.6; or set your flash to emit f-5.6 light and adjust your camera to f-4. Since either one of these two settings will ensure your getting one full f-stop of overexposure onto your film, you can photograph an entire wedding without deviating from those two f-stop combinations. By adjusting the flash to automatically produce a specific f-stop of light and setting the camera's f-stop to a one f-stop larger opening, we add one extra f-stop of density to the film, yielding good printable negatives.

## 3. Flash and Ambient Light Balanced

Photos are executed with both ambient light and flash acting as a main light. Although you might not be able to use this method for most of your wedding photos due to lack of strong ambient light, consider using this method whenever you can; it's relatively foolproof and there's a built-in safeguard.

For example, assume we wish to photograph the bridal couple outdoors, in the late afternoon light. We position the subjects under the shade of a tree and take a meter reading of the strongest light (the highlight side) which is striking them, and which the camera is going to see.

Assume the meter indicated a reading of f-5.6 at 1/60th second. If we were taking a photo solely by ambient light and based upon the meter reading, we would then set our camera to f-5.6 at 1/30th second or to a reciprocal, such as f-4.0 at 1/60th second, and take the photo. Either setting would ensure one full f-stop of overexposure of our film. For purposes of this example, we'll assume that we choose to work at f-5.6 at 1/30th second.

Next, we introduce a flash and place it on the highlight side of the subjects. We would then adjust the flash's power output to emit one full f-stop of light more than that which was set on our camera. And, in this example, we would set the flash to emit f-8 light. Since the camera was set at f-5.6 and f-8 light is one f-stop of more powerful light than f-5.6 light, our film would be exposed by one full f-stop of overexposure due to the flash.

As you can see, employing this method almost always guarantees a photo result. If for some reason the flash did not fire, ambient light alone would properly expose the film. Also, if the flash fired but our shutter speed dial didn't work, or was incorrect, light from the flash would properly expose the film. If both worked, we would still get a result, the film being exposed by ambient light as well as by the flash.

This may seem like a lot of overexposure but we have found it yields excellent prints when using color negative film.

## 4. Flash as Main Light and Ambient Light as a Fill Source

The procedure is simple: Take an incident light meter reading of the light falling onto the subject. Whatever values the meter reading indicates, set these exact values or numbers on your camera. Then introduce a flash and adjust its power to emit one full f-stop of more light than the f-stop setting on your camera. Since the flash is the more powerful light source, it becomes the main light while the ambient light, which is one whole f-stop of less intense light, becomes the fill source.

## THE FIVE LIGHTING CHOICES:

1. Use available lighting only.
2. Use flash only.
3. Flash and ambient light.
4. Flash as main light and ambient light as a fill source.
5. Ambient as the main light and flash as the fill light source.

For example, we want to take some photos of a couple by the light of late afternoon. We take the couple outdoors, position them and then take a meter reading of the light; assume the meter indicated a reading of f-5.6 at 1/60th second. We would then set these two values on our camera: f-stop to f-5.6; shutter speed dial set to 60 (1/60th second).

Next, we would position a flash near our subjects and adjust its power output to emit one full f-stop of more light (and in this case it would be f-8 light) and take our shots. Since our camera was set at f-5.6 and the flash was set at f-8, and since f-8 light is a stronger, more powerful light than f-5.6 light by one full f-stop, all of our film would be overexposed by one full f-stop of light from the flash while the ambient light acted as a fill source. [1]

## 5. Ambient as the Main Light and Flash as the Fill Light Source

This method is just the opposite from method number 4. Take an ambient light meter reading of the light falling onto the subjects. Whatever values the meter reading indicates, either decrease the shutter speed setting by one whole number or open up the f-stop by one whole f-stop.

Next, introduce a flash and adjust its power to emit one full f-stop of less light than the f-stop setting on your camera. Since the ambient light will then be the more powerful light source, it becomes the main light while the light from the flash becomes the fill source.

For example, if we took an incident light meter reading indicating a reading of f-8 at 1/60th second, we could set f-8 and 1/30th second on our camera and then position a flash near the subjects and adjust its power output to emit one full f-stop of less light than the f-stop set on the camera (in this example, it would be f-5.6 light) or we could set our camera to f-5.6 at 1/60th second, and then set the flash's

output to emit f-4.0 light. In either case, the ambient light would be overexposing our film by one full f-stop of light while the flash underexposed the film by one full f-stop and otherwise acted as a fill source. [2]

## Potpourri

Before we get into a discussion about the equipment we take to a wedding, there are two other areas of information which need to be brought to your attention: synchronization and flash; and bounce flash.

### Synchronization and Flash

If you are taking photos solely by ambient light, it frequently doesn't matter which f-stop/shutter speed combinations you set on your camera so long as the final setting is at least one full stop of overexposure based upon a meter reading.

Thus, if you took an incident light meter reading and the meter indicated f-8 at 1/60th second, you would have a number of options. You could set your camera to f-5.6 at 1/60th, f-4 at 1/125th, f-2.8 at 1/250th or f-8 at 1/30th, f-11 at 1/15th, or f-16 at 1/8th of a second and so on. Any of these settings will yield the same exposure result on the film: one full stop of overexposure. Only the depth of field would be affected.

However, once you introduce a flash into the lighting set up, two additional propositions must be considered: f-stops control flash; and not all cameras will sync with flash at all shutter speeds.

*F-stops control flash.* In order for a frame of film to properly record the light from a flash, a cameras f-stop must be properly set. F-stops control the amount of density (light) which gets recorded onto a frame of film from a flash light source, shutter speed settings have no affect whatsoever.

If you had a flash adjusted to emit f-8 light, and set your camera's f-stop to f-11,

2 One of the nice things about using this method (if it's executed properly) is that the resulting photos will look like they have been executed solely by ambient light. The shadows will not be eliminated, just lightened as a result of the flash.

1 Ambient light values can change rather quickly, especially when photographing outdoors during the early morning or late afternoon hours, Accordingly, constantly meter the ambient light to ensure maintaining the constant of one full f-stop of overexposure on our film no matter what the intensity of the ambient light might be.

f-16, f-22 and so on, the photo results would be one full f-stop of underexposure, two full f-stops of underexposure, and three full f-stops of underexposure respectively, and so on.

The higher the f-stop number set on the camera in relationship to the flash's power output, the smaller the opening on the camera's lens. Therefore, less light from the flash will be seen by the camera.

Conversely, if you had a flash adjusted to emit f-8 light, and set your camera to f-5.6, f-4.0, f-2.8 and so on, the photo results would be one full f-stop of overexposure, two full f-stops of overexposure, and three full f-stops of overexposure respectively, and so on.

The lower the f-stop number set on the camera, in relationship to the flash's power output, the larger the opening on the camera's lens, and more light from the flash will be seen by the camera.

Assume that you were in a very dimly-lit room, such as a dark reception hall, and adjusted your flash to emit f-8 light, set your camera to f-5.6 at 1/60th second and took a photo. The frame of film would be overexposed by one full f-stop of light from the flash.

What would be the result if the flash remained at the same power output (f-8), the camera's f-stop remained the same (f-5.6) but we changed the shutter speed setting to 1/125th, 1/250th, or even 1/30th of a second? The frame would still be overexposed by only one full f-stop of light from the flash. Changing the shutter speed settings will have absolutely no effect on the density of the film, since the density has only been put there by the flash.

*Not all cameras will sync with flash at all shutter speeds.* Notwithstanding that shutter speeds generally have no effect on the exposure of film when flash is used, there is additional information which you should know. First, all cameras have basically one of two types of shutters: leaf or focal-plane.

**2-22:** A 35mm camera with a flash as the sole source of illumination was set at its maximum sync speed: 1/60th of a second. You will note that the subject has been fully exposed.

**2-23:** The manufacturer's suggested sync speed has been exceeded. You can easily see the difference between this shot and photo #2-22; this frame of film has not been fully exposed.

A camera that has a leaf shutter, such as a Hasselblad, will synchronize with electronic flash at any shutter speed. However, 35mm SLR cameras generally have focal-plane shutters which impose some limitations. Most will only synchronize if the shutter speed setting is set to the X position, or at any speed from X up to 1/60th or 1/125th second; a few at 1/250th; none will sync with electronic flash at all shutter speed settings. Each camera's manual will inform you as to the limitations. If you exceed the manufacturer's recommendations, and sync at a faster speed than that suggested, you will only get a partially exposed photo result. (See photos #2-22 and #2-23.)

As long as the film is exposed at the recommended sync speed or slower, a

shutter speed setting has no affect on a photo exposed by flash.

Therefore, if you are photographing an evening wedding with flash, and are not concerned with introducing any of the ambient light into your scene, you can set your camera to a fixed shutter speed setting and leave it there for the entire wedding, exposing all of your film solely by flash illumination.

### Bounce Flash

Some wedding photographers frequently use their portable flash units in the bounce-flash mode. Instead of pointing the light directly at a subject, they bounce it off a card, wall, or some other surface first. (See diagram #2-24)

The surface effectively becomes the light source and since it is larger than the flash head itself, softer light is produced. There are problems associated with using this method, therefore, we rarely use it. The problems include the following:

First, most portable flash units have no modeling lights and without modeling lights, one has to guess where the bounced light will strike a subject. Even if the portable unit does have a built-in modeling light, it takes so much power just to operate the modeling lamp that frequently little power is left for photos.

Secondly, you must choose bounce surfaces carefully. Bounce light only from white surfaces. If any other color is used, your subjects will take on an unwanted color cast.

The final problem has to do with light loss. Light from the reflecting surface has a greater distance to travel to illuminate a subject than light which is traveling directly.

With some low-powered flash units, this can present exposure problems and can cause you to work at very low f-stops. If you intend to use the bounce-lighting method, we would suggest that you use a portable flash of at least 200 watt-seconds in power.

## THE WEDDING EQUIPMENT LIST

We offer a prospective bride a number of choices when it comes to bridal packages; from the very modest to the very elaborate. Although we shall be developing bridal packages in detail in a later chapter, it's important for you to know a little something about these packages now since they have a bearing on the equipment used for a wedding.

### Bridal Packages

Almost all wedding photographers offer some choices when it comes to bridal packages. Typically, a moderately priced bridal package includes the services of one wedding photographer, for a limited amount of time, usually four or five hours, a limited quantity of prints (e.g., 20), in a pre-determined size (such as 5x7-inches) and an inexpensive photo-album. This assures a bride limited photo coverage of her wedding event. This type of bridal package is usually perfect for the bridal couple who plan a small wedding in a chapel, and a modest reception at a nearby restaurant for 10 to 15 people.

By contrast, a more expensive bridal package will include the services of two or more wedding photographers, along with two or more photo assistants, for an expansive amount of time (usually six to ten hours), with an expansive quantity of prints (such as 40 to 60) in larger sizes (such as 8x10-inches), in one or two very expensive photo-albums.

This package assures a bride very elaborate and extensive photo coverage of her entire wedding. This is perfect for the bride who plans a large wedding: a ceremony of 30 to 60 minutes, 8 or more people in the bridal party, an elaborate reception for 200, and so on.

The size of the bridal package has a great bearing upon the quantity and type of equipment a photographer must take to a wedding. For a small bridal package, less shooting and less equipment will be

If your main purpose in using bounce light is to obtain soft light, we would recommend that you use a soft box. A soft box would eliminate guess work, make your photo results more predictable, and give you more power to work with, and hence a higher f-stop for greater depth of field.

**"THE SIZE OF THE BRIDAL PACKAGE HAS A GREAT BEARING UPON THE QUANTITY AND TYPE OF EQUIPMENT A PHOTOGRAPHER MUST TAKE TO A WEDDING."**

needed. The larger the bridal package, the more time you will spend, and the more sophisticated the poses, the lighting, and the equipment you'll use.

Don't think that the package the bride selected is the sole criteria for deciding how much equipment you should take to photograph a wedding. There are other factors to consider, such as the size of the wedding party, and family group to be photographed, the length of time to be spent at the affair, the attractiveness of the wedding location, and how elaborate or involved the event is to be.

Because of these variables, we offer you a list of equipment we would have one photographer take to an average wedding consisting of a bridal party of 10 people and lasting five hours. This choice of equipment also assumes a medium bridal package.

1. Two camera bodies, one mounted onto a flash bracket.

2. Three lenses: wide-angle, standard and medium telephoto.

3. Soft-focus filters.

4. One warming light-balancing filter for each lens.

5. Four-point starburst filter.

6. Two ambient-flash exposure meters.

7. Fix-it kit: all the items mentioned in Chapter 1 (see page 15).

8. Three portable flash units. One mounted onto a flash bracket; the others capable of being mounted onto light stands.

9. Two wide-angle dispersers for the flash unit on the flash bracket. (One is backup.)

10. Three rechargeable gel-cell batteries.

11. Two remote-controlled, ultrasound, or infra-red slave unit receivers, and one transmitter.

12. Two slaves for the remote electronic flashes.

13. Four synchronization cords.

14. A roll of black tape and a roll of gaffer's tape.

15. One kit of jeweler's screwdrivers.

16. One brick (4 Pro Packs) color negative film: VPS III daylight film.

17. One tripod.

18. One package of plastic sheeting to cover wet ground.

19. 2 cable releases.

20. One two-step metal stepladder.

21. Small flashlight.

22. Lens cleaner and tissue.

23. One collapsible, silver/white reflector.

24. Small plastic bags to cover the cameras in case of rain.

25. Two lightweight, 8-foot light stands.

For a more substantial bridal package, we would add the following studio equipment to our list:

26. Two four-foot soft boxes.

27. Two heavy-duty light stands.

28. Two 1,000-watt-second electronic flash power packs.

29. Three flash heads for the above power packs.

30. Two synchronization cords.

31. One flash meter.

32. One portable 6x6-foot to 6x9-foot earth-tone background.

33. One background light and small stand.

34. One posing stool.

35. Two 50-foot extension cords.

36. Portable background stand and 3 clamps for holding background onto stand. (See diagram 2-A.)

A word of caution! No matter how modest the bridal package might be, don't be deluded into thinking that you can get by without having backup equipment with you. From a legal as well as practical standpoint, you should always carry spare backup equipment to all weddings.

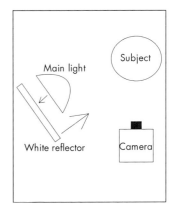

**2-A:** Bouncing lighting can yield very beautiful lighting, if used correctly and you have enough power available. In this diagram, the small main light source (e.g., a 6 inch bowl light source) is being directed away from the subject and onto a relatively large white reflector. As a result, the bounce light produced is a very soft light. Bounce light will usually require a great deal more power to illuminate any given subject at any given f-stop. Further, bounce light is frequently incapable of being precisely configured to have it produce a precise lighting result.

## CHAPTER THREE

# FORMAL AND CASUAL PORTRAITS

Of all the phases which comprise a wedding, this phase can be the most fun, creative, and financially rewarding of them all. However, as with all the wedding phases, if this phase is to be successfully executed, it will take some time and effort on part of the photographer, as well as a fair amount of equipment and preparation.

## THE OVERVIEW

The successful wedding photographer usually offers a bride photography from both areas of formal and casual photography, rather than from one, for a very business-like reason: It's the combination of the two which will provide a wide variety of images, and a complete wedding story for her wedding album. This usually results in to increased sales.

At an actual wedding, you'll be photographing on location with limited time. You won't be able to shoot all the film as you want, you'll be forced to use different equipment, and you won't be as creative as you would like.

By contrast, this phase of photography affords a photographer great latitude; the choice of locations, control over the time

within which to photograph, as well as the quantity of film to expose, control over the lighting, and other pieces of photographic equipment to use, and the luxury of being as creative as he or she can be all enter into the equation.

Formal portrait photography involves structured, not candid, photos. They sometimes involve the groom, but always the bride, and always in formal wedding attire. In addition, they are usually taken in a studio, or on location, and well in advance of the day of the actual ceremony. However, sometimes, at the request of the bride, they are taken at the ceremony site just hours before the ceremony begins.

Casual portrait photography can involve structured or candid photos. Here we shall only be dealing with the structured type. Structured casual portrait photography always involves the bride and groom, both together and individually, and excludes family members, with one exception. If there are children from a previous marriage, the couple may want them included. As with the formal photos, photos from this casual phase can be taken in the studio, on location, or both. They are taken well in advance of

**"...THE MOST FUN, CREATIVE, AND FINANCIALLY REWARDING OF THEM ALL."**

the day of the actual ceremony, with the parties attired in casual clothing.

## FORMAL PORTRAIT PHOTOGRAPHY

Since this type of photography involves the bride and takes place prior to the time of the actual wedding ceremony, a photo session of this type is usually referred to as a pre-bridal formal photo session.

If you are going to photograph weddings as a business, you should be a full-service photographer, and offer whatever photography is required and directly or indirectly associated with the wedding. To us, this includes doing pre-bridals.

### The Pre-Bridal Session

To a photographer, the purpose of a formal pre-bridal session is usually obvious: it allows a photographer the luxury of not working under pressure; there are few time constraints; creativity is not limited; there's an opportunity to offer a bride more variety; the photographer can use all the equipment he or she would like, and so on.

To a bride and her family, the purpose is more subjective: It serves as a dry run. In addition, it produces photographs which stylize as well as depict the loveliness of a bride-to-be in her wedding gown. Admittedly, you'll be photographing the bride in her gown throughout the course of the wedding day; however, these will often be just quick candid views. Formal, pre-bridal photos are carefully planned photographs, which should do full justice to the bride and her gown.

### Scheduling a Formal Pre-Bridal Session

At our studio, we prefer to schedule a formal pre-bridal photo session well in advance of a bride's wedding date by at

> **"FORMAL, PRE-BRIDAL PHOTOS ARE CAREFULLY PLANNED PHOTOGRAPHS WHICH SHOULD DO FULL JUSTICE TO THE BRIDE AND HER GOWN."**

**Shooter's Log: A Mother's Request**

Recently we were conducting a formal pre-bridal session in our studio. After having exposed more than 20 frames, all full-length shots of the bride in her gown, we casually announced that we were then going to do a few three-quarter-length shots, and then some tight head-and-shoulder shots.

The bride's mother, who was observing, responded, "If you don't mind, I really want more full-length shots. I didn't pay all of that money for the gown not to have it fully displayed in the photos." We acceded to the mother's request.

least two to four weeks. This gives us plenty of time to engage in a re-shoot, just in case of problems: The bride's dress may not fit well; she may not like the way she photographed; she may not care for her hairstyle; she may want different poses; or the lab may have ruined some frames during processing. Whatever you do, don't try to schedule a formal pre-bridal session one or two days before the wedding. You'll frequently be asking for trouble, and a re-shoot, if you do.

### The Time Involved in a Pre-Bridal Session

How long it will take you to photograph a formal pre-bridal session will depend upon two things: where the photo session is to take place and whom is to be included in the photos. One thing is certain. Most of your time should be devoted to photographing the bride.

1. *Photographing only the bride in a studio:* For this type of photo session you should generally plan on at least two hours: 30 to 45 minutes for her to do her makeup and change into her gown; 60 minutes for photos; 15 to 30 minutes for her to dress in street attire at session's end. Including other people: If other people are to be included in some of the pre-bridal photos — her mother, sister, husband-to-be, and so on — allow at least another 30 to 45 minutes.

2. *Photographing only the bride on location:* If the session is to take place somewhere on location other than at the wedding site, plan on the bride being dressed in her gown in advance and ready for photos the moment she arrives

Our experience has taught us that whenever we have scheduled a pre-bridal photo session just a day or two prior to the wedding date, the photo results are less than perfect. Most brides become very anxious prior to the date of their wedding; they often feel tense, rushed and harried. This shows in their expressions while they are posing for formal photos, and leads to less than great photo results.

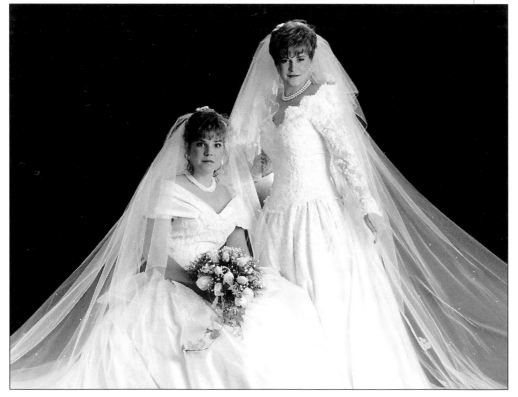

**3-1:** When doing a formal pre-bridal session, encourage the bride to do a few photos with other people: mother; sister; etc. In this case, both sisters were being married within a month of each other. Accordingly, and during their pre-bridal formal photo session, we managed to incorporate a few photos of the two of them together. The subjects were lit by one 4-foot softbox to the right of camera axis, at about 45 degrees. The fill light was also to the right, at about 20 degrees; its power was set to one half that of the main light. A kicker light was to the left of camera axis, at about 90 degrees. It was set to emit the same power of light as the main light. A top and back light, with power adjusted to emit two full stops less light than that of the main light, rounded out the lighting setup.

at the designated locale. Thereafter, you will usually spend about 60 to 90 minutes photographing her.

Including other people: If family members are to be included, some photos will be taken of them with the bride and some of just them.

For example, if the bride wishes her sister photographed too, you'll take some photos of the sister by herself: full-length, three-quarter, and tight head-and-shoulder views, and then additional shots of her with the bride. Generally plan on spending an additional 45 to 60 minutes when there are other people to be photographed.

You'll often spend more time taking photos when the session is on location than at your studio because you'll change settings within any given locale, for variety, at least a couple of times. All of this moving around takes time.

3. *Photographing at the wedding site:* If you are going to do a pre-bridal photo session on the day of the wedding, at the wedding site, be prepared! Not only will you be photographing the bride but frequently all other major parties in the bridal party (maid of honor, best man, etc.), as well as the groom and selected family.

Since the session will usually occur just one or two hours before the ceremony begins, you'll be working very fast. You will often have only 30 or 45 minutes to photograph everyone.

## How Much Film to Shoot

Film is your cheapest commodity. Therefore, never skimp of the quantity of film being used. Typically, when we do a pre-bridal photo session of just the bride in our studio, we use between one and two full rolls of 220 film (24 to 48 exposures). If other people are also to be included, we generally expose an additional one to two rolls.

If the pre-bridal session is to take place somewhere on location, other than at the wedding site, it would not be uncommon to expose two to three rolls of 220 film (48 to 72 frames of film) of just the bride alone, especially if the locale is pretty.

If the photo session is to take place at the wedding site, an hour or so before the actual wedding ceremony is to begin, limited time prevents us from exposing as much film as we would like.

## Sites for a Pre-Bridal Session

For best control of lighting and background, we shoot in our studio. However, we also shoot pre-bridals at other places, such as the bride's home, or outdoors, in an old monastery, at a park, or even on the beach.

If a bride desires an outdoor location, we will always suggest a location we are familiar with. If we are forced to work in unfamiliar surroundings, such as a locale suggested by the bride, then, before the pre-bridal session, we will visit the site and conduct at least one test photo session with a non-paying client.

This test photo session helps us determine if the new locale is suitable for pre-bridal photography. If the location setting is at the wedding site, and the photo session is to be done just prior to the start of a bride's wedding ceremony, we will often work with a large, portable background, rather than the actual environment. We know what results we can achieve with our portable background. We're not always sure what the photo results will look like if we rely on the environment of the church or temple.

## Poses

Whenever you photograph a bride in a formal session, you should place her in various poses to cover all aspects of the gown and her face. We normally follow a routine that starts with full-length shots:

1. The back of the bride's dress and train, with her face in profile.
2. The front of the gown, with the bride facing the camera.

> **"IF A BRIDE DESIRES AN OUTDOOR LOCATION, WE WILL ALWAYS SUGGEST A LOCATION WE ARE FAMILIAR WITH."**

**POSES OF THE BRIDE:**
1. Back of bride's dress and train, bride's face in profile
2. The front of the gown, bride facing the camera
3. Each side of dress

3. Each side of the dress.

After these photographs, we do a series of seated poses with the aid of a Victorian chair or attractive bench. These photographs will primarily be three-quarter-length and secondarily full-length. First, the bride is seated so that her back is partly facing the camera, with her face in profile. Then, a frontal shot is made, and finally each side. A series of tight head-and-shoulder images follows, including full-face, three-quarter and profile.

If you think your subject doesn't have the facial structure to support a good profile image, take the photograph anyway. You'll be amazed at how often photographs you think are less than attractive, but which have been well executed, will be well received and will sell.

Once any basic pose has been established, take several photographs, varying only the bride's facial expressions. Then, modify the pose slightly and take more exposures before making any major posing change. Changing your lighting will also go far in affording extra pictorial variety, even with the same pose.

When one or more other people are to be included in the pre-bridal session, remember the bride should always be the prominent person in any photo composition. A bride should never be positioned in a state of lesser prominence.

## A Bride's Assistant

Wherever you are doing a formal session, it will be common for the bride to have someone with her. She might bring a girlfriend, her mother, or other relative to assist her with her gown, her makeup, and hair, or just for moral support.

You should encourage the helper to sit in on the photo session to observe you working at your craft. This helper can later report to the bride how wonderful she looked while being photographed;

> **"ONCE ANY BASIC POSE HAS BEEN ESTABLISHED, TAKE SEVERAL PHOTOGRAPHS, VARYING ONLY THE BRIDES FACIAL EXPRESSIONS."**

**Shooter's Log: Mistaken Identity**

Ascertain the attendant's relationship to the bride immediately upon being introduced. Otherwise, you could be in for some embarrassment. We were starting a pre-bridal session in our studio, and I noticed the bride's attendant, whom I had not been previously introduced, standing in the hallway between the dressing room and the set we were working on. Wishing to be polite, I approached the bride and announced so that the attendant could hear me, "It's perfectly all right if you want your mother to sit in on the photo session and watch." Unfortunately, the attendant was not the mother, but the bride's younger sister. I have since learned my lesson.

how great the poses were which you arranged for her, and how professional you and your assistants were while taking the photos. This sort of interaction goes far in pre-selling the bride on you, your studio, and your photography long before she ever sees any photo results.

### Pay Attention to Details

During a formal session you must pay strict attention to details: fluffing of the brides gown and train; the correct placement of her veil; the brides makeup and hair; the correct positioning of the brides hands, and so on.

This attention will yield a more professional look, and the bride will appreciate the extra time and effort. You'll make her feel special.

### Equipment and Lighting

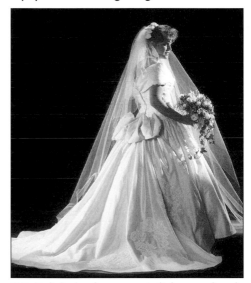

**3-2:** To light the dress, a main light was placed 90 degrees to the right of the camera. The fill light was also placed to the right, but at about 45 degrees. A kicker light was used to outline the veil and was placed left of the camera, about 90 degrees. Both the fill light and kicker light power was set at half the power of the main light.

At a wedding, constraints on time and space will often dictate the quantity and type of equipment which you'll be able to use for taking photos. With formal pre-bridal photos, you'll usually

have no such restrictions. For an outdoor formal session, we suggest that you use portable lighting equipment, type B (page 31). With this type of equipment, you'll really have a number of lighting alternatives:

1. The flash on your camera can act as a fill light and a second, remote controlled off-camera flash on a stand, can act as the main light.

2. Use three remote controlled off-camera flash units on stands: one can act as the main light; one as a fill light source; and one as a back light.

3. Use one, remote controlled, off-camera flash unit on a stand to act as the main light and use the available daylight as a fill light source or vice versa.

For an indoor formal session in your studio or at the bride's home, use studio lighting equipment. Images created with this lighting will have a distinctly different appearance from shots captured with portable lighting. It's also a good idea to use both low-key and high-key lighting set-ups.

*Low-key images.* These are images which are created on a set which has a dark background and floor. Use a minimum of four lights: a main light; a fill light or reflector; a back light, and a top light (see diagram 3-A).

During the course of any given outdoor formal session, we will frequently employ all of these lighting methods, since they will afford a greater pictorial variety over just one method.

**"IT'S ALSO A GOOD IDEA TO USE BOTH LOW-KEY AND HIGH-KEY LIGHTING SET-UPS."**

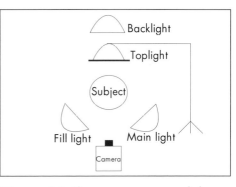

**Diagram 3-A:** There are many ways to light a bride in her gown in a low-key (dark) setting. This diagram shows one of the ways. Be careful not to over-light or under-light any subject.

Images of the bride taken with this setup will have a distinctly different look to them over anything else you'll be able to produce at the actual wedding. The resulting images will appear very dramatic and the gown, if lit properly, will stand out and show great detail (see photo #3-2, on page 47).

Our basic studio lighting setup for formal full-length and three-quarter length views, in a low-key setting, goes one step further and usually consists of five or six lights: a main light in a six-foot white-lined soft box; a four-foot soft box as fill light; a back light; a top light on a boom stand; and one or two kicker lights, in 4-inch snoot housings, to accent the brides gown (see diagram 3-B).

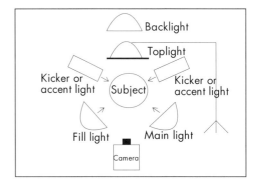

**Diagram 3-B:** This is a low-key lighting setup. It differs from 3-A is one major respect: kicker, or accent lights. Kicker lights are excellent for high-lighting certain portions of the gown. We most often use the 4-inch Norman snoot lights.

*High-key images.* These are images which are created on a set which has a white background and floor; we frequently use a minimum of five lights for this setup: a six-foot silver-lined umbrella as a main light; a six-foot white-lined soft box as a fill light; a top light in a bowl reflector, and two four-foot silver-lined umbrellas, one on either side of a white background, for even illumination (see diagram 3-C).

Images of the bride taken with this type of lighting setup, on a high-key setting, will also have a distinctly different look to them over any other photos you

will take, including images taken in a low key setting. Unlike low-key images, which are often characterized as being dramatic and even mysterious in appearance, high-key images are often described as ethereal, airy, and even dream-like.

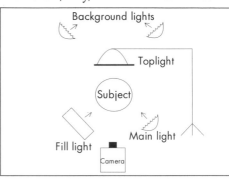

**Diagram 3-C:** A high-key setup: two background lights, a main and fill light and a top light. Use a white background, illuminated so it receives at least two f-stops of more light than the main light falling on your subject.

*For head shots.* For tight head and head-and-shoulder views in either a high or low key setting, we use a softer and smaller main light source and locate it much closer to the subject. Depending upon the effect we are after, we'll use either a two-foot soft box or a two-foot bowl reflector covered with diffusion material. We'll also use a white 2x2 or 3x3-foot reflector board, placed below the face of the subject, out of camera view. This white reflector serves to bounce some light back into the eyes of the subject and adds sparkle to the photos.

### Lighting the Gown

When it comes to lighting a bride in her gown, or for that matter, lighting anything, follow one simple rule: if you want to see it, light it; if you don't, don't! Just don't over light the bride's dress, her face or any portion of the set. It is better to be more conservative with your lighting than over zealous.

During the entire formal session, it is essential to display the bride's gown to its utmost. This entails paying close attention to lighting quality and direction.

**3-3**: When we do a formal pre-bridal session in our studio, we photographically cover all aspects of a bride's gown. We want to ensure that we have a bride's gown well documented.

*Lighting Direction.* To record detail in a white wedding gown, do not light it by direct, flash-on-camera light. The gown should receive oblique light, such as at an angle of 30-45 degrees from camera-subject axis (see diagram 3-D), rather than striking it straight on.

By using oblique lighting, you will cause light and shadows to dance in and out of the folds of the gown, giving it dimension and increasing its texture in the photos. The more oblique the lighting, the farther to the right or left of the camera you move the main light, the more dramatic the shadows on the gown, and the more vibrant the image.

### Lighting Quality

In your studio you have the greatest amount of control: you can choose the source, power, and combination of lights, as well as the type of setting you think will best suit your purpose, etc. Outdoors you may have to compromise with lighter equipment, and the time of day and weather may not be ideal. All of this has an affect on lighting and your photo results.

For example, a cloudless day at noon may produce light that is perfect for the gown, but too harsh for a bride's face. An overcast sky early in the morning may yield lighting that is ideal for a subject's face, but too soft for capturing all of the details in the gown.

The best time to do a formal session outdoors is early in the morning or late in the afternoon, when the sun is low. The presence of some clouds, as reflecting surfaces, helps. This will yield a light, not only soft enough for a bride's face, but also crisp enough to bring forth the details in the gown.

Wherever the formal pre-bridal session takes place, avoid flat lighting. The closer the main light source is to the camera's viewpoint or axis, the flatter the lighting. Texture and detail of the gown will be greatly lessened, if not totally eliminated with flat lighting. This is one of the reasons that candid photographs, lit only by on-camera flash, do not look as dramatic as properly lit, formal photos.

### Backgrounds

*Portable backgrounds.* For head views of individuals or couples, a portable, 6x6-foot earth-tone background will usually be sufficient. For three-quarter length shots of two to four people, we usually use a 9x9-foot background and a 9x18-foot background for doing full-length views. White, black, or earth-tone seamless background paper could be used for this purpose. As they are fragile and don't last as long, we use canvass or muslin material instead.

*Natural backgrounds.* At a bride's home or at a wedding site, we use a portable background because the photo results are predictable and assured. At a bride's home, or at the wedding site, backgrounds can be cluttered, busy looking, the wrong color, and so on.

If a portable background is not used on location, be very selective about the background where you position the bride. Keep the area behind her as uncluttered and as simple as possible. Choose a background (both as to type and color) which not only compliments her face, but also her gown.

Flowers, trees, plants, tables, chairs, and other objects can be distracting and will de-emphasize the gown as well as detract from the images you are creating. Either minimize background elements, or make them a subtle, supporting part of your scene. This may involve moving one or more of those elements, relocating the bride to another area, de-emphasizing the lighting which may be striking the background, or a combination of all three.

## CASUAL PORTRAIT PHOTOGRAPHY

Wedding photographers often lose sight of the fact that a wedding involves

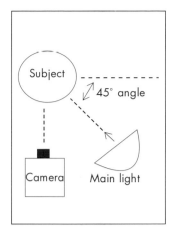

**Diagram 3-D:** Whether you are photographing in high, medium, or a low-key setting, if you really want a white wedding gown to stand out from the background and have it take on an air of dimension, the gown should ideally be lit with oblique lighting: lighting that strikes the gown at an angle rather than straight on. This diagram depicts only one form of oblique lighting: 45 degree lighting.

"**THE BEST TIME TO DO A FORMAL SESSION OUTDOORS IS EARLY IN THE MORNING OR LATE IN THE AFTERNOON, WHEN THE SUN IS LOW.**"

two main people, the bride and the groom. Since tradition has the bride or her parents hiring the photographer, one tends to cater to a bride and to give scant attention to the groom. Many images and sales are lost as a result.

To cover this situation, we always try to have the bride and her intended spouse, in pre-bridal photography, both formal and casual. But, this sometimes presents a problem.

Many of the brides we photograph do not want their husbands-to-be to see them in their wedding gowns before the day of the wedding. Therefore, in these situations, a bride will not involve a groom in formal pre-bridal photos. However, no such problem exists with photographing the couple in casual clothing, either in a studio setting or in a casual environment.

Since this phase of photography is done with a bride's wedding album in mind, it, like the formal session, is also referred to as a pre-bridal session; a pre-bridal casual photo session.

## The Casual Pre-Bridal Session

Many goals are accomplished by conducting a casual pre-bridal photo session:

1. Often a couple will have few or no good photographs of themselves, either alone or together. The casual session affords them the opportunity to obtain some excellent portraits.

2. The casual session can afford you the opportunity to become better acquainted with the bride. At the time of booking, your exchange is often formal and brief. At the formal and casual sessions, you'll have a chance to become friends and not just hired help. This can be very important because it can make your job at the wedding easier. You'll receive more cooperation from all concerned.

3. The session also gives you the opportunity to meet the groom, usually for

the first time. Get to know him, and build a strong rapport with him. This too will make your job smoother when photographing the wedding ceremony.

4. By establishing a strong rapport with both the bride and groom, you will find that any additional time which you might need to accomplish a particular photo result on the day of the wedding will usually be no problem. In no event should you take advantage of your relationship with them, ignore their request, and attempt to detain them for the originally agreed time or longer. This will have a negative effect on the photos you have to take for the balance of the day.

5. As with the formal pre-bridal session, the casual session will be another time when you will be able to offer the bridal couple pictorial variety for their wedding album, and this equates to increased sales.

### Scheduling The Casual Photo Session

Unlike the formal pre-bridal session, a casual photo session can really be held at any time before the date of the actual wedding, or even after the wedding date if need be. When we conduct the session in our studio, we usually schedule it one to two weeks before the wedding date.

We schedule outdoor sessions about four weeks prior to the wedding date. This gives us enough time to re-schedule the sitting in case we have to cancel the outdoor shoot due to weather conditions, and still have proofs and a finished product for them to see before their wedding date.

### The Time Involved in a Casual Photo Session

In the interest of saving time, a bride will frequently request that we do both the formal and casual pre-bridal photos on the same day. Although we will

For example, at the time of booking, the bride might agree to allot 45 minutes for the taking of altar return photos. However, on the day of the wedding, things might change: the wedding might start late; the bridal couple or their families might feel rushed and anxious to get to the reception, and so on. Don't be surprised if the bride or groom comes to you and advises that altar return photos must be completed in a shorter time, say done within 30 minutes. If you have previously established a good rapport with the bridal couple, the fact that you might need a few minutes more than allotted will usually be no problem, provided it will be just a few minutes.

### GOALS OF A CASUAL PRE-BRIDAL PHOTO SESSION:

1. Obtaining excellent portraits of the couple

2. Becoming better acquainted with the bride

3. Meeting the groom

4. Establishing a strong rapport with bride and groom

5. Providing a pictorial variety of the bridal couple

accommodate her, we don't like to do it; it can be tiring for them, and this can show in the resulting photos. Both sessions will usually involve them for about two or three hours and this is a lot to ask of a couple who is not accustomed to posing for photos.

Although we prefer to do a casual photo session in our studio as well as on location, many brides often don't want to devote the time for both sessions. Between the two, we would prefer to do location photos, but most often a bride will choose a studio setting for the casual photos; it's more convenient for them, and less time is involved.

Most men don't like to have their photos taken. Realizing this, when we do a casual photo session in our studio, we try and work faster than usual. We have a set routine for our lighting and poses which we usually follow, and thus can accomplish all the photos we need to take in about 45 minutes. If we do a location shoot, the couple must plan to commit to a longer time; about one to two hours.

## How Much Film to Shoot

If the casual session takes place in our studio, and even though we never skimp on film, we can usually accomplish all of the casual photos we need with one roll (24 frames) of film. However, on location, it's another matter. It would not be uncommon to expose two to three rolls (48 to 72 frames) of film, provided the weather is good, the site lovely, and the couple cooperative.

## Clothing

A casual photo session gives a couple an opportunity to dress down, to wear their favorite clothing, and engage in relaxed, happy and often romantic poses. Notwithstanding, you can't rely on the bridal couple to know what to wear, so you'll have to advise them.

Prior to the day of the casual photo session, have a discussion with the couple about the clothing they should wear. Convince them that they should dress in the same color, or at least in the same tone. Their clothing should harmonize as much as possible. Instruct the couple to avoid clothing with patterns: no checks, stripes, prints, and plaids. The resulting images would not only appear too busy, but patterns have a tendency of making a subject appear heavier in the photos.

The couple should also be dressed in a similar style of attire in keeping with the environment in which they are being photographed. For example, if you are photographing in a park, you don't want the bride dressed in a white cocktail gown and the groom dressed in white jeans and sweatshirt.

Whether you are photographing in a studio or on location, the images should emphasize the subjects, their facial expressions and body language, not their clothing. Their clothing should be merely a secondary, supporting element. 📷

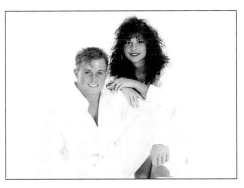

**3-4:** Casual high-key pre-bridal portraiture is popular at our studio. As with formal portraits, we do full-length, three-quarter and tight views in order to offer pictorial variety. We would prefer to have the couples dress all in white.

## Locations-Settings for the Casual Photo Session

Even though we would have greater flexibility and control if we photographed in our studio, environmental casual portrait photography can be a tremendous and different-looking addition to any bridal album. In addition, the men feel more relaxed, and the brides become

Since we do all of our studio casual photo sessions on a high-key (all white) setting because the mood created is one of lightness and cheerfulness, and it works well with subjects in casual clothing, we prefer to have bridal couples dress all in white: white shoes, slacks (or jeans), shirts, blouses or sweaters. If this is not possible, we then suggest that the couple dress in light tones: light tan, beige, light blue, and so on. If the session is to take place on location in a park or other areas where there is a lot of greenery, have the couple dress in white or earth-tone colors.

more relaxed, and this lends itself to better photographic results.

A casual photo session could be done anywhere where there are beautiful surroundings. Because we happen to live in southern Florida, we tend to favor two primary locales: the beach at sunrise or a nearby park in the late afternoon.

In any case, whether it be amid falling leaves in Maine, a wooded area in North Carolina, or sunsets in California, such casual photography sessions of bridal couples outdoors can yield stunning images, and can help increase photo sales tremendously.

*Choose locations carefully.* A location should be chosen because it contains at least one fantastic photographic area: a waterfall; a wooden bridge that spans a brook; a floor of deep green grass; a heavily wooded area where light streams through the trees, and so on.

Don't choose a location simply because it is convenient. Few locations are so versatile that they will serve for all the casual sessions you want to do. You should have several on your list and choose the best one.

*Plan ahead.* Whatever you do, don't attempt to find a location on the day of the scheduled photo session. By the time you find the right spot, the couple will be exhausted and in no frame of mind to spend an hour or so being photographed.

Find a location well in advance and do a test shoot first, with non-paying clients.

*If you are unfamiliar with likely spots in your area, a visit to your local city hall, and particularly to the department of parks and recreation, will help. The people there will usually be able to give you some good advice.*

You should make certain that the area you want to photograph in lends itself well to the type of photography you plan to do.

## Poses

Although there are no strict posing rules for a bridal couple to follow during a casual pre-bridal photo session, all of the poses should suggest love and togetherness. Even loving poses, however, can fail if you have not paid attention to details; haven't won the couples cooperation, or have failed to have them interact with each other.

*Pay attention to details.* Even though the bridal couple will be dressed in casual attire, this is not time to relax your guard; pay attention to all details: pin ill-fitting clothing so that it looks neat and straight, smooth out wrinkles, remove a grooms watch if it looks too prominent, and so on. Overlooking a detail, even a small one, could ruin an otherwise great-looking pose.

*Elicit cooperation.* Getting the bride to cooperate with you and your photographic purpose will usually present no problems. She has hired you to capture great photos and she'll be anxious to help accomplish this. Working with the groom, on the other hand, may be a different story; he often will be less than enthused. We suggest the following:

Once you are on the set or at the location site, and before you place them into any pose, spend a few minutes talking with the bridal couple. Attempt to get them, especially the groom, to know you as a person. Let them both know what you are going to do, what is involved for them and what you hope to accomplish. Show them the type of poses you'll be using. Put them both at ease and you'll gain his confidence and cooperation.

This will make the session go more smoothly. If you have done your work well, by the end of the session, the groom will be the first one to thank you for your efforts.

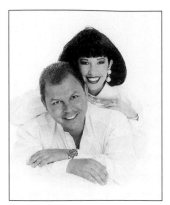

**3-5:** Here is another example of a casual high-key pre-bridal portraiture. Even though the bridal couple will be dressed in casual attire, you must still pay attention to details for better photos and more sales.

If the groom you are going to photograph has the facial and physical appearance of a football player, you'll often be ill-advised if you choose an area that is laden with a lot of delicate flowers. A location which has a more rugged terrain will be a better choice. The groom will fit in better, be much more at ease, and will usually photograph better as a result. Interestingly enough, the rugged area will often be a great area for the bride, especially if she's pretty. She'll stand out like a sore thumb.

*The couple must interact with each other.* Some bridal couples show their love readily whenever they are in each other's company. Photographing such people is easy; the emotional interaction is there, waiting you to merely capture the feelings on film. However, people of this sort are the exception rather than the rule.

Most bridal couples will hesitate to interact with each other in public; they are often embarrassed to display their emotions or show how they truly feel about each other unless prodded.

If you photograph such people without having them interact with each other, without having them show signs of love, caring, or emotion toward each other, your photo results might be technically and academically correct, but they will appear lifeless, dull, and boring. In addition, they won't sell.

Whenever we have a shy couple to photograph, we structure all of our casual poses. We show our subjects exactly how to sit, place their hands, tilt their heads, look at each other, and so on. We strive to have the resulting poses look perfectly natural, at ease, and bespeak of love and togetherness even though they may be very contrived and take several minutes to set up. Being able to accomplish this is tricky. The skill comes with practice and experience.

*Not all poses work.* On prior photo sessions, you might have used five or six poses and had all of them look well. However, when you try the same poses on this bridal couple, nothing seems to work. Don't despair; this is typical. This is just another reason why it becomes important to have backups.

*Backup poses.* Just as you should have backup equipment when you photograph a wedding, you must also have backup poses in case your main poses fail to work.

Have at least 12 to 18 poses in mind before you start any photo session. This will help keep you from getting stuck when one or more of your poses doesn't work for any given couple.

*Move quickly from one pose to another.* If you are trying to photograph a bridal couple by the first light of dawn or at sunset, you can not afford to spend a lot of time thinking about poses. Accept the fact that a pose may not be working, forget it and move on.

Keep in mind that you will be dealing with couples who don't know how to properly position themselves for photographs. At your home or studio, you can afford to take all the time you need studying the problem of why your poses didn't work for the couple you were photographing. You can practice the problem poses with friends, relatives, or assistants, and learn how you can make them work.

*Posing ideas.* Study the photos in this book and use our poses as a guide. Eventually, you will develop your own style and way of posing people.

We suggest a trip to your local library. Look through some pictorial books on dance, especially ballet books. You can get a lot of great ideas from such source materials.

### Others to Photograph

If you attempt to get other people (close family members or friends) involved with a bridal couple in a casual, pre-bridal session, you'll often make your job harder.

Our experience has shown that even couples who openly show their affection for each other will fail to interact with each other when in the company of their families.

This attitude does not lend itself to good photo results. There are, however, two notable exceptions: children and pets.

*Children.* If either the bride or groom have children from a previous marriage, they will often want them included in some of the casual photos. If they don't mention it to you, you should suggest it.

> **"WHENEVER WE HAVE A SHY COUPLE TO PHOTOGRAPH, WE STRUCTURE ALL OF OUR CASUAL POSES."**

No matter where the casual session takes place, our usual routine is to take a series of full-length, three-quarter and tight head views of the couple together, and then individually. Admittedly, we expose more film of the bride and groom together, but we never forget to do individual shots of each of them. They add a lot to a bridal album and will increase your sales.

As with the formal shots, casual photos of the bridal couple with the children will increase your sales and make great additions for the wedding album. If the children are to be included in the photos, their clothing should be the same color and tone as the bridal couple.

And, don't forget to take some individual shots of the kids as well. This too will increase your sales, even though the couple may not add those particular photos to their bridal album.

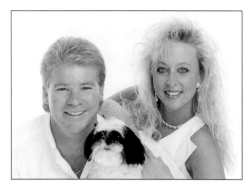

**3-6:** When doing casual photos of the bridal couple, encourage them to include their pet in a few of the photos. Such photos make a great contribution to any bridal album. In this photo, the main light (to camera right) was set to emit f-22 light, while the fill light set to emit f-11 light. The camera was set at f-16.

*Pets.* By the same token, don't forget to inquire about pets. Many times the bride or groom will have a dog, cat, or other pet which is being brought into the marriage; it's to become part of the family. Therefore, including the pet in some of the photos with the bridal couple is almost a guaranteed winner (see photo #3-6).

When working with pets, be prepared to spend some additional time photographing. Pets often will not be cooperative, especially when in the great outdoors, and additional time must usually be spent to get the pose right.

If you have the time, try to capture some individual shots of the pet. Although such photos will not be used in the couple's bridal album, they usually sell.

## Equipment and Lighting for the Casual Location Session

Take as much equipment as you'll need, plus backups. Since you will not have the constraints or pressure of working within a given amount of time as at a wedding, the prepared photographer will often take much more equipment than he'll need with him , just to be on the safe side. Other than camera, film, some props and filtration, you'll need no other photographic equipment. The following is a list of equipment which we take on location. After you have done a few location photo sessions, modify this list as your needs dictate.

### Lenses

We frequently use only one lens for our location casual photo sessions, a portrait lens of 150mm for our Hasselblad equipment. With either a standard or wide-angle lens, the background becomes too remote; the sense of space behind the couple is too vast. With the portrait lens, the background is compressed and the couple appear involved with the space around them. In addition, it is really the only lens when doing tight head or head-and-shoulder views of the bridal couple. It won't distort facial features.

### Tripod and Cable Release

You'll definitely need a tripod, and sometimes you'll need a cable release. Often, you'll be working with very slow shutter speeds and you don't want to risk blurring your images by either hand-holding your camera, or firing the shutter with your finger. Even when you are working at fast shutter speeds, it's better to work with your camera mounted on a tripod; camera shake is reduced, if not eliminated.

### Reflectors

Whenever you take photos of a bridal couple, you will need two light sources: a main and fill. A reflector can act as the

source for the fill light, provided the level of light you are working in is of medium to high intensity.

If you are at a beach, the sand could act as a natural reflector. However, we usually use a more controllable fill light, such as a simple fold-up 2x4-foot or 4x8-foot foam board or a collapsible 3 or 4-foot round, silver-white or white-gold reflector.

## Flash

Although we could do an entire casual location photo session solely by natural light, most often we use flash for a main light source, or a fill light, or for both functions.

Since most of our casual pre-bridal sessions take place in locations which are away from any household electrical power, portable equipment must be used.

Although we could use two, three or even four flash units for our location photography, for speed and ease of mobility we typically use only one light: one remote-controlled Multiblitz or Norman 400B flash unit, mounted on a light stand,

### Shooter's Log: Location Photography Trauma

We have one particular beach location that we favor when doing casual pre-bridal photos: the area is relatively isolated, there are beautiful rocks located near the waters edge which are great to pose people on, and the beach is well-groomed.

Since we have photographed in this particular area for years, and routinely photograph there, we didn't think it was necessary to visit it between casual photo sessions.

About five years ago, we scheduled a casual photo session there; it was set for the first Sunday in September. The last time we photographed at that site was at the end of July. We arrived early and were shocked. The lovely rock area was underwater and unusable; a storm had caused serious erosion.

The bridal couple arrived shortly and to their dismay and our embarrassment, the photo session had to be postponed. Taking the couple for breakfast soothed them and put us back into their good graces, but all of this could have been avoided had we visited the area in advance.

connected to a Venca remote-controlled receiver.

This flash is used as our off-camera main light, while the ambient daylight (with or without a reflector) serves as our fill light source.

Should the day be a rather bland, grayish day, or should the overall light level be rather low, we'll substitute another flash for the ambient light; we will use another off-camera flash (one which is also remote-controlled) as our fill light source.

### Remote-controlled lighting

If you don't want to invest in a system like the Venca (they are expensive), you could still use off-camera, remote-controlled lights: regular flash units.

For example, if you wanted to use one off-camera flash, you could attach a simple flash to your camera and put the other and better off-camera flash on a stand and have it slaved.

Set your on-camera flash to emit its least powerful light. Your remote light will be your main light; ambient light can act as the fill source. The flash on your camera should have its power adjusted to its lowest setting so that it will have no exposure effect on the picture. Its only function will be to trigger your off-camera flash.

### Props

For an outdoor casual session, props are usually not a problem. A picnic basket, a blanket, some flowers or a red rose, wine glasses and a bottle of wine will usually suffice.

Keep them simple to avoid distracting attention from the couple or the surroundings. Props should only be used if they will enhance the composition.

### Filtration

Filtration can be important when you do outdoor sessions. When we shoot at the beach, we use a warming filter. The warming effect on the final prints is desirable even on an already colorful day.

On a gray day, or in open shade under a blue sky, such filtration is essential. At sunrise or sunset, a warming filter further enhances the existing warmth of the light conditions.

### Shoot at Sunrise

Although we usually start our sunrise photo sessions before the sun actually comes up on the horizon, once it does start to appear, we have to work fast. The first dawn of light is extremely beautiful, very soft, and extremely colorful and flattering for portraiture, but it's short lived.

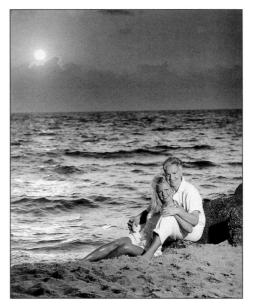

**3-7:** When we do pre-bridal photos on the beach, during the first light of dawn, we know that we must work very quickly. This first light can be gorgeous, soft and very colorful, but will only last for a short time, usually just a few minutes. We will often shoot as much as 24 to 30 shots of the couple in five or six different poses, often within five or six minutes.

The warm glow of this first light will usually only last about five or six minutes and this is not much time to capture a lot of images unless you are well prepared. You must know the poses you want to do and the lighting you wish to use, and have it all set up, metered, and ready.

*"AT SUNRISE OR SUNSET, A WARMING FILTER FURTHER ENHANCES THE EXISTING WARMTH OF THE LIGHT CONDITIONS."*

After this brief time period, the quality of light changes drastically. Resulting photos will have an entirely different look.

In addition to the light changing, the intensity will frequently change rapidly. This forces us to meter about every 30 seconds to ensure good exposures. It is not uncommon to start a shoot with a meter reading of say f-5.6 at 1/2 second and end five or so minutes later with a meter reading of f-5.6 at 1/125th of a second; an increase of six full f-stops.

In our sunrise sessions, we strive to produce photographs that give a deep tone to the sunrise while properly lighting the couple's faces and bodies. This means controlling the ambient light by underexposing the film to it (using the camera's shutter-speed control) and illuminating (and overexposing) the subjects with flash controlled by the camera's f-stop setting.

For example, at the beach we might stand a couple near the waters edge, with their backs to the water and sun. We'll take an incident-light meter reading of the sky, with the dome of the meter facing the horizon. We will then take another incident-light reading at the subject's faces, with the dome of the meter pointed toward the camera.

Assume the meter indicated a reading of f-5.6 at 1/8th second for the sky and f-5.6 at 1/2 second for the subjects. We would then set our camera to f-5.6 at 1/30th second. At such a setting the faces of the couple would be extremely underexposed and therefore dark.

To avoid this, we would use one portable, remote-controlled flash on the subject's faces and adjust it to emit f-8 light. With our camera still set at f-5.6 at 1/30th second, this would overexpose the subject's faces, from the flash, by one full f-stop while underexposing the background by two full f-stops.

On color negative film, this would produce a good, but deep image of the colors in the sunrise, while properly exposing the subjects faces and bodies.

We shoot at sunrise because our beaches in eastern Florida face East. The same principles would apply when shooting at sunset.

## Potpourri

Many brides (and most grooms) tend to be nervous during photo sessions. They will not know what to expect or what is expected of them. Most will not have been photographed in years. They may exclaim that they photograph poorly. You must be prepared to take charge to ensure that the session runs smoothly. To accomplish this, we offer some additional advice:

### Use Music

Whether in a studio or on location, we have found that having some background music playing throughout the session helps relax subjects. But don't think that all people will like the type of music you like.

When in your studio, you can play what the couple wants, provided you have the selections. On location you really can't afford to take a wealth of music with you for space sake. The easiest thing to do is to ask the couple, in advance, the type of music they most favor, and then bring those selections. Playing the type of music which they both like during their photo session will be very professional and make them feel special.

Use compact discs or tapes when on location rather than music from a radio station. Commercials, editorials, news and weather reports during station breaks can cause distraction.

### Be Prepared: Follow a Plan

If you are on location and you have multiple sites from which to choose, you should also know in advance which photos you want to take on which site, as

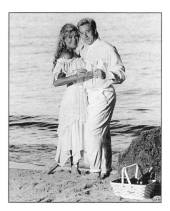

**3-8:** The first dawn of light is extremely beautiful, but it is short lived and we have to work fast to get all the photos we want taken. In this beach-side photo, we have also incorporated a few props (a bottle of champagne in a basket and glasses) to enhance the composition.

Our experience has shown that older couples like light classical or big band music; couples in their early to late 40s often like soft rock from the 1960's and 70s, and couples in their 20s prefer contemporary music. However, recently we were photographing an older couple who favored contemporary country music, and a younger couple who favored heavy classical.

well as how many sites you intend to work in. Nothing should be left to chance and in no event should you ever wing it with a paying photo session.

No matter where the session is to take place, attempt to have all of your equipment set up prior to the couple's arrival at the site. When the bride and groom arrive, they can be escorted to the shooting site and the session can begin with minimal delay. If you are going to photograph in an area which you have not been in a while, it will often pay to visit the location before the session takes place to ensure that nothing has changed.

Preparing for a session is a must. If you don't prepare, valuable time will be wasted during the course of a paying photo session and your credibility will suffer.

## Communicate

Whether subjects have been photographed before or not, none of them will be familiar with what you are trying to accomplish. However, be careful how you communicate. You can't afford to have the bride, groom, or any subject feel that you are making sport of them, or that you think of them as stupid, awkward, or uncoordinated. Many subjects will tune you out and fail to cooperate.

## Show Confidence

No matter where the photography takes place, the bride, groom and all onlookers will be watching you conduct the session. It is important that you appear to know what you are doing. If you make a production about setting up a pose or moving a light, a bride might have second thoughts about entrusting her wedding to you. You may be more nervous than the bride but don't show it!

## Photos in this Chapter:

With the exception of the beach photographs, and unless we indicate otherwise, the following information applies to all of the images presented in this chapter: the point of focus is the eyes of the subjects. The camera settings were f-11 at 1/60th second. This setting gave 1 and 1/2 f-stops of overexposure based upon an incident-light reading of the main light. A Hasselblad camera was used with a 150mm portrait lens. Either a 1,200-watt-second Balcar power pack and head or Broncolor power pack and head were used for the main light. The fill light power pack and head were the P-2000 and LH-2000 by Norman. Back, top, and 4-inch snooted kicker lights were by Norman, with Norman P-2000 power packs. The housing for the Norman fill light was a four-foot soft box by Chimera.

The housing for the main light was either a 42-inch white Balcar umbrella with a shower-cap diffuser, a Balcar Opal-Light bowl reflector, with a 20-degree grid spot and a shower-cap diffuser, a 2x2-foot softbox by Broncolor, or a 4x7-1/2-foot softbox called a Shero Light (a light housing we designed). Back and top lights were housed in 6-inch bowl reflectors.

Unless noted otherwise, the following equipment and technique were used in the beach photos displayed in this chapter: a Hasselblad camera, a 150mm lens with an 81A warming filter, one Multiblitz flash unit remotely controlled by a Venca transmitter/receiver, and a Minolta Auto 3F meter. Exposure was as follows: the camera was set at f-5.6 with its shutter speed set at two f-stops under what the meter indicated for f-5.6 ambient light. The flash was adjusted to emit not less than f-8, nor more than f-8.3 light.

"PREPARING FOR A SESSION IS A MUST. IF YOU DON'T PREPARE, VALUABLE TIME WILL BE WASTED DURING THE COURSE OF A PAYING PHOTO SESSION AND YOUR CREDIBILITY WILL SUFFER."

# CHAPTER FOUR

# PREPARING FOR THE CEREMONY

The preparation phase involves candid photography of the bride, her family, and attendants while they dress and as they prepare to leave for the wedding site. Although this phase usually occurs about one to two hours before the ceremony and at the bride's home, it sometimes takes place on the premises where the ceremony is to be held.

This is usually a hectic time for the bride and her family. Last minute details must be attended to and there are things going wrong: flowers may be late in arriving; bridal clothing may not fit precisely; buttons may break; the bride's hair and makeup may not be correct; the limousine may be late, and so on. Despite this chaos, brides often want specific photographs of the activities and excitement associated with this preparation.

## PHOTOGRAPHING THE PREPARATION PHASE

You'll have to work very fast to cover all the activities happening during the preparation phase. Keep one fact in mind: film is your cheapest commodity, so shoot as much as you need, and capture images of all involved.

### The Site Often Dictates Whom You Photograph

Although this phase could apply to both the bride and the groom, it frequently applies only to the bride and her group, especially if the preparation is somewhere other than at the wedding site. Deference is usually paid to the person who hires the photographer. This usually means the bride, her family and her side of the bridal party will get this phase covered rather than the groom and his side of the family.

If the preparation takes place at the wedding site, and you've finished all the required photos of the bride, her entourage and family, you should then attempt to photograph the groom, his attendants, and family as they prepare for the ceremony.

### The Specific People You should Photograph

Typically, you will find the following people present at the preparation site: the bride, her mother; father, siblings, attendants, possibly her grandmother and grandfather, aunts and uncles, nieces and nephews, etc. If you are hired to photograph this phase, then by all means

**"DESPITE THIS CHAOS, BRIDES OFTEN WANT SPECIFIC PHOTOGRAPHS OF THE ACTIVITIES AND EXCITEMENT ASSOCIATED WITH THIS PREPARATION."**

capture candid photos of all of these people. Take candid, portrait-type shots of each of them individually, as well as candid photos of them interacting with the bride. Additional photos to take for the preparation phase are listed at the end of this chapter (page 72).

### When in Doubt, Photograph Everyone

No matter where the preparation phase takes place, there frequently will be a lot of people you will not know milling about. Although good practice dictates that you ask the bride or her mother who the important people are, sometimes time doesn't permit it. Therefore, when in doubt, you should photograph everyone that is present.

Frequently you'll find that people whom you originally thought were hired help (hair stylist, makeup artist and so on) were in fact close friends or family members.

> It's better to shoot more and have the images than to fail to photograph people who might be very important to the bride.

### Types of Photography Used in the Preparation Phase

Due to the limited time and space, you frequently will not be able to use dimensional lighting. You'll most often be restricted to flash on-camera photography. This phase usually dictates that you merely record rather than stylize, structure, or pose.

For example, if you observe the bride having makeup applied, photograph it as it's being done. If you don't, don't attempt to set up a pose simulating the event.

It is also typical to engage in formal portrait-type photos (using a large portable background and studio-type equipment) during or immediately following this phase. (We shall discuss this a little later in this chapter.)

## VALUE OF THE PREPARATION PHASE

Although many brides may initially indicate that they want specific photographs of the activities and excitement associated with the preparation phase and request it be photographically captured at the time they book their wedding, the chance for sales is limited.

**4-1:** When taking a photo of the bride wearing her garter, have the maid of honor interact with the garter to some extent. Although we usually only involve the bride and her maid of honor for this type of shot, in this case, the background was particularly cluttered and the best way to solve the problem quickly was to position all the bride's maids around the bride and the maid of honor.

### This Phase might not Generate a Lot of Sales.

Technically, wedding photographs should depict the full story of the wedding day. Photographs of the bride, her family, and attendants preparing for the ceremony, give a wedding story its logical

> "THIS PHASE USUALLY DICTATES THAT YOU MERELY RECORD RATHER THAN STYLIZE, STRUCTURE OR POSE."

> "TECHNICALLY, WEDDING PHOTOGRAPHS SHOULD DEPICT THE FULL STORY OF THE WEDDING DAY."

beginning. One would think that these photos would be automatic sellers, especially when a bride has specifically requested that you photograph the events. Unfortunately, our experience has shown that such is not always the case.

The reasons usually boil down to the following: she wants to save money; the photos have little meaning since neither the groom nor his family were present; the same people photographed during the preparation phase were also photographed later during the wedding day; there wasn't as much action as the bride anticipated, and so on.

### Increasing the Value of the Preparation Phase

If a bride is insistent that the phase be photographed, we'll direct her to a larger, more expensive bridal package, which includes coverage of this phase and compensates us for our time. However, if the preparation phase is at the same locale as

the ceremony, we always photograph it, regardless of the cost of the bridal package selected. After all, we are already on site, so why not take advantage of another photo opportunity?

No matter where the preparation phase takes place, or how modest the bridal package selected might be, we ask for an additional hour or so before the ceremony, either during or immediately after the preparation phase, to do formal portrait photography. We always look for an opportunity to set up a portable background and studio lighting to photograph the bride, her attendants, and family using a portable background and studio, or type-B, portable flash equipment. Photo results will look different from on-camera flash candids, and they sell. Not only do they make terrific additions to any bridal album, but they also serve as excellent gifts from the bride and groom to the various members of the bridal party and their families.

4-3: Once the bride has finished dressing, don't forget to capture some full-length shots of her, by herself. Try to capture some portion of the environment as well.

Some photographers are fortunate in that their bridal subjects dress and have their ceremony and reception under one roof. For us, it is most common to have a bride schedule her dressing for one locale, the ceremony in a second, and then still a third area for the reception. Although the home preparation-photographs are important, they are not critical since they don't generally produce a high volume of sales. Accordingly, if a bride has selected only a modest bridal package, and the preparation phase of the wedding will not occur under the same roof as the ceremony, we frequently forgo photographing this phase and so advise the bride. It's too much work, time, and trouble to photograph the phase.

4-2: Once the bride has finished dressing, don't forget to orchestrate a couple of important shots: the bride with her father and the bride with her mother. Take at least one shot where the parties are looking at each other, and one where they are looking at the camera and smiling.

## The Time Factor

The amount of time you'll need to photograph the preparation phase depends upon a few considerations: your degree of preparation, where the phase is to take place, and the number of family and bridal party members at the preparation site. Assuming that the preparation phase is to take place somewhere other than at the wedding site, we offer the following advice and observations:

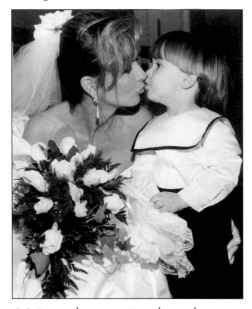

**4-4:** During the preparation phase, photo opportunities will usually be all around you, if you are sensitive to their presence. For example, the bride with the ring bearer (above), should not be overlooked. They are quite easy to capture and require little to no orchestration. A simple flash on-camera is all that is needed.

*Arrive on time and be ready to shoot.* If you are late or unprepared, it will cut back the number of photographs you will be able to take. The bride will leave for the ceremony on time, even if you've not finished.

*Plan on candid, flash on-camera photography.* This will allow you to work fast and cover a lot of situations in a very limited amount of time.

*Plan on spending between 20 and 30 minutes.* Obviously, the fewer the people, the faster you'll be able to photograph this

phase, but you should be able to take all the photographs you'll need in this time.

*Choose your images carefully.* Take the most important shots first (such as the bride's mother fussing with the bride's hair, or her father putting a good luck penny into the bride's shoe) and leave the secondary for last. Have particular photographs in mind before you arrive. If the bride or family members suggest other shots, do them and then immediately continue with your planned photographs.

*Take an assistant.* If the preparation phase is being held at the bride's home, the session will go much faster if you have an assistant to capture the secondary shots (such as a small child asleep on the sofa, the bride's disheveled bedroom) while you concentrate on the more important ones. And you can have your assistant set up all equipment needed for the formal poses while you photograph the preparation phase. Once the preparation phase is over, you can then escort the subjects to the area where your studio equipment is set up and begin.

## Equipment

The amount of equipment needed is dependent upon two considerations: whether you are photographing only the preparation phase, or if you are going to do formal portrait photography as well. (For a more detailed discussion about the following equipment, please refer to chapter 2.)

### Photographing Only the Preparation Phase

1. Take two complete cameras, with a standard lens on one camera and a wide-angle lens on the other. This will allow you to shift from one photographic situation to another, with a choice of focal lengths, with speed and ease. There is no time to assemble your equipment or even to change lenses once you are on site.

2. Each camera should have its own, on-camera flash already attached to its

### HOW TO SAVE TIME DURING THE PREPARATION PHASE:

- Arrive on time
- Plan on candid, flash on-camera photography
- Plan on spending 20-30 minutes
- Choose images carefully
- Take an assistant

**4-5:** Even if time is limited, don't forget to capture a shot of the bride with her bridesmaids. This photo uses a non-traditional pose for a more contemporary look.

### EQUIPMENT FOR THE PREPARATION PHASE:

1. Two complete cameras
2. Each camera should have its own on-camera flash
3. Have all film backs fully loaded
4. Have all equipment available
5. Take an ambient light meter
6. Flash meter and two off-camera-slaved flash units

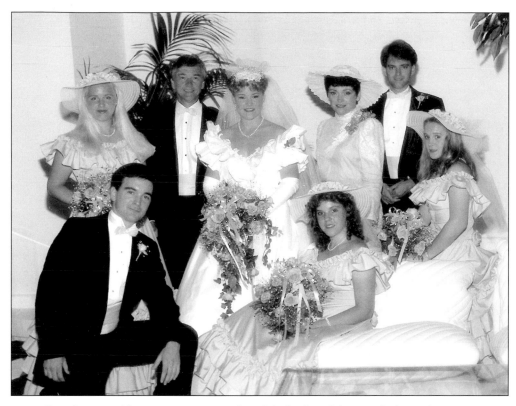

**4-6:** Although it's good business to capture a shot of the bride with her maids during the preparation phase, don't overlook taking photos of the bride with individual family members, as well as the bride with all of her family.

own flash bracket. Each should be ready to use the moment you walk onto the site.

3. Have all film backs fully loaded. In addition, you should have another film back as a backup.

4. Have all equipment readily available. Whatever equipment you think you will need, make sure it is with you. Once you have started, you won't be able to run to your car for other pieces of equipment.

5. Take an ambient light meter. Even though time constraints will not allow you to use a meter during the candid photos, there may be a later opportunity.

For example, when the bride, her attendants and her family prepare to leave the preparation area to board the limos to take them to the wedding site, there will be stronger daylight present. You'll be able to engage in some hand-held, available light photography. Your flash on-camera can act as a main light with the ambient daylight as a fill light source, or vice versa. In this situation, it is advisable to measure the existing daylight, and for this we always use a hand-held ambient exposure meter in the incident mode position.

6. Take a flash meter and two off-camera-slaved flash units. Each flash unit should be mounted on its own light stand and ready to use.

With these additional units, you will be able to set up a few different lighting situations. Whenever you use dimensional, off-camera lighting, you should measure the quantity of light from your flash units falling onto your subjects. This necessitates the use of a good flash meter. (Make certain to take some additional batteries as backups.)

## Optional Equipment

If you think that you might have the time and space to engage in dimensional lighting, you'll need the following:

*Formal Photos During Or After The Preparation Phase.* If you have made

## Shooter's Log: The Bride Doesn't Run this Church

Many years ago we were scheduled to photograph a preparation phase at a local church; the bride, her attendants and her family were to dress there. The bride had also previously requested that we work in some formal shots using a portable 9x9-foot background and studio lighting during some part of the preparation phase. We arrived early to set up all of our equipment, to be certain that we would be ready the moment the bride, her attendants and family, arrived.

As we were unloading, the minister approached and asked what we were doing. (We had made no prior arrangements to photograph at the church and thus, no official permission.) We explained that we were the wedding photographers and informed him of the bride's request.

The minister responded: "The bride doesn't run this church, I do, and I say that you can't bring all this stuff in here. When my wife and I got married, the photographer had only one camera and needed to take only six or seven shots. If that was good enough for us, then it's good enough for her."

Since we were on his property, we had no choice but to remove our equipment and report to the bride. Later, at the reception, and with much additional trouble, we used the portable background and studio lighting, and took the formal shots.

arrangements with the bride to take formal portraits at the preparation site, then in addition you should have:

7. A portable background, no larger than 9x9-foot. It should be of an earth-tone color.

This color will lend itself well to formal wedding attire and the size will allow you to do at least head-and-shoulder and three-quarter length shots of up to eight people.

For full-length views use a 9x12-foot or 9x18-foot background; however a background of these proportions is often too big to use in someone's home. It usually works best at a wedding site, where there is more space.

8. A portable background stand or two light stands and two clamps.

9. A tripod.

10. Two posing stools. You can't always rely on the bride to have seats

**Above:** Tight head views, such as this photo, are not only great additions to any bridal album, they are usually expected by a bride and her family when you're doing a formal portrait session. In our studio, we always do tight head views when we do formal pre-bridal photo sessions, and we always do a number of different poses. Different poses afford a bride a pictorial variety and a choice. It also helps to increase sales.

**Right:** Most often, soft focus should not be used for full-length views. Soft focus filtration tends to greatly reduce detail in a bride's gown and thus defeats one of the purposes of full-length, low-key, studio bridal photography. In this photo, you'll notice that we did not use soft focus filtration.
(*See Chapter Three*)

**Right:** Although we would prefer to have the couples dress all in white for their casual high-key pre-bridal portraits, if the subjects request a different color scheme or garb, don't ignore it. It will usually have a very special significance for the couple.

**Below:** This is one of our favorite shots. Unfortunately, and even though we photograph couples on the beach at least one time per week, each week throughout any given year, duplicating this shot for other couples does not always yield similar results. The time of year, the given month, and even a given day will all take its toll. The character or quality of light will dramatically change from one time period to another.
(*See Chapter Three*)

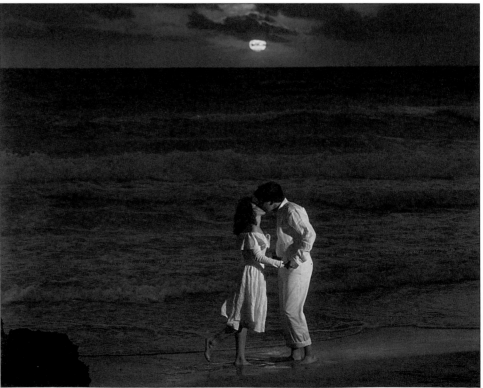

**Left:** A mirror shot is always popular, and most always sells; however, if the bride's mother is available, it is preferable to include the mother in the shot too – perhaps fussing with the bride's veil; kissing the bride on the cheek; and so on. Focus on the bride rather than on the mirror image.

**Below:** Once the bride has finished dressing, don't forget to capture a shot of her and her bridesmaids.
(*See Chapter Four*)

**Above:** Once you have captured all of the required shots of the bride and her family during the preparation phase, and assuming that time permits, begin to photographically concentrate on the groom, his best man, and all of the ushers. A shot such as this one is always well-received and can be quickly orchestrated.

**Right:** If the surroundings where the bride has dressed lends itself well for photography, don't forget to capture some full-length shots of her, by herself, making certain to capture some of the environment as well. However, in the event that the surroundings are less than ideal, then forget the full-length shots; take a few three-quarter or tight head and shoulder shots, at relatively low f-stop settings. This will ensure a blurred, out-of-focus background; one which will not compete with the bride.
(*See Chapter Four*)

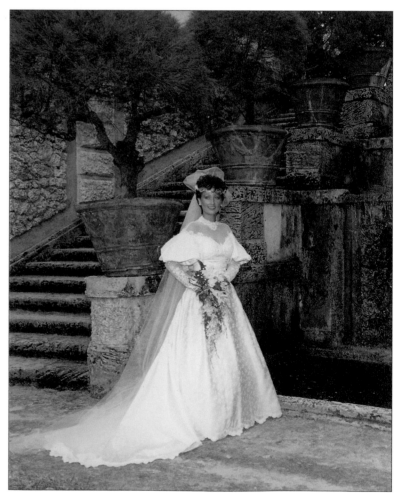

which will lend themselves to photography. And, you will not have the time to search for the just right stool or ottoman. A straight back chair will not have the versatility of a photographic posing stool.

11. A sync cord, remote controlled units, a transmitter, and slaves. As we noted in item number 6, if you're going to engage only in simple dimensional lighting, you'll probably use type-A.

However, with formal photography, you'll usually want better lighting than type-A can give you, and this means using at least type-B, or preferably, studio lighting.

Each one of these off-camera flash units should be slaved with better slaves than those used with the type-A lighting. They ensure greater reliability and dependability. Take at least one more slave than you will need, in case one of

them fails to work. In addition, make certain to have a sync cord with you just in case your transmitter fails.

12. Three studio or portable type-B lights. Two of these lights should be housed in 4x4-foot soft boxes; one as a main light, the other as a fill light source.

The soft boxes will give good coverage for a moderately large group, as well as soft light for the tight head images.

Since such sources will also put some light onto the background, the third light should be used as an additional background light, housed in a 6-inch bowl reflector.

13. Long extension cords and two track boxes. You'll often face the situation where, due to the amount of power drain, you won't be able to connect all of your power packs to one electrical outlet. If

## OPTIONAL EQUIPMENT FOR THE PREPARATION PHASE:

7. A portable background
8. Portable background stand or two light stands and two clamps
9. Tripod
10. Two posing stools
11. Sync cord, remote controlled units, a transmitter and slaves
12. Three studio or portable type-B lights
13. Long extension cords and two track boxes
14. Extra film

*"TAKE TWO POSING STOOLS. YOU CAN'T ALWAYS RELY ON THE BRIDE TO HAVE SEATS WHICH WILL LEND THEMSELVES TO PHOTOGRAPHY. "*

**4-7:** Once the bride is dressed and is preparing to leave for the ceremony, don't forget to capture a shot of the bride getting into the conveying vehicle. Typically, such a shot contemplates the presence of three elements: the bride, the transporting vehicle (car, boat, carriage, and so on), and the person who is going to "give her away" at the ceremony site. This person is usually her father, but it could be her mother (as in this case), some other relative, or just a close friend. Make sure all three elements are in the photo composition.

you're not careful, you might find yourself blowing some main fuses in the building.

14. Film. Always take more film with you than you think you will need, depending upon the type of photography you're going to do, as well as the amount of time you'll be given.

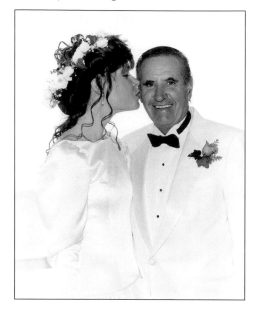

**4-8:** This is one of my favorite shots. Although it looks like a high-key studio shot, Sheila actually took this outdoors, with the beach and sky as a background. The on-camera flash supplied the main exposure for the subject's faces, but the background was "blown-out" (controlled by the camera's shutter speed) to give a high key appearance.

If you are only going to do the preparation phase, do candid, flash-on camera-type photography. You'll probably have a limited amount of time to work in. Generally, you'll need and use two to three rolls of 220 film (48 to 72 frames of film). In this situation, we would carry five rolls of 220 film with us, just to make certain that we had enough.

In addition, if you are going to do formal photos with dimensional lighting and a portable background, and have at least an hour to photography, it would not be uncommon to shoot five to six rolls of 220 film. In this situation, we

would take a supply of at least two full pro packs (ten rolls of 220 film).

## Effective Use of Portable Backgrounds

If you are going to do some formal portraits at the bride's home during the preparation phase, and you intend to use a portable background together with studio or portable type-B equipment, then you should make the most use of the background.

## Photograph the Bride, her Attendants and Family

At a minimum, you should photograph the bride alone, with her maid of honor, and then with each of her attendants. Photos of the bride with each attendant make a great gift for the bride to give. Then photograph the bride with her mother, with her father, then with both of her parents, then the parents, without the bride, then the parents individually.

Following this, the bride should be photographed with all of her family members in the shot. (Do individual shots of each family member only if you have the time; you can take such photos later, at the altar return phase, or at the reception.) Lastly, photograph each of the bride's attendants individually. They are frosting, not mandatory photos. If you take the formal photos at a hotel or country club, then do the same for the groom, his entourage and family.

Finally, photograph the bride and groom together. If the bride and groom do not wish to see each other before the ceremony, you'll have to wait until afterwards, during the altar return phase, to photograph them as a couple.

## Get Permission for Location Photography

If the preparation phase is conducted at the ceremony site, and you intend to record it, you'll usually not need any spe-

> "**ALWAYS TAKE MORE FILM WITH YOU THAN YOU THINK YOU WILL NEED...**"

cial permission to do so, provided you're going to engage only in candid, flash on-camera-type photography. The people in charge usually expect this type of photography to be done. However, if you are going to be bringing a lot of equipment onto the site, it may be another matter.

### Get Advance Permission to Shoot

If you intend to do formal, portrait-type photos with a large portable background and a number of different studio or portable B-type lights and power sources, get advance permission from the wedding official before you shoot. Don't assume anything! Just because you have been hired by a bride to be her official wedding photographer does not give you a license to photograph anywhere or anytime you want.

### Make Prior Arrangements for a Shooting Space

Even if you get permission to shoot in an area, this will be no guarantee that there will be space set aside for you to use. You must arrange for this in advance.

Make certain that the space is large enough for you and your equipment (including a portable background), as well as all of the people you intend to photograph. The space should also be relatively free of furniture and clutter.

### Who Should Get Permission

Although the bride or her family could seek permission and arrange for the space, we prefer to do this ourselves. If the ceremony site is at a church or temple, we consult with the minister, priest, or rabbi; at a hotel or country club, usually the head caterer will be the one we'll speak with.

## Checklist of Poses During the Preparation Phase

The following list of poses is offered only as a guide until you have developed your own style:

**4-9:** Don't forget shots of the groom, best man and ushers. We would suggest that you photograph the group in more stately poses first, then photograph them in a lighter vein. These photos are fun and provide pictorial variety.

1. Bride getting dressed and having her makeup applied and hair fixed. Take at least two photos of each situation.
2. Bride in full gown; a full-length shot.
3. Bride in full gown; a three- quarter or head- and- shoulders shot.
4. Bride with mother.
5. Bride with father.
6. Bride with both parents.
7. Mirror shot: bride looking into a mirror while her mother adjusts veil.
8. Bride with sisters and brothers.
9. Bride with grandparents.
10. Bride with family: mother, father, sisters, brothers and grandparents.
11. Bride with maid of honor.
12. Bride putting on garter, assisted by maid of honor.
13. Bride standing or seated near large window, illuminated by flash as primary light source.
14. Bride standing or seated near large window, illuminated solely by natural light.
15. Bride with all attendants.
16. Maids and their preparation, such as

Let's say you have permission to shoot in one of the hotel ballrooms. You might find it loaded with tables and chairs, making the room unusable for your photographic purposes. You should not assume that, in advance of your arrival, the people in charge of the premises will go to any lengths to clear the area for you, or will help you move anything to make your job easier. The best advice we can give you is once you get permission to shoot and have arranged for the space to work in, visit the site the day before you intend to use the space.

**4-10:** If one or more children are involved in the wedding, make certain that you do not overlook taking photos of them dressed in their formal attire. Orchestrate the shots; style their poses and outfits. The extra time and effort you spend doing this will be worth it. Not only will the families greatly appreciate the extra effort on your part, you will experience increased sales.

applying their makeup, fixing their hair, and so on.

17. Children, in preparation or in cute situations.

18. Three- (or more) generation shot: the bride, her mother, and her grandmother.

19. Bride, maid of honor, and all attendants leaving the preparation site for the wedding site.

20. Bride with her mother and father in front of the preparation site (showing the home).

21. Bride getting into the limousine, assisted by her father, with her mother looking on.

22. The attendants preparing to enter the limousine.

## MUST-GET PHOTOGRAPHS FOR THE PREPARATION PHASE

Although we have just listed 22 photographs that could be taken, we consider only a few of them as essential photographs. The remainder will depend on the time and circumstances. The required photographs for this phase are as follows:

1. The bride by herself, then with her mother, then with her father.

2. The bride with both of her parents.

3. The bride with all of her family.

4. The mirror shot: bride and her mother.

5. Maid of honor assisting the bride with her garter.

6. The bride at the window, illuminated by natural light.

7. The bride with the maid of honor and all her attendants.

8. Three-generation pose: the bride, her mother and grandmother.

9. The bride getting into her limousine, assisted by her father, with her mother looking on.

### Photos in this Chapter:

Unless indicated otherwise, all of the photographs depicted in this chapter were taken with the following equipment and at the following exposure settings: Hasselblad camera; 60mm lens; one Vivitar on-camera flash (Model #283) attached to a specially designed flash bracket; exposure of f-5.6 at 1/60th second, plus flash adjusted for emitting f-8 light, and a Minolta Auto 3F meter in incident-light mode for metering ambient light.

## MUST-GET PHOTOGRAPHS FOR THE PREPARATION PHASE:

1. The bride by herself, then with her mother, then with her father

2. The bride with both of her parents

3. The bride with all of her family

4. The mirror shot: bride and her mother

5. Maid of honor assisting the bride with her garter

6. The bride at the window, illuminated by natural light

7. The bride with the maid of honor and all her attendants

8. Three-generation pose: the bride, her mother and grandmother

9. The bride getting into her limousine, assisted by her father, with her mother looking on

WEDDING PHOTOGRAPHER'S HANDBOOK

## CHAPTER FIVE

# THE CEREMONY

Of all the events which occur during a typical wedding day, the ceremony is the most important and most critical. To adequately photograph a wedding ceremony, a photographer must selectively photograph people and activities immediately before, during, and immediately after the actual wedding service. Because of such things as religious differences, ceremonial procedures can vary from one wedding to another; however, there are common threads that run throughout almost all weddings. This chapter addresses these common occurrences, the three major parts of a wedding ceremony, and their various segments.

From a photographer's standpoint, an entire wedding ceremony is comprised of three major parts: pre-ceremony service events; the ceremony service events, and the post-ceremony service events. Each part is comprised of two or more segments, distinct, but bound together. It will assist your handling of the entire ceremony if you keep these parts and their various segments in mind, as listed here:

1. The Pre-Ceremony Service Events

   A. Discussion with the person officiating at the ceremony.

   B. Events preceding the processional into the church.

2. The Ceremony Service Events

   A. The processional.

   B. The ceremony service.

3. The Post-Ceremony Service Events

   A. The recessional.

   B. Down time.

   C. The receiving line.

   D. Re-enactment of the ceremony.

## PHOTOGRAPHING THE CEREMONY PHASE

The photo results obtained from the ceremony phase can have a direct and profound effect on a photographer's future wedding sales and business.

Capture dynamic photos of totally irrelevant and meaningless ceremonial situations while failing to record the truly important events, and you'll usually face a loss of wedding sales and future business.

In addition, you might very well find yourself on the wrong end of a lawsuit. One well founded lawsuit against a wedding photographer could literally put him or her out of business.

### PARTS OF THE WEDDING CEREMONY:

1. The Pre-Ceremony Service Events

2. The Ceremony Service Events

3. The Post-Ceremony Service Events

## What to Expect

Typically, you can expect some degree of chaos to prevail during the ceremony phase, especially during the first part: the pre-ceremony service events. During this time, it'll also be typical to find most everyone who is to participate in the actual wedding exhibiting some degree of nervousness. Tempers may flare, people will be excited, there will be tears of joy, and many will not know exactly what to do or when to do it. Although this will be a hectic and confusing time, it's also a great time for candid photos, so capture as many as you can.

## Take Charge?

Although there will be many times throughout the wedding when it is advisable, if not obligatory, for a photographer to take charge of a situation, the ceremony phase is not one of them. For the ceremony phase, the wedding official will be in total control, at least with respect to

> "ALTHOUGH THIS WILL BE A HECTIC AND CONFUSING TIME, IT'S ALSO A GREAT TIME FOR CANDID PHOTOS, SO CAPTURE AS MANY AS YOU CAN."

### Shooter's Log: A Shocking Outburst

Once we photographed a wedding which took place in a restaurant, located atop a fashionable hotel. During the course of the service, and just after the bridal couple had exchanged their vows, the rabbi turned to the best man and maid-of-honor and asked for the rings.

The rings were handed to the rabbi and a blessing was given over them. Following this, the rabbi handed the groom the bride's ring and said, take this ring and put it on the bride's left forefinger and repeat after me...

These words were no sooner out of the rabbi's mouth when the bride's mother blurted out, "No! That's not right! The ring should go on her ring finger!" The rabbi, shocked by this outburst, said in an equally loud tone of voice, "I'm the rabbi here and I say what is right and what is not; the ring goes on the forefinger and that's the end of it." The mother, obviously very embarrassed, cowered back.

The wedding continued without further incident. (At some Jewish weddings, the rabbi initially has the rings put onto the bridal couple's forefingers. Once the rabbi has pronounced them husband and wife, the rings are then allowed to be changed over to the ring finger.)

the procedural parts of the wedding service. As a result, until the wedding service is over, the general rule to follow is simply assist, if and when you can, but don't orchestrate. If you attempt to take charge, you might find yourself adding to the confusion or, you might find yourself giving instructions which contradict those given by the wedding official.

### Follow Instructions

Since the wedding official will usually control most of the events during the first two parts of the ceremony phase, a prudent photographer will adhere to the official's wishes and follow his instructions as closely as possible. A photographer who has violated too many of the official's instructions may well find himself ousted from the wedding site before its over. Or even worse, being prohibited from photographing in the church or temple ever again.

### Be Prepared

For most all of the parts of the ceremony service, a photographer should have at least two complete cameras with him at all times. One should be in his hands with the other at his feet or immediately next to him. One camera could have a normal focal length lens attached to it while the other has a wide-angle lens, or both could have the same focal length lenses.

Both cameras should have their own, separate flash units attached and ready to go. Each camera should have its own, fully-loaded, film back, with two additional, fully loaded film backs on the photographer's person for immediate use. Ideally, the photographer should also carry an additional two or three rolls of film in his pocket, just in case. Since this phase often involves only candid, flash-on-camera type of photography, no other equipment will be needed.

We cannot stress the importance of having all of the above equipment with

you when you start the ceremony phase. This phase will be no time to change film, change lenses, or go to the back of the church or temple to retrieve other pieces of equipment in case something has failed. Time will be of the essence.

## Pre-Ceremony Service Events

There are two important segments to the events that happen before the actual wedding ceremony: talking with the wedding official and the events before the processional. Although only one of these segments involves the taking of photographic images, both are equally important.

### Talk with the Official

No matter what form of photography you intend to engage in, and before you photograph on private property, there is a habit you should adopt: ask for permission before you photograph! With wedding photography at a church, temple, hotel, or country club, seeking advance permission to shoot is not only good business and the proper thing to do, it's obligatory!

When you first arrive at the ceremony site, it is imperative to seek the person officiating at the ceremony. Let him know who you are and why you are there, and that you're interested in knowing his rules regarding photography before, during, and immediately after the wedding. Let him know you intend to conduct yourself in a professional manner and will do nothing to cause him, his institution, or any of the people at the ceremony any embarrassment or delay. He'll appreciate your professional manner and generally give you whatever assistance you require.

In the beginning of your career, you will not know all of the officials at all the ceremonies you attend. In time you'll get to know them and a rapport will develop. They will learn to trust you and your

*"...UNTIL THE WEDDING SERVICE IS OVER, THE GENERAL RULE TO FOLLOW IS SIMPLY ASSIST, IF AND WHEN YOU CAN, BUT DON'T ORCHESTRATE."*

*"...SEEKING ADVANCE PERMISSION TO SHOOT IS NOT ONLY GOOD BUSINESS AND THE PROPER THING TO DO, IT'S OBLIGATORY!"*

work and, eventually, will allow you photographic license without any prior conversation.

Your discussion with the official should include the following topics:

1. Level of light for the altar.
2. Length of the ceremony.
3. Restrictions on photography and movement during the service.
4. Recreating parts of the ceremony.
5. Exactly when and where the signing of the marriage documents will be taking place.

### Level of light on the altar

No matter where the service is to take place, find out in advance what the light level on the altar is going to be for the actual wedding ceremony service. There will generally be some form of altar with some form of illumination to distinguish it from the surrounding area.

When you first look at the altar, the light level may be different than what will be used for the actual service. Ask the official, and if he doesn't know, find out who is in charge of the lighting and ask him or her. Ask for the light to be set at the level that will be used for the actual ceremony service, and then meter that light level and remember it.

Knowing in advance the exact light level for the actual ceremony service is important. Since you'll often want to do some available-light photography from the rear of the church or temple during the actual service, you'll need to know what the exact light level will be. This will help you to calculate your film exposures accurately.

Taking light meter readings later, during the actual service and only from areas adjacent to the altar, will not suffice. It'll frequently be too inaccurate; you'll make yourself too conspicuous, and you might disrupt the service. 📷

You must be prepared for changes. On more than one occasion we have been at a wedding where the wedding official has told us that the light level, as we were then observing it, was to remain the same throughout the entire service.

Once the service started, the light was reduced to a much lower intensity. If this happens to you, you'll have no choice but to guess at the appropriate f-stop, shutter speed combination, and then bracket your exposures.

Eventually, experience will allow you the luxury of accurately guessing what the exposures should be, without the necessity of bracketing. It's not that wedding officials will lie to you; sometimes they get rushed and may not pay attention to your questions or to the importance of the information which you seek.

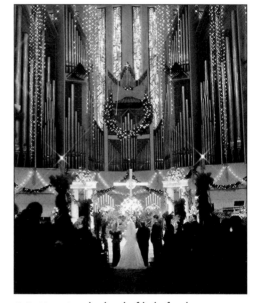

**5-1:** Knowing the level of light for the ceremony in advance is important. You also must be prepared for changes. If the light level unexpectedly changes during the ceremony (reduced to a much lower intensity, for example), you have no choice but to guess at the appropriate f-stop, shutter speed combination, and then bracket your exposures.

### Length of a Ceremony

Always ask the wedding official for his best estimate, in minutes, of the approximate time he thinks the actual wedding service will take. However, use

**DISCUSSION TOPICS WITH THE WEDDING OFFICIAL:**

1. Level of light at the altar
2. Length of the ceremony
3. Restrictions on photography
4. Recreating parts of the ceremony
5. Signing of the marriage documents

Before a ceremony starts, we take an incident-light reading from the spot where the couple will stand during the actual ceremony. Aim the dome of the meter toward the rear of the church, toward our camera's intended position. (Note! Prior to doing this, we ask the church officials if they intend to change the light level for the ceremony. We don't want to be caught off-guard by having metered the wrong level of light.) Once we have obtained a meter reading, we use this information to set our camera's f-stop and shutter speed dial in accordance with the way we like to expose our film.

this information as a guide only. We have photographed many weddings at which the official told us the ceremony would last 30-40 minutes, only to have it last 15.

You don't want to be at the rear of the ceremony site, with your flash detached, and your camera mounted on a tripod, when you learn that the service is over, the bride and groom have just kissed, and are about to walk up the aisle. As a professional wedding photographer, you are expected to anticipate and be prepared for such happenings.

## Restrictions on Photography

There are no generalizations which can be made regarding the restrictions on taking photographs during an actual ceremony service. It's a policy made by each wedding official at each church and temple. And, once a wedding official has made a decision about taking photographs, it will usually be final, absent some intervention by the bride, groom, or family members. Accept this fact and don't argue with it.

Some churches and temples will have few restrictions; others will have stringent rules. This policy decision can even vary at the church or temple depending upon which wedding official is presiding.

Some institutions hold that the service starts when the processional begins. As a result, some officials will not permit any form of photography, not even by available light, once the processional has started, even when the ceremony is being held at a home, hotel, or country club. At other locations, you may be allowed to photograph both the processional and recessional, but not the actual service. And, at still other locations, you'll be able to photograph the entire event, from beginning to end, and at some, not at all.

If you are permitted to photograph some of the service, the official may impose additional restrictions and limit you to photograph by available-light only

and from specific areas, such as the rear of the chamber. Others will permit you to use flash during the entire event provided you are not obtrusive and merely use on-camera flash. Usually dimensional lighting will not usually be tolerated. When you are faced with restrictions, you must arrange to take all of your required photographs after the service is over.

### Report Restrictions

Whatever you do, you should immediately report any restrictions imposed upon you to the person who hired you. You want them to know, in advance, that you are not being remiss when you fail to capture all of the images which you had planned to take. At the same time, give them assurance that you will do all of the photography you can do, after the ceremony has ended.

### Follow Restrictions

Whatever restrictions are imposed, heed them well. If the official says you can take photographs of the processional up until the time the bride and groom actually step up onto the altar, but then stop, when the couple reaches this point, stop! Don't try to capture just one more shot. If the official allows one photograph of the groom placing the ring upon the bride's finger, don't take three.

If you violate the official's instructions, you could find him stopping the service and announcing that he will not continue until you have stopped photographing or worse, until you have left the premises.

Even though you may have been given permission to engage in photography during the ceremony service, this does not mean that you may move freely about. In fact, many officials impose restrictions on movement because they dislike the idea of people scurrying about once the ceremony gets under way. In such cases, the official will give you his or her guidelines and expect you to con-

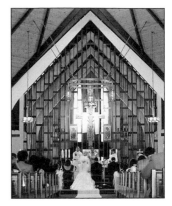

**5-2:** Some churches and temples will have restrictions on photography; others will have stringent rules. At some weddings you may not be permitted to photograph some or all of the service. Report any and all restrictions which are imposed upon you to the person who hired you and make sure you follow the restrictions. When you are faced with restrictions, you must arrange to take all of your required photos after the service is over.

**"...MANY OFFICIALS IMPOSE RESTRICTIONS ON MOVEMENT BECAUSE THEY DISLIKE THE IDEA OF PEOPLE SCURRYING ABOUT ONCE THE CEREMONY GETS UNDER WAY."**

form. Follow these instructions carefully! If he allows available-light photography from the rear of the church, don't take photographs 10 feet from the altar. If you want to take some closer views, ask permission. If you are given permission to move during the service, find out what areas in the church or temple are off-limits.

For example, a number of religious buildings have lofts or second floors which lend themselves to beautiful wide-angle, available-light photography.

Don't presume you have access to such areas simply because you are given permission to photograph the service. Most often you'll be prohibited from the altar and all photography will have to be done from the aisle, immediately behind the bridal couple, or side areas.

### Re-Creating Parts of the Ceremony

Generally if the official has not allowed you to photograph during the service, he will promise to help you re-enact a portion of it afterward. Immediately following the conclusion of the service, remind the official you'll need him for three or four photographs, and assure him you'll work quickly.

Once the ceremony is over, you should take the shots which he is to be involved in first: giving a blessing over the bridal couple; the ring exchange; standing with the couple at the altar, and so on.

Once his part has been concluded, no more than a few minutes, thank him and allow him to go. Then continue on with your other altar return photos. This courtesy will go far in your future dealings with the official.

## Events Before the Processional

To assist you through this segment, it will help if you think of the following photos as being in four distinct categories. This will prevent you from missing meaningful, must-get photos.

### Category #1  Photos involving the Groom:

After talking with the official, find the groom and best man. Usually, they will be in a waiting room near the rear of the altar.

This may be your first meeting with the groom and the best man. Introduce yourself, congratulate the groom, and let him know that you are there to do whatever photography he and his bride wish.

Listed here is a summary of the shots you should capture for this category:

1. Groom by himself.
2. Groom with his best man, shaking hands.
3. Groom with his father.
4. Groom with both parents.
5. Boutonnieres being pinned on the groom, best man, and ushers.

Watch the background carefully. In most churches or temples, the waiting room will not be an attractive area. If it is too bad, move the subjects into a hallway or even outdoors.

### Category #2  Photos involving the Bride:

Once the groom, his best man, and family have been photographed, go to the rear of the site and prepare for the bride's arrival.

The following is a summary of these important shots:

1. Bride and father exiting the limousine in front of the church.
2. Bride by herself, full-length, inside the church's waiting area.
3. Bride being fussed-over by her attendants and parents.
4. Bride being kissed by her father.

Look for strong emotion, perhaps tears of joy, kissing, or hugging. Such photographs will outsell any in which a subject is standing, staring blankly at the camera.

If you haven't inquired about the off-limit areas in advance, use good judgment and be as inconspicuous as possible. Do nothing which might cause embarrassment or distraction. Officials have told us stories of photographers who have literally suspended themselves from raised pulpits just to capture that unusual shot during a service. Such photographers make it hard for the rest of us and are usually the ones who have caused restrictions to be set in place.

### CATEGORY 1 PHOTOS INVOLVING THE GROOM:

1. Groom by himself
2. Groom with best man, shaking hands
3. Groom with his father
4. Groom with both parents
5. Boutonnieres being pinned on groom, best man, and ushers

### CATEGORY 2  PHOTOS INVOLVING THE BRIDE:

1. Bride and father exiting the limousine
2. Bride by herself inside church waiting area
3. Bride being fussed-over by her attendants and parents
4. Bride being kissed by her father

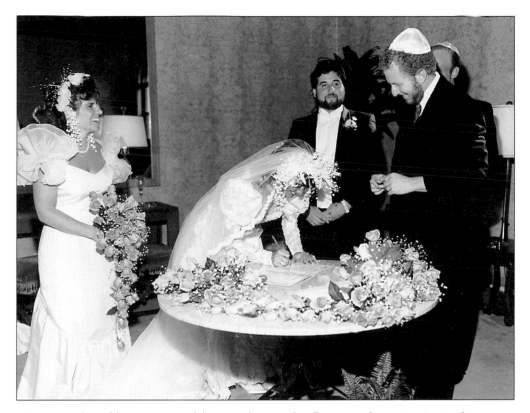

**5-3:** At Jewish weddings, it is critical that you photographically capture the parties signing the Ketubah – the Jewish wedding contract. Brides and their parents expect and buy such photos. You should take at least one photo, preferably with a wide-angle lens, of each person who signs the document: the bride, groom, and each witness. At non-Jewish weddings, photographing the signing of the civil marriage license is usually met with little fanfare and is generally not required nor desired.

### Category #3  Signing of the Marriage License and Wedding Contract:

Don't overlook taking photos of the bride and groom signing the official wedding license and signing the marriage contract. These are important events and should be photographically covered, especially at Jewish weddings. For most of the non-Jewish weddings we have photographed, the signing of the marriage license has been considered a bland event. We always photograph this event even though we have found that most brides do not buy the resulting photos.

By contrast, most bridal couples at Jewish weddings treat the signing as a special event. At Jewish weddings, the signing of the marriage license is often accompanied with a bit of fanfare.

Immediately following the signing of the State's license, there will be an additional event: the signing of the Jewish Wedding Contract (the Ketubah).

At Jewish weddings, it is absolutely critical that you photographically cover the signing of both documents. Don't skimp on film. Not only will such photos be expected by the bride, groom, and their families, it's an opportunity to capture some good emotional photos. Photos such as these are usually well-received and lead to increased sales.

The following is a summary of the photos you should take for this category:

1. Bride signing the marriage license.
2. Groom signing the marriage license.
3. Each witness, as he or she signs the marriage license.

### CATEGORY 3  SIGNING OF THE MARRIAGE LICENSE

1. Bride signing license
2. Groom signing license
3. Each witness signing license
4. Wedding official signing license
5. Bride signing the Ketubah
6. Groom signing the Ketubah
7. Each witness signing the Ketubah
8. Rabbi signing the Ketubah
9. A shot of all present in room
10. Close-up of the Ketubah

4. The wedding official signing the marriage license.

5. Bride signing the Ketubah.

6. Groom signing the Ketubah.

7. Each witness, as they sign the Ketubah.

8. The rabbi signing the Ketubah.

9. A shot of all present in the signing room.

10. A close-up shot of the Ketubah.

### Category #4  Photos involving other People and Events:

Following the photos involving the wedding contract, there will frequently be a lull in the activities before the processional starts. This particular time is often referred to as the pre-processional. It'll be a great time to capture candid photos of other people and activities.

For example, just moments before a processional starts, ushers will stop escorting regular guests to their seats and will begin escorting only a few special people: the grandparents of the couple, the parents of the groom, and the mother of the bride. These special people will usually be seated close to the altar, in the first or second row.

After the seating of these family members, the next event will usually be the rolling out of the white carpet. Two ushers will typically begin to unroll this material, which will be your clue that the processional is close to starting. Don't waste your time or by recording this event. It is meaningless for bridal couples and we have never sold photos recording this event.

Once done, all the ushers will move to the front to meet the groom and best man. If they walk down the aisle individually, take an individual photograph of each of them. If they walk down as a group, capture a wide-angle shot. If you miss these shots, don't worry about it. Absent any instructions to the contrary, they are merely frosting photos.

If you have an assistant while all this is going on, instruct him or her to photograph the bride, her father, and the attendants as they form their line at the back of the sanctuary. These few anxious moments can yield some very interesting, attractive, and salable images.

The following is a summarized list of photos and situations which you should capture for this category.

1. Ring bearer and flower girl.

2. Grandparents of the bride, walking down the isle and seated.

3. Grandparents of the groom, walking down the isle and seated.

4. Parents of the groom, walking down the isle and seated.

5. Mother of the bride, walking down the isle and seated.

6. Soloist or harpist singing or playing, if one has been hired.

7. Groom and ushers standing at the altar, awaiting the processional.

## THE CEREMONY EVENTS

The ceremony really contains two segments: the processional and the actual wedding service. It's critical that both segments be thoroughly and adequately covered.

### The Processional

When the time for the ceremony is at hand, the bride, her father, and usually all of the bride's attendants, will line up at the rear of the church or temple to prepare for the walk down the aisle (the processional). From a procedural standpoint, it signifies the official beginning of the wedding ceremony service.

To assist you with this segment, it will help if you think of the processional as being divided into two parts: the first involves everyone in the processional except the bride and her father. The second involves only the bride and her father.

### CATEGORY 4  PHOTOS INVOLVING OTHER PEOPLE AND EVENTS:

1. Ring bearer and flower girl

2. Grandparents of the bride being seated

3. Grandparents of the groom being seated

4. Parents of the groom walking down aisle and being seated

5. Mother of the bride walking down aisle and being seated

6. Soloist singing or harpist playing

7 Groom and ushers standing at altar

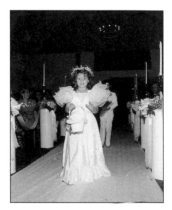

**5-4:** The processional signifies the official beginning of the wedding ceremony service. Make sure to capture at least one shot of each person as they walk down the aisle. If you miss any, plan to photograph them during the recessional.

The wedding official makes the decision to start the processional, and it starts whether the photographer is prepared or not. Typically, the wedding official will either walk down the aisle to the altar, or will enter the altar area from a side position. There will usually be some music playing, which he will signal to end. There will be a pause and then different music will start to play.

Once this processional music has started, the official will then signal the bridal participants to begin their processional walk. This will also be your clue that the wedding service has officially started.

### Whom to Photograph During the First Part

You must take at least one photograph of each person who is directly participating in the wedding service, as he or she is walking down the aisle toward the altar. If you miss taking any of them, plan to photograph them as they walk back up the aisle during the recessional.

**5-5:** During the processional, you need to photograph each person as he or she walks down the aisle. For example, photograph the mother of the bride as she is being escorted to her seat, the ring bearer and flower girl, and, of course, each of the bridesmaids (above).

Tradition dictates that the bride and her father will be last to walk down the aisle. However, there is no tradition which governs who else walks down the aisle when, or even the order of their progression. This decision will be made by the bride or the wedding official. Ascertain this information before the processional starts to keep from being caught off guard.

For example, if the bride is having a ring bearer and flower girl, these two children could walk down the aisle together or separately. They could also be the first people to walk down the aisle, next to last or somewhere in between the other people who are also to walk down the aisle. In any case, make certain that you capture at least one photo of everyone as they walk toward the altar.

### Spacing the First Part of the Processional

Typically, the bride, her family and all those in the wedding will be given vague instructions by the wedding official moments before the processional starts. Usually these instructions are subject to interpretation. A wedding official might say something to the bride like, as the people are walking down the aisle make sure that they don't walk too fast or too close to one another; put some space between them.

You'll often find these instructions ignored: the people will often walk down

We suggest a time interval of at least five seconds. This will make flash photography more feasible. This will also allow your flash to recycle between shots.

"THE WEDDING OFFICIAL MAKES THE DECISION TO START THE PROCESSIONAL, AND IT STARTS WHETHER THE PHOTOGRAPHER IS PREPARED OR NOT."

the aisle only three to five feet apart, and they will walk rather briskly. This type of spacing makes it very hard on a wedding photographer, as there may be only time to photograph a few of these people and that would not be acceptable.

Ideally, if it doesn't interfere with the wedding official's instructions, an assistant should be located at the rear of the church. He can ensure sufficient time and space between the people in the bridal party as each is to walk down the aisle. .

### The Second Part of the Processional

Once all of the processional participants, except the bride and her father, have walked down the aisle, the processional music will end. This signifies the end to the first part of the processional. There will then be a pause and the bridal march will begin to play; whereupon, the wedding official will gesture for the audience to stand. This is the official start of the second part of the processional.

### What to Photograph During the Second Part of the Processional

Of all the photographs taken during the processional, the most important are:

1. The bride walking down the aisle with her father.
2. The father lifting the bride's veil and kissing her.
3. The groom and bride's father shaking hands or hugging.
4. The groom next to the bride
5. A wide-angle shot of the backs of the bridal couple as they stand before the official at the altar.

At this point, the music will stop, a signal that the processional is over and the ceremony service phase has begun.

### Once the Processional is Over

If you have been instructed that flash and available-light photography have been prohibited during the ceremony service, it is at this point you must stop

photographing and retire to the rear of the church. Don't take any more photos.

If you have permission to take available-light photos of the ceremony service, then, once the processional is over, quickly retire to the rear of the church, or the spot designated by the official, and set-up for the service events to follow. You won't have a lot of time, only about one or two minutes at best, so act quickly.

### The Ceremony Service

Typically, a ceremony will follow a standard procedure. After the couple step up to the altar, the official will give a speech. The couple will then exchange their wedding vows; the official will give a blessing over them and their rings. The bridal couple will exchange rings, the official will bless them, pronounce them man and wife, and allow them to kiss. At the time the couple kiss, the wedding service will then be official. Sometimes, even if you have been prohibited from taking photos prior to this point, you'll be given license to engage in flash photography of the couple kissing as well as all events thereafter. The couple will then turn and face the audience and the official will introduce them for the first time as Mr. and Mrs.

While this introduction takes place, the couple will be standing at the altar, facing the audience, arm in arm. This will be a perfect opportunity for your first photograph of them as a married couple.

### Procedural Variations

Religious differences can cause procedural variations.

*At Jewish weddings:* Prior to the wedding official announcing the bridal couple as Mr. and Mrs. to the audience and before the couple kisses, there will be a traditional ritual: the breaking of the glass. This is an extremely important event, and one which must be captured. Even if photographing the entire wedding service has been prohibited, most all

5-6: Once the bride and her father have walked down the aisle and reached the foot of the altar, they will frequently pause, turn, and look at each other and then kiss. Try to capture as many processional shots of the bride with her father as you can. These shots will be full of love and tenderness.

### MOST IMPORTANT PHOTOS OF THE PROCESSIONAL:

1. The bride and her father walking down the aisle
2. The father lifting the bride's veil and kissing her
3. The groom and bride's father shaking hands or hugging
4. The groom next to the bride
5 A wide-angle shot of the backs of bridal couple at the altar

rabbis will permit this event to be recorded. The rabbi will place a glass covered in cloth on the floor, and the groom will stomp on and break the glass. Following this, the couple will kiss and be announced. The event will always occur and it must be photographed.

If possible, try to get at least two shots of this ritual: one as the groom first lifts his foot to break the glass, and one showing the groom's foot actually breaking the glass. These shots are required if you are to attain adequate coverage and at least one of the two will sell.

*At Catholic weddings:* If a full mass is performed, you will often find the wedding official offering communion: the partaking of bread and wine. Communion will be offered to the bridal couple first, then to the bridal party, and finally to all in the audience.

Our experience has shown that, absent instructions from the bride, photographs of communion don't sell. If your wedding is to include communion, ask the bride at the booking.

*A sign of peace:* At some non-Jewish weddings there is another ceremonial variation: the sign of peace. After the wedding official announces this event, the bridal couple will kiss each other, and then hug or shake hands with their bridal party. Each person in the audience will shake the hands of the people around them. These photos also don't sell.

*A sign of love:* Prior to the end of the wedding service, the official may make an announcement that the bridal couple wish to give a sign of love. The bridal couple will walk to the bride's parents, where the bride will present her mother with a rose, and kiss her parents. The groom will then kiss the bride's mother and shake hands with the bride's father. The couple will then repeat the procedure with the groom's parents. The bridal

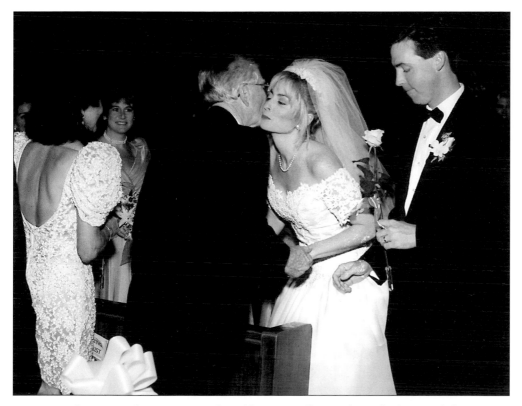

**5-7:** During the course of some non-Jewish weddings – usually near the end – there might be a procedure called "a sign of love." The bride and groom will walk over to both sets of parents and give each mother a flower and then both will kiss each parent and hug them. Try your best to adequately cover this scenario; it's one that is usually filled with real emotions.

couple will then return to the altar. Photographing this event is important, although no easy task; you'll have to work fast and make certain that you don't intrude on the action.

To adequately cover this event, you should photograph each activity. Take at least one shot of the bride presenting the rose, kissing her mother and father, and so on until they return to the altar.

During this time, you should take the following photos:

1. Back view of the bridal couple as they kneel or stand before the official.

2. Back view of the bridal couple as they receive a blessing from the official.

3. Lighting of candles by the bridal couple (if applicable).

4. Shot of bridal couple as they face each other to exchange their vows. (A must-get shot.)

5. Ring exchange between the couple. (A must-get shot.)

6. At Jewish ceremonies: the couple sipping wine from a goblet.

7. At Jewish ceremonies: the Ketubah as it is handed to the bride by the rabbi or groom

8. At Jewish ceremonies: the groom as he breaks a glass (A must-get shot.)

9. At non-Jewish ceremonies: the sign of love (if applicable). (A must-get shot.)

10. The kiss between the couple; it's a must-get photo.

11. The couple standing, facing the audience, after the kiss and before the recessional starts.

## POST-CEREMONY SERVICE EVENTS

Once the ceremony is concluded, and before the altar return phase starts, the typical wedding will have four additional events: the recessional, down time, the receiving line, and the re-enactment. And

for the first time since the ceremony started, you, as photographer, will have a great deal more control.

### The Recessional

Once the bridal couple start their walk back up the aisle, the recessional phase of the ceremony will have begun. The recessional involves nothing more than the bridal couple and all the bridal participants leaving the altar and walking to the rear of the church or temple, generally paired.

Typically, the recessional will follow a very precise order. The bridal couple will be first to walk up the aisle, followed by the maid-of-honor escorted by the best man, then all the maids escorted by ushers. They will be followed by the bride's parents, then the groom's parents, and then grandparents.

*To make certain that we have all of the events of a wedding day covered, we always take at least one photo of each couple involved in the recessional as they are walking up the aisle.*

Once the last set of grandparents have reached the rear of the church or temple, the recessional phase will be over. This will be a signal to all of the guests that they can then leave.

### Must-Get Photos

Even if you have decided not to photograph the entire recessional, you must not miss the bride and groom walking up the aisle. Take at least two or three of these shots, varying your distance from them each time.

## IMPORTANT CEREMONY PHOTOS:

1. Back view of bridal couple at altar
2. Bridal couple receiving blessing from official
3. Lighting of candles by couple
4. Bridal couple facing each other exchanging vows
5. Ring exchange
6. Couple sipping wine (Jewish ceremonies)
7. The Ketubah handed to the bride (Jewish ceremonies)
8. Groom breaking glass (Jewish ceremonies)
9. Sign of love (if applicable)
10. Kiss between couple
11. Couple facing audience

**"...YOU MUST NOT MISS THE BRIDE AND GROOM WALKING UP THE AISLE."**

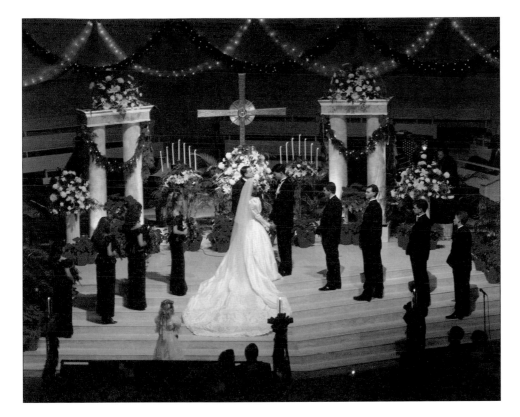

**Above:** Once the bridal couple is standing at the altar before the wedding official, it behooves you to capture at least a few ambient light photos from the rear of the ceremony site.

**Right:** At most traditional weddings, the father walks down the aisle with his daughter, the bride. He then "gives away" the bride to the groom. This is a must-get shot during the processional phase of the wedding ceremony. (*See Chapter Five*)

**Above**: At Jewish ceremonies, it is absolutely critical that you photograph the groom as he is about to "break the glass." For a shot of this nature, we prefer to use a wide-angle lens and capture a full-length view. This enables a viewer to see the groom, the action, and all the people standing within his immediate area. Such a composition makes the shot much more interesting and appealing.

**Left:** Here is an example of a wedding ceremony taking place in natural light (inside a glass dome structure). You don't have to worry about the light at the altar changing after the ceremony begins, unless of course the amount natural light (sunlight) changes.
(*See Chapter Five*)

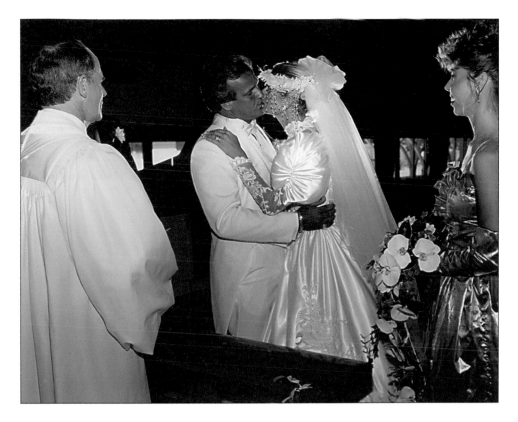

**Above:** When the wedding official announces that the bridal couple may kiss, it officially signifies that the wedding service is technically over. Not only do we photographically capture the kissing scene as it happens, but later, after the altar returns, we stage it again. This gives us and the bridal couple a choice of "kiss shots" to choose from for their wedding album.

**Right:** If the bridal couple plans a candle lighting during their ceremony, you should plan to photographically capture it; it's important. If time permits, the use of a 4-pointed star filter will help add some interest to the overall scene. (*See Chapter Five*)

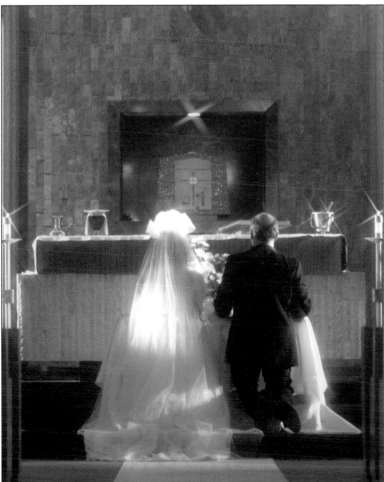

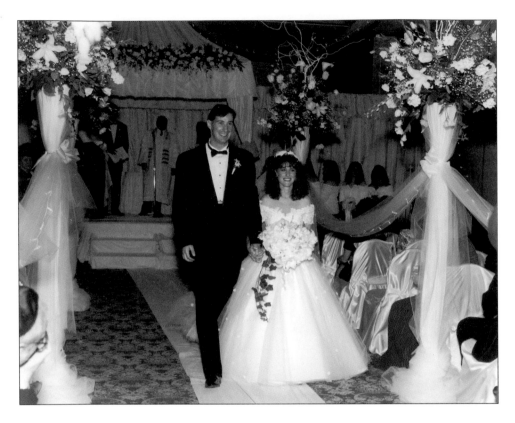

**Above:** The most important recessional shot is the one depicting the bridal couple as they walk back up the aisle. In order to ensure ourselves that we have captured the "right" shot — one which shows the couple smiling at each other, or at their guests, or looking tenderly at each other — we usually plan on taking at least three to four shots as they walk up the aisle.

**Right:** We always photograph both the processional and recessional just in case something happens: a flash did not fire during the moment of exposure; the subject had his or her eyes closed, and so on. Pre-focus on a spot and then, once the subject arrives at the predetermined spot, take your shot. So long as you get a well-exposed, full-length view of the subjects, you can not be held accountable if the subjects are not looking directly into your camera and smiling.
(*See Chapter Five*)

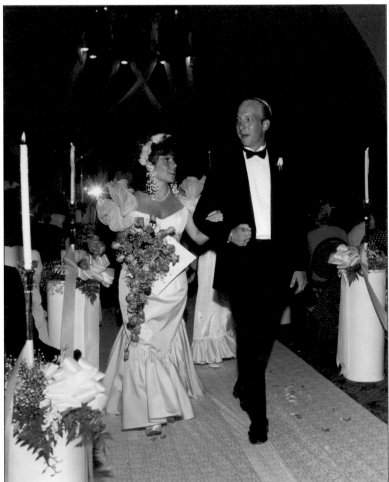

Make certain that at least one is a full-length view and at least one a three-quarter view. If possible, have your assistant shoot at the same time, but from a different camera angle, to ensure that you capture this event well.

### Photographic Problems During the Recessional

As with the processional, the wedding official will say nothing about the spacing or timing of the recessional. As a result you'll often find all the bridal participants scurrying up the aisle, relieved that the pressure is over.

Haste is only part of the problem; the biggest problem will be that the couples are too close together. As a result photography becomes difficult, if not impossible. You may not have time to photograph each couple because of your flash.

Having an assistant with you could solve your problems. Post him or her near the altar prior to the recessional starting. The assistant's main job will be to ensure that all the couples walk back spaced at least four seconds apart. This will afford you enough time for one shot of each couple.

**5-8:** Don't pass up the opportunity to record emotions. The determined look on this young man's face, as he returns from the altar during the recessional, is truly priceless.

### Wasted Photos

Once the guests start to file out, your inclination might be to grab a few candid shots of guests as they are walking up the aisle. However, absent instruction from the bride, we wouldn't. Any photos which you might take may be meaningless to the bridal couple or their families. You're better off preparing yourself for the next occurrence.

### Down Time

Immediately following the recessional, and before the receiving line forms, there is an interesting event we term *down time*. No one plans for this event; in fact, most aren't even aware that it exists. It will last only a minute or so; therefore, be prepared for it and work fast.

As the bridal couple, their parents and the members of the bridal party finish the recessional, they will begin to relax and begin to hug, kiss or congratulate one another. This is a great opportunity for unique candid photographs that will display strong emotion. Don't orchestrate any poses, just capture what the people are doing.

If your timing is right and you've captured the peak of action, just as a couple is about to hug or kiss, or as tears are being shed. The resulting photos will be winners. Not only will your sales increase, but you'll quickly gain the reputation knowing exactly what to do, and being in just the right place at the right time.

### The Receiving Line

Typically, the bride, the groom, each member of the bridal party, and the bridal couples parents will line up and greet each of their guests as they file out. Photographically speaking, the receiving line is not a useful part of the wedding events.

Our experience has shown that the bride and groom don't think of it as too important. Photo sales are usually limited even if the bride requests this event be covered. If the bride has not requested that you photograph this event, photograph some of it, but limit the amount of

> "THE ASSISTANT'S MAIN JOB WILL BE TO ENSURE THAT ALL THE COUPLES WALK BACK SPACED AT LEAST FOUR SECONDS APART."

Do not stop the progression of the recessional. We have heard complaints about photographers stopping couples in the middle of the aisle while they focus, load film, and pose the subjects, or while they wait for their flash units to come to full power. This could affect your credibility as well as your future wedding business.

film you would use and otherwise treat the resulting photos as frosting photos.

### Receiving Line Problems

Usually, there are three major problems associated with a receiving line:

1. *Changes in plans:* Even though a receiving line forms at most weddings, and even if your bride asked that it be photographed, it does not mean that the event will even come about.

a) Cancellation: If the wedding ceremony runs late, or the bride or her family feel too rushed, sometimes they will cancel the receiving line phase at the last minute.

If you are not on top of the situation, you could find yourself rushing to prepare for the event, for nothing. Therefore, during the down time, inquire of the bride if there are to be any changes from the initial plan.

b) Varying the line: If the bride does elect to have a receiving line, she might opt for a shortened version of the line. For example, instead of the entire bridal party being involved, they may have only the bride and groom receive their guests. The guests can move through a short receiving line much more quickly.

2. *The time factor:* Usually at the time the bride books her wedding she says how much time is allotted for the receiving line, typically between 20 and 30 minutes.

However, things do not always go as planned. No matter what the problems might be, do not interrupt the receiving line during the time the bride originally told you.

However, after that period has elapsed, remind the bride that you still have other photos to take. She might have completely forgotten that you still have work to do.

Remember, you can't afford to have a bride, groom, or bridal party be late, or you may find that whatever time they used will be taken off the time for re-enactment and altar return photos. Take charge and keep things moving.

3. *The crowd:* Good photography is often difficult to capture during the receiving line due to the crowd of people that gathers around the bridal party. Consequently, it won't be surprising if the only shots you're able to capture are of someone's back. These shots will be totally meaningless.

Once in a while you will be able to get a view of the bride or groom kissing or hugging a special guest, and the photo will sell. If you are really lucky, you'll find a high vantage point from which to photograph, permitting a wide-angle photograph of the entire event. Such a view will usually sell since it will look different from your other photos of the wedding.

### Re-Enacting the Ceremony

Just after the receiving line segment, and before the altar return phase begins, you'll frequently have an opportunity to re-enact some parts of the wedding ceremony service to cover possible mistakes, or to get better shots than you were able to get during the actual service.

If you were not permitted to photograph the wedding service as it was unfolding, then you must re-enact special parts of the wedding service. The photo scenes which we would re-enact are as follows:

1. Back view of the bridal couple as they stand or kneel at the altar, facing the wedding official.

2. Bridal couple standing at the altar, facing each other, simulating their exchanging of vows.

3. The ring exchange: the groom putting the bride's ring onto her finger and vice versa.

4. The wedding official giving a blessing over the bridal couple.

5. The lighting of candles by the bridal couple, if applicable.

### PHOTO SCENES TO RE-ENACT:

1. Back view of bridal couple at altar

2. Bridal couple facing each other exchanging vows

3. Ring exchange

4. Wedding official giving a blessing over bridal couple

5. Lighting of the candles by the couple

6. Groom breaking glass (Jewish ceremonies)

7. Kiss between couple at altar

6. At Jewish weddings, the groom breaking the glass.

7. The bridal couple kissing at the altar.

Even if you were allowed to photograph the service, we suggest you re-enact a couple of scenes anyway, to assure you have gotten all of the important ones covered. When you photograph, seek better camera angles, lighting, or expression than you originally had; you'll get different and often better photo results.

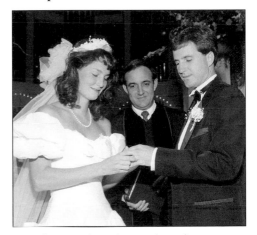

**5-9:** Photographing the couple as they exchange rings is an important event. If you are not allowed to capture it during the actual ceremony (some wedding officials will not permit flash photography during the ceremony) plan to re-create the ring exchange later, immediately following the service.

## Photos Not to Take

If, for some reason, we missed a processional or recessional shot of someone, we would not attempt to photograph them at this time. Compared to photos actually taken during a processional or recessional, re-enacted shots of these events will have no guests in them; therefore, the photo results will look bare.

## Problems

Three problems come about during the re-enactment segment: boredom, anxiousness, and scheduling. These problems are all linked by time.

1.) *Boredom:* You'll need to work fast to keep the bridal party from becoming bored. After all, they just recently left the altar, and you're asking them to recreate scenes which they had already been involved in. As a result, their attention span will be limited.

2.) *Anxiousness:* In addition to the official being anxious to leave, the bride's parents and all of the bridal party will be anxious to get the photos over and done with so that they might leave for the reception, have fun, and be with their guests and friends.

Know, in advance, exactly what you want to do. Do not shoot tons of film. Quality should always take precedence over quantity.

3.) *Scheduling:* At the time of booking, you may have told the bride of your possible need to re-enact some of the photos once her ceremony has been concluded.

Notwithstanding, don't be surprised if the bride forgets her arrangement with you. At best, they might require that you take the time for this segment from the altar return phase.

Brides and their families often don't understand why you might have to recreate a shot or two. They only expect good photos of the wedding day. As a result, you must learn how to re-enact and photograph in a very limited amount of time.

In the beginning, you'll be a little slow. On the average, you'll probably spend about one and one-half minutes on each scene you have to recreate. (Try not to make it longer.) Plan for this amount of time in advance. Eventually your speed will increase.

## Be Creative

Despite the pressure associated with this segment, try to be creative. Try to use off-camera, dimensional lighting for as many of the photographs as is feasible. Be creative with your poses or camera angles and spend an extra few seconds paying

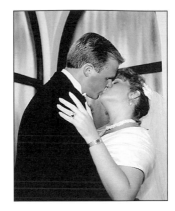

**5-10 and 5-11:** During the re-enactment of the ceremony, we like to get several different poses of the couple kissing. If there is an abundance of time, vary these photos by having close-ups and full-lengths views as well. These are popular photos and the variety will help them to sell.

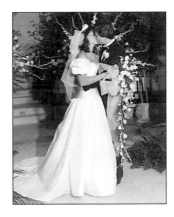

attention to all details: the bride's gown; flowers; head angle; the groom's stance; expression, and so on. The results will be more dramatic.

## MUST-GET PHOTOGRAPHS OF THE CEREMONY

Of all the photo situations which we have listed in this chapter, the following are must-get photos:

1. Groom by himself.
2. Groom with his best man.
3. Groom with both of his parents.
4. Mother of the bride walking down the aisle and being seated.
5. Parents of the groom, walking down the aisle and being seated.
6. Processional images: An individual photograph of each member of the bridal party walking down the aisle; the bride with her father walking down the aisle; her father lifting her veil and kissing her.
7. Groom shaking the bride's father's hand.
8. An available-light, wide-angle view of the couple at the altar from the rear of the church or temple.
9. A back view of the bridal couple as they kneel or stand before the wedding official at the altar.
10. A back view of the bridal couple as they receive a blessing.
11. A shot of the bridal couple as they exchange vows.
12. The ring exchange.
13. The lighting of candles by the bridal couple, if applicable.
14. At a Jewish wedding, the groom breaking the glass.
15. The kiss at the altar.
16. The bride and groom walking up the aisle.

### Photos in this Chapter

Unless otherwise noted, all of the photographs in this chapter were taken with a Hasselblad camera; 60mm or 80mm lenses; one portable flash attached to special on-camera bracket; camera exposure setting of f-5.6 at 1/60th second, and flash adjusted to emit f-8 light.

## MUST-GET PHOTOGRAPHS OF THE CEREMONY:

1. Groom by himself
2. Groom with best man
3. Groom with both of his parents
4. Mother of the bride walking down aisle
5. Parents of groom walking down aisle
6. Processional images
7. Groom shaking bride's father's hand
8. Wide-angle view of couple at the altar
9. Back view of couple at altar
10. Back view of couple receiving blessing
11. Bridal couple exchanging vows
12. Ring exchange
13. Lighting candles by couple
14. Groom breaking glass (Jewish ceremony)
15. The kiss at the altar
16. Bride and groom walking up the aisle

# CHAPTER SIX

# BACK TO THE ALTAR

Once the ceremony phase and all of its segments are over, it'll be time for the altar return phase. This phase involves a lot of people returning to the altar for formal photography: the bride, groom, their parents and grandparents, brothers and sisters, spouses and children of their brothers and sisters, and the entire bridal party.

Among wedding professional photographers, the photos taken during this session are commonly referred to as altar return photos or, more simply, *altar returns*.

## THE IMPORTANCE AND VALUE OF THE ALTAR RETURN PHASE

This phase is not complex, but it's nonetheless very important. In fact, this and the ceremony phase are the two most important phases of a wedding for the photographer. Accordingly, competent and adequate photo coverage of this phase is not only desirable, it's mandatory.

Of all the photographs that brides purchase for their album, altar return photographs head the list, with photos of the actual ceremony phase a close second. Altar return photography can be hectic,

chaotic, exhausting, and frustrating, but it can also be very rewarding.

Unlike other wedding phases, where a photographer will often have some photographic choices — choices such as command, must-get, suggested and frosting photos — the altar return phase will not be so liberal. Whether the bride or her family have requested them or not, *all* of the photos which should be captured during this phase are considered must-get shots.

If a photographer fails to capture any of the required photos, or takes them poorly, at the very least, he or she will face some dire consequences: a loss of credibility and reputation; a loss of sales, and a loss of referral business for future weddings. There might even be a lawsuit if the photo results were really deficient or badly done. All is not bleak, however, as there are big positives which can be derived from this phase.

The altar return phase provides a wedding photographer with a great chance to promote him or herself and capitalize on a terrific sales opportunity. Not only will altar return photos appeal and sell to the bride and her parents, assuming they have been competently

> "...COMPETENT AND ADEQUATE PHOTO COVERAGE OF THIS PHASE IS NOT ONLY DESIRABLE, IT'S MANDATORY. "

executed, but everyone photographed during this phase will be potential customers. The more time a bride allots you for altar return photography, the more photos you can offer. The more variety you can offer, the more the sales you can get. In fact, from this phase alone, sales could run into the hundreds of dollars.

For the wedding photographer to truly appreciate the importance of altar returns, he or she should also know why this phase is so important to a bridal couple and their families. For the professional wedding photographer, this phase can be a financial blessing. For the bride, groom and their parents (especially the bride's parents), the altar return phase is also important, but for different reasons:

1. Memorializing the bridal couple in their wedding attire.
2. Memorializing the location site.
3. Memorializing the family.

### The Importance of the Phase to a Bridal Couple and her Family

Over the years, we have heard varied and sundry reasons why altar return photos are so important and valuable to a bridal couple and their families. Of all the reasons we've heard, three of them always seem to be present:

#### Memorializing the Bridal Couple

With the ceremony service behind them, this phase will usually mark the first time that the bride, groom, and their parents have had to take a really good look at themselves and others around them; to take pride and admire the way the bride looks in her wedding gown; to see how handsome the groom looks in his former attire; to see how the parents look in their finery, and so on.

A wedding is a very special time in the lives of a bridal couple and their parents; a time which hopefully will only happen once. A lot of people will have gone to a lot of trouble and expense to get to this point and it's a point which most all involved want to remember for a lifetime. And, since weddings are steeped in tradition, and wedding photography is now a part of this tradition, what better way to keep remembrance alive than through dynamite photography?

However, mere flash on-camera, candid-type photography will usually not be sufficient to accomplish the goal. It's really not capable of capturing the essence of how the bridal couple looked in their wedding attire. It's too documentary. The light from a mere on-camera flash tends to wash out and flatten details in clothes rather than emphasize them; it doesn't help stylize the clothing or capture its essence. The only solution to this is to use dimensional, off-camera lighting. The altar return phase will be one, if not the only, time you will be afforded the chance to use this type of lighting. It will allow you to capture the type of photos which the bridal couple and their families expect to see.

**6-1:** When taking altar return shots, you should avoid taking a documentary, flash on-camera shots. A tight shot can really be taken anywhere — the altar environment should be depicted along with the bride and groom.

> **"THE MORE TIME A BRIDE ALLOTS YOU FOR ALTAR RETURN PHOTOGRAPHY, THE MORE PHOTOS YOU CAN OFFER. THE MORE VARIETY YOU CAN OFFER, THE MORE THE SALES YOU CAN GET."**

**THE IMPORTANCE OF THIS PHASE TO A BRIDAL COUPLE AND FAMILY:**

1. Memorializing the bridal couple
2. Memorializing the site
3. Memorializing the family

**6-2 (Above):** One of the first altar return shots you should take is the bridal couple with the wedding official. If time is a factor, capturing a simple shot such as this one will suffice. A 60mm lens was used on a Hasselblad camera with one flash, on camera, for sole illumination. The flash was set to emit f-8 light; the camera set to f-5.6.

**6-3 (Below):** Here's a shot of the bride with her father. This phase is very important to you and to the bridal couple. For you, the more shots, the greater potential for high sales. For the bridal couple, their special day will be memorialized by your photos.

**6-4 (Above):** Time may be a factor in the number of altar return shots you are able to take. One photo on your "must-get" list should be the bride with her maid of honor. If you have more than ample time, then of course you should take a shot of the bride with as many of the other important bridal party members as you can.

**6-5 (Below):** No altar returns would be complete without a shot of the bridal couple with the best man and maid of honor. In this shot, the exposure was balanced: the off-camera flash units and the ambient light were equal. Remember to include as much of the environment as is appropriate and possible.

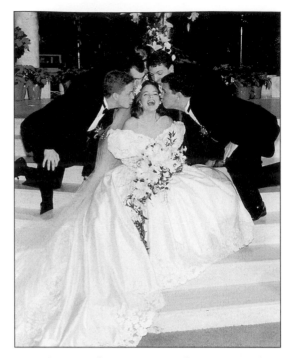

**6-6 (Above):** It often pays to get a bit "cutesy" and have the subjects a bit more relaxed. In this shot, the ushers and best man pretend to give the bride just "one last kiss".

**6-7 (Below):** If more time is available for altar returns, you can start to take more "cutesy" photos such as this one — the bridal couple kissing as the rest of the bridal party looks on.

**6-8 and 6-9 (Above and below):** Here are two traditional photos for the altar return phase: the bride with all of her maids, and the groom with the ushers and best man.

**6-10 (Above):** Another "cutesy" shot to take is the groom surrounded by the maids pretending to "kiss him good-bye".

## Memorializing the Site

Most brides and their families choose a wedding site because of its appearance or because of its religious significance. As a result, this environment becomes an integral part of the wedding day and wedding story; it's clearly important to memorialize it on film.

However, mere photographs of the ceremony site (the front of the church or temple, or of a barren altar alone), without the bride, the groom, members of their family, or members of the bridal party, will usually be meaningless; they will have little appeal and sales value. You must include the important and necessary people with the wedding site; people who have some significance for the bride, groom, and their families. To further illustrate how important it is to include the site in your photos, consider this:

6-11: A bride and her parents expect certain photos to be taken at the wedding site. This photo is one such "command" photo — the bride and groom with her parents. Other shots that should be taken are: the bride and groom with his parents, and the bride and groom with both sets of parents.

Assume that the bride wanted a particular shot: a command photo of her mother and father standing at the altar. However, for some reason, you failed to take it during the altar return phase; in your rush, you simply forgot it.

Later, during the reception, you remembered the photo the bride wanted and decided to photograph the parents there. You used dimensional, studio-type lighting; paid meticulous attention to all details; took plenty of time; posed them in a gorgeous environment, and shot an abundance of film. Assume further that you got some dynamite photos of the bride's parents as a result. You think this would satisfy the bride and rectify your failure to capture the shot she really wanted? Our experience has shown that it definitely would not! Brides and their parents expect certain photos to be taken at the wedding site, and specifically at the altar (altar returns), and nothing you can say, do, or offer will change this fact.

## Memorializing the Family

Four factors make this segment very important for altar return photography: togetherness; neatness; captive audience, and sobriety.

*Togetherness:* A wedding offers a good excuse for people, especially wedding participants or their family members, to get together. Many may not have been together in years. The wedding will often have acted as a catalyst for a reunion. For some, it will be the first time that all of them have ever gotten together, all at the same time, all under one roof.

Whatever the situation and although this fact may not seem too important to the bride and groom at the time, having all of the family together at one time is usually the single most important point for doing altar returns in the first place. The competent professional wedding photographer cannot afford to ignore this fact nor fail to capture photos of all the family.

*Neatness:* At most weddings, the bride, the groom, each member of their respective families, and all the members of the bridal party will dress up for the occasion. They will all look their best at the time the service takes place and immediately after, during the altar return photography session.

Consequently, these are the best time for photos. People who look good usually

6-12: It is very important that you capture at least one or two photos of the bridal couple at the altar. This photo memorializes the wedding site for the couple and is a must-get shot.

6-13: Remember to get a shot of the bridal couple with each set of parents. Here, the bride's mother and father pose proudly with their daughter and new son-in-law. In this example, some of the environment was captured as well.

feel good about themselves; and, if they feel good about themselves, they will usually photograph well.

Once at the reception, people begin to relax and think less about their appearance. Ties get undone, collars get opened, clothing becomes stained and wrinkled, makeup becomes smeared, and so on. Such a messy appearance will not lend itself well for formal images; the photos will not sell as well.

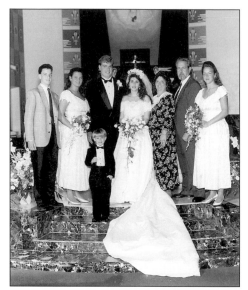

**6-14:** Many weddings are also family reunions. Thus, photos memorializing the family are very important. Many families will not get together again perhaps for a long time. These photos will be very special for the bridal couple and their families.

*Captive audience*: At the ceremony site, you'll have a captive group in that all of the important people to photograph will usually be there. Once the altar return phase is over, one or more of these people may leave or become unavailable.

For example, at the reception, some of these people may be dancing while others are at the bar or visiting guests at various tables. If the group to photograph is large — say 15 to 20 people — it may be difficult or impossible to get them together for photographs once they get to the reception. You will have missed an opportunity to record pictorially a valuable facet of the

bride's day. If a bride wishes a photograph of her entire family, but her brother is absent, she might refuse to have the picture taken or, if she does allow it to be taken, the chances of her buying it will often be slight.

*Sobriety*: Inebriated people most often make poor photographic subjects. At the ceremony site, generally all of the important people you will have to photograph will be sober, will look and feel their best, and will be somewhat cooperative.

However, once at the reception, some may have a bit too much to drink and this can lead to problems. Their appearance often becomes disheveled and they frequently become less than cooperative. Consequently, photo results often look less than great.

## THE PHOTOGRAPHER'S PREPARATION

Good preparation is important for all wedding photography, but especially for the altar return phase. This phase makes the greatest demand on the professionalism of the wedding photographer. He or she must be able to take charge, know what to do, when and how to do it, and accomplish it all within a very limited amount of time. Everyone involved will expect this.

Without solid preparation, you throw the results of the session open to chance and subject your photographic credibility to doubt.

To help you guard against this and to enable you to photograph an altar return successfully and quickly, we suggest the following:

1. Have a game plan.
2. Be acutely aware of the time factor.
3. Make an informed decision about an assistant.
4. Prepare to work around other photographers.

"ONCE AT THE RECEPTION, PEOPLE BEGIN TO RELAX AND THINK LESS ABOUT THEIR APPEARANCE"

**A PHOTOGRAPHER'S PREPARATION:**

1. Have a game plan
2. Be acutely aware of the time factor
3. Make an informed decision about an assistant
4. Prepare to work around other photographers

## Have A Game Plan

Of all the wedding phases, the altar return phase requires the most precise organization. Your game plan must allow you to work effectively, fast, efficiently, and systematically. There will be no time to "dilly-dally" around, to look for needed pieces of equipment, or to think about what it is you want to do or how you want to do it. You must know what it is you need to do, then do it! If you don't, you'll lose the interest and attention of most, if not all, of the bridal participants and their families. This will seriously impair, if not totally destroy, your photographic efforts. To help you arrive at an initial game plan for your altar returns, we suggest the following:

### Set Up Equipment in Advance

The moment you are finished photographing the receiving line phase, immediately head for the front of the altar and set up all of the equipment you will need. All equipment, including lighting, must be set up before the bridal couple, their families and all the bridal participants arrive at the altar to be photographed. They should never have to wait for you.

Thus, if a receiving line is to take 15 or 20 minutes, you should be able to get all the photos you need from that phase in about 10 minutes. This will leave you enough time to go back into the sanctuary area and set up everything you'll need to photograph altar returns before the bridal party arrives.

### Have Equipment Needs Thought Out in Advance

Before you arrive at the ceremony site, you should know exactly how much and what type of equipment you're going to need for the altar returns. During the altar return phase, there will be no time to think about pieces of equipment which you could have used which might be out in your car, or back in your home or studio. You must have anticipated these needs and prepared for them.

At a minimum, you should have at least two fully loaded cameras (one with a wide-angle lens, the other with a normal focal-length lens), two additional fully loaded film backs, at least 10 rolls of 220 film, one camera mounted onto a tripod, a #1 grade of soft focus filter slaves connected and readied, a sync cord (in case of failure of the transmitter), plenty of light stands, studio or portable type-B lighting equipment (at least two and preferably three off-camera flash units), a flash meter, and ambient light meter.

> A step-stool or small ladder is a very important piece of equipment – and one that should always be with you in case you need it!

### Have an Alternate Site Planned for Altar Returns

Even though you, the bride, and her family might have planned for all the altar returns to be done at the altar of the ceremony site, sometimes you'll both be in for a surprise. The altar might not be available for altar return photography at the time you planned to use it.

Sometimes a church or temple will have booked another wedding, one which has been scheduled to follow immediately after yours has concluded, and they will have forgotten to tell you or the bride about it. When this happens, the wedding official will forbid you from using the sanctuary after your bride's

## EQUIPMENT LIST FOR ALTAR RETURNS:

1. Two fully loaded cameras
2. Two additional fully loaded film backs
3. At least ten rolls of 220 film
4. One camera mounted onto a tripod
5. #1 grade of soft focus filter
6. Slaves connected and readied
7. A sync cord
8. Light stands
9. Studio or portable type-B lighting equipment
10. A flash meter and ambient light meter

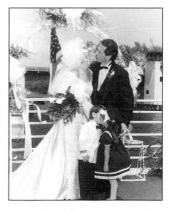

6-15: If you have a game plan and follow it, hopefully you will get all the must-get and command altar return photos, and still have time to take some more casual photos like the one above.

wedding; they'll need the area cleared for the next wedding.

If the wedding ceremony is being held at a hotel our country club, you'll often face another dilemma: the tearing down of the altar to prepare for the reception.

Once the actual wedding ceremony service is over, many hotels and country clubs use part or all of that ceremony site's space to set up additional tables and chairs for a bride's reception. Typically, and even before all of the guests have filed out from the ceremony site at recessional's end, the hotel or country club's staff will start breaking down the altar and otherwise begin preparing the area for the forthcoming reception. You'll not only have no altar to work with but, because of their staff milling about, you'll often have no room to work in.

Sometimes, if this condition occurs at a hotel or country club, you might be able to buy some time. If you "sweet-talk" the caterer in charge, you might be able to buy an additional five or six minutes before the altar is torn down. This would give you at least enough time to photograph the bridal couple and maybe their parents at the altar. But, in any case, no matter where the ceremony service is held, you must be prepared for the condition of "no altar-no space," and you must have an alternate planned for.

### Know Whom to Photograph

Don't wait for the altar phase to decide whom to photograph. If you do, precious time will be lost sorting out the various individuals, couples, and groups whom you think you should photograph.

Even though you might have prepared an exhaustive list of the people whom you intend to photograph, if you are pressed for time and are forced to capture only a few photos of some very selected people, we would then suggest that you take at least the following shots at the altar:

1. Bride by herself.

2. Groom by himself.

3. Bride and groom together.

4. Bride and groom with bride's parents.

5. Bride and groom with groom's parents.

6. Bride, groom and the entire bridal party.

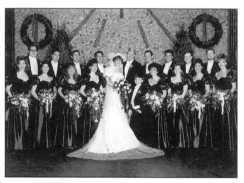

**6-16** One of the six "absolute bare minimum" shots of the altar return phase is of the entire bridal party. There are different kinds of poses for these shots: the straight-line pose; the civil war pose; upside-down V pose (above); and the split-T pose.

These six situations constitute the absolute bare minimum for altar return photography and will take you about five to ten minutes to accomplish. If, on the other hand, you have been given 30 to 45 minutes to photograph altar returns, then in addition to the above six, we would do the following:

7. Bride, groom, bride's parents, and bride's brothers and sisters.

8. Bride, alone, with all of her brothers and sisters.

9. Bride, alone, with her parents.

10. Bride and groom, bride's parents and grandparents, and all of her brothers and sisters with their spouses and children.

11. Bride and groom with her grandparents.

12. Bride, groom, his parents, and all of his brothers and sisters.

13. Groom, alone, with all of his brothers and sisters.

### ABSOLUTE BARE MINIMUM FOR ALTAR RETURN PHOTOGRAPHY:

1. Bride by herself

2. Groom by himself

3. Bride and groom together

4. Bride and groom with bride's parents

5. Bride and groom with groom's parents

6. Bride, groom, and the entire bridal party

When we've needed an alternate location, we have often photographed altar returns on the grounds of the ceremony site. There needs to be some available light and the grounds should be attractive. The grounds should also lend itself to this form of photography, with the number of people we have to photograph. If it doesn't, we have resorted to some other, vacant, large room at the reception site; we've even done altar returns in a lobby of a hotel. The point is, we always have an alternate space planned for, just in case something goes awry.

14. Groom, alone, with his parents.

15. Bride, groom, groom's parents, and his grandparents, and all brothers and sisters with their respective spouses and children.

16. Bride and groom and his grandparents.

17. Groom with best man.

18. Groom, best man, and ushers.

19. Bride with maid of honor.

20. Bride, groom, maid of honor, and best man.

21. Bride, maid of honor, and bridesmaids.

22. Groom with maid of honor and all the bridesmaids.

23. Bride with best man and all the ushers.

24. Bride, groom, and entire bridal party; do at least two different poses.

Almost as important as knowing whom to photograph is knowing whom not to photograph. If you photograph the wrong people together with the bride and groom at the altar, it could prove embarrassing, if not disastrous, to the entire photo session.

For example, you may have a bride whose parents are divorced and who have insisted that they not to be photographed together. However, most often they will want to be photographed with the bridal couple, but only if they can be in the photos with their new spouses or companions.

In such a case, you will have to photograph the bride and groom with the bride's mother and her new husband or companion, then retire them to the sidelines and then photograph the bride and groom again, but with the bride's father and his new wife or companion. Whatever you do, don't force any person or couple onto the bride and groom. If the bridal couple tell you that they don't want one or more people in the altar

return photos (such the bride's mother's new husband), comply and move on.

If a family "problem" arises during the course of your photography, immediately turn the problem over to the bridal couple and let them solve it. Whatever you do, don't ever get into the middle of any family dispute. If you do, one thing is certain: you'll loose and you'll often become the "heavy."

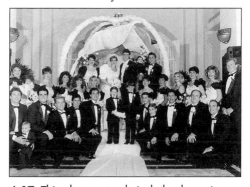

**6-17:** This photo not only includes the entire bridal party, but also children of the bridal party members, as well as family members of the bridal couple.

### Follow a Definite Order

To have altar returns flow smoothly and quickly, you must have a definite order in mind. You must not only know whom you are going to photograph, but who is going to be first, second, third, and so on. If you don't, you'll often end up wasting a lot of valuable time, cause a number of people to become irritated, and cause your own credibility to suffer. Following some sort of order sounds simple; however, the real problem is knowing which order to follow.

Most wedding professionals we know follow a definite order for their altar return photography, but the order will often vary from one photographer to another.

Even at our studio, Sheila follows one order when she photographs altar returns, I, another. This doesn't make either one of us wrong or right, just different. The important point is that both of us strictly follow a procedural order.

*"To have altar returns flow smoothly and quickly, you must have a definite order in mind."*

For example, I will always photograph the bride alone first, then the bride and groom together. Then, I will always photograph the bride and groom, but only with people from the bride's side of the family that need to be photographed. Once this is done, I allow all of these people to leave for the reception, unless their presence is required in some future photos.

When the bride's side of the family has all been photographed with the bride and groom, I employ the same procedure and photograph the bridal couple with people from the groom's side of the family.

After both the groom and bride's entire family have been photographed with the bridal couple, I then photograph the bridal couple with selected members of the bridal party, and then with the entire bridal party. When this is all done, I allow everyone to leave, except the bridal couple.

Once you have allowed the parents and families of both the bride and groom to leave for the reception, a great deal of pressure will be taken off the bridal couple. Bridal couples are often very concerned that their guests will be left unattended at the reception site. Having their families be there assures them that the guests will be entertained until they arrive.

At this point, the bride and groom feel even more relieved and relaxed; it will be the first time, since they have been officially married, that they will have been alone. This atmosphere allows you more time to photograph them at the altar and for the next phase: romantics of the bridal couple, a topic which we will be dealing with in the next chapter.

### The Type of Images to Take

Since most weddings are steeped in tradition, many of the posed altar return photos will be traditional, environmental images, with the altar as the background.

Such poses are accepted in wedding tradition as standard poses and brides, grooms, and their parents, expect to see such poses and want to have them. You'll be expected to have the knowledge and the ability to produce them. This does not mean to say that you should not be innovative and creative. You should! However, it does mean that you must do some traditional photography first and then, time permitting, turn to more contemporary images, perhaps using more creative lighting and posing.

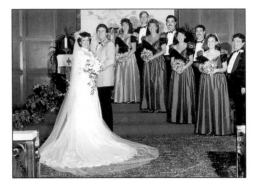

**6-18** Traditional altar return photos are expected by the bride, groom, and parents. Here is an example of the bridal party in a split-T pose. This pose works best when the bridal party is relatively small: 6 to 12 people.

### Be Aware of the Time Factor

Time will always be a nemesis when doing altar returns and its importance will vary depending upon whom is being affected by it. The wedding photographer, the bride, groom, their parents and the wedding official, will all think time is an important factor but for different reasons.

### The Importance of Time to the Photographer

As a general rule, you'll need from 30 to 60 minutes to complete the altar return photography. This amount of time will vary, more or less, depending upon a few things: the total number of family and bridal party members to be photographed; how cooperative they are; the space in which you have to work, and the amount of time the bride has allotted you.

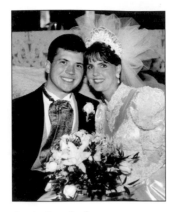

**6-19:** Avoid taking a documentary, flash on-camera shot like the one depicted above. Although it's an acceptable shot, a tight shot of this nature can really be taken anywhere. Not enough of the altar environment is being seen to make it a memento of where it was captured. Time should not be wasted on shots like these during the altar return phase.

*"TIME WILL ALWAYS BE A NEMESIS WHEN DOING ALTAR RETURNS…"*

*Number of people:* The guidelines are simple — the more people you have to photograph, the more time you'll need. Altar returns of a bride and groom, a bridal party consisting of only four people, and only four family members, will take very little time to photograph; about 15 to 20 minutes. A bridal party consisting of 14 to 16 people, with dozens of family members to photograph, will often take you 60 minutes or more.

*Cooperation:* No matter how small or large the group might be that you're going to photograph, if one or more of those persons becomes uncooperative during the course of the session, their conduct could have a serious, disruptive effect on your time schedule.

When you are faced with persons who exhibit an uncooperative attitude, immediately take the problem to the bride and groom and let them solve it. Don't become involved and don't waste your time trying to get uncooperative people to cooperate.

*Space:* Whether it be in a church, temple, country club or hotel, altars are usually designed to accommodate a limited number of people, as well as some religious artifacts (kneeling bench, candelabras, and the like).

If you are to photograph a large group of people, the altar in question might not accommodate the people, the artifacts, and all of your equipment, all at the same time. This might tempt you to move one or more of the religious artifacts so that you can better accomplish your photography. Don't! Move nothing that does not belong to you without first getting permission from the wedding official.

Because of limited space, you might find yourself having to move people and equipment each time the size of the group changes. All of this moving can put a great dent into your allotted time. However, if this is what you have to do to accomplish satisfactory altar returns, then be prepared to do it, but do it quickly.

*Time allotment:* At the time you book a bride's wedding, and based upon the size of the bridal party and family members to be photographed, you should tell her the approximate time you think you'll need for adequate altar return photography. Then find out how much time she intends to allow you. These two time factors may differ considerably.

You must be prepared to work within the time limit she has prescribed, but tell her that you may not be able to get all of the shots she wants taken. Advise her that you'll take all of the more important shots first, then as many of the others as you can. This will shift the burden of responsibility over onto her shoulders, allowing her to select which shots are the most and least important to her.

### The Importance of Time to a Bridal Couple and Their Families

Once the actual ceremony is over, most brides, grooms and their families will be anxious to leave, have fun, play host, and attend to their guests at the reception. However, they'll also want good, solid altar return photography. This paradoxical situation can cause additional anxieties for you, the bridal couple, and their families; they'll frequently be pressing you to hurry.

At the time of booking her wedding, a bride may initially be very generous about the time she intends to allot you for the altar returns. However, and for one reason or another, you should be prepared for her to change her mind on the day of her wedding.

There have been many instances when we thought we had 60 minutes in which to do altar returns, only to find out on the wedding day that we had been cut back to 15.

Notwithstanding these pressures, never let your haste and zeal to work quickly overshadow the quality of the work you must do. Each altar return photo must be properly exposed, well-

**FACTORS THAT AFFECT ON TIME DURING THE ALTAR RETURN PHASE:**

1. Number of people
2. Space
3. Time Allotment

*"THERE HAVE BEEN MANY INSTANCES WHEN WE THOUGHT WE HAD 60 MINUTES IN WHICH TO DO ALTAR RETURNS, ONLY TO FIND OUT ON THE WEDDING DAY THAT WE HAD BEEN CUT BACK TO 15."*

composed, posed, well-lighted, and in focus. Anything less will be unacceptable.

### The Importance of Time to the Wedding Official

No matter what agreement you may have made with the bride about altar returns and no matter what her or her family's wishes might be concerning time for photography after her wedding service, if the wedding official at the church or temple (or the person in charge at the hotel or country club) decides otherwise,

you must abide by that ruling. For example, the bride may have planned on giving you 30 minutes for altar returns, but the wedding official may only allow you 10. Ten minutes is what you will be held to and this will usually not be enough time to do all of the required shots.

In this case, just make certain that you inform the person who hired you (usually the bride) of this condition and assure the bride that you will take all of the required photos later. Whatever you do, don't

"EACH ALTAR RETURN PHOTO MUST BE PROPERLY EXPOSED, WELL-COMPOSED, POSED, WELL LIGHTED AND IN FOCUS. ANYTHING LESS WILL BE UNACCEPTABLE."

## Shooter's Log: The One and Only Photographer

About 15 years ago, we had the opportunity of studying on a one-on-one basis with one of the "old time" greats of the wedding business. During the tutelage, we had the chance to see him photograph an entire wedding.

While he was photographing the altar return phase, one of the ushers and bridesmaids happened to take one snapshot with their respective point-and-shoot cameras. As soon as their flashes had fired, the photographer whirled about as though he had been shot, threw his camera to the floor and in an extremely loud and irate tone of voice started shouting obscenities. He, in essence, then exclaimed, "I'm the official photographer here. No one is going to photograph but me, otherwise I'm leaving."

The bride, groom, and the bridal party were all embarrassed and spent the next few minutes calming the photographer and each other down so that photography could be resumed.

Later, we heard a number of comments about the photographer's outburst and conduct from many of the bridal participants: "Wasn't he rude?" "What was wrong with him, is he nuts?" "Where did they find this guy? I'd never use him for any wedding of mine."

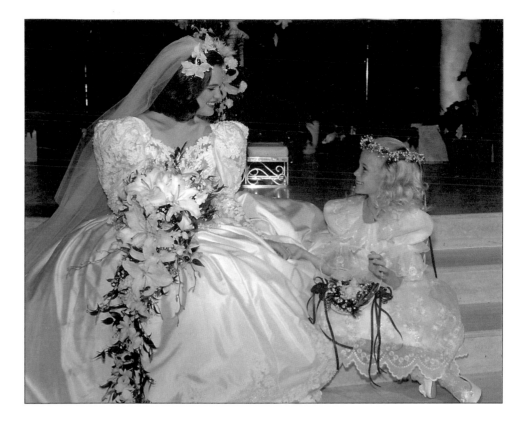

**Above:** Don't be too rushed for time to forget other important shots such as the bride with her maid of honor and other bridal party members, the parents, grandparents, brothers, sisters and so on. This photo shows the bride with the flower girl.

**Right:** Even if you are pressed for time, it is mandatory that you capture at least one or two traditional-style photos of the bridal couple at the altar. Also, if the wedding is held outdoors, don't forget to take some shots of the bridal couple and the bride by herself in the environment in which they were married. These photos will hold special meanings for the couple.
(*See Chapter Six*)

**Right:** A wedding often brings members of a family together — some may not have been together in years. The wedding will have acted as a catalyst for a reunion. Taking shots of the family is therefore important and expected. Here, the bride's family poses with the bridal couple.

**Below:** When doing altar returns, it is important to make every photo count and to move from one group of people to another efficiently. Having definitive poses and lighting placements well in mind, in advance, will help you achieve your goal. This photo shows the bridal party in an upside-down V pose, which is probably one of the most versatile of all the altar return poses.
(*See Chapter Six*)

**Left:** It is important to get different shots of the bride – many poses offer the bride a pictorial variety for her album. Whether photographing the bride indoors or outdoors, it is important to show all sides of a bride's dress: the front, side, and back of her dress.

**Below:** For a slight variation to the straight-line pose, but still using the straight-line lighting concept, we have a pose which we call the civil war pose; people closest to the camera are kneeling or seated while people behind them are standing or kneeling. Whether standing or not, all subjects are still in a straight line or plane and perpendicular to the camera axis. (*See Chapter Six*)

**Above:** Once the traditional photography has been concluded, and if time permits, it often pays to get a bit "cutesy" and have the subjects get a bit more relaxed. Here, the ushers and best man are gathered all around the bride.

**Right:** During the course of an actual ceremony the bridal couple will usually exchange wedding rings. Notwithstanding the fact that we may have photographed that exchange when it actually happened and felt confident of the photo results, we always try to recreate the "ring shot" at the conclusion of the altar returns. This gives the bridal couple more choices and photos for their album. (This photo was shot with a Hasselblad camera with a 60mm lens and one flash on-camera; flash set to emit f-8 light; camera set at f-5.6.) (*See Chapter Six*)

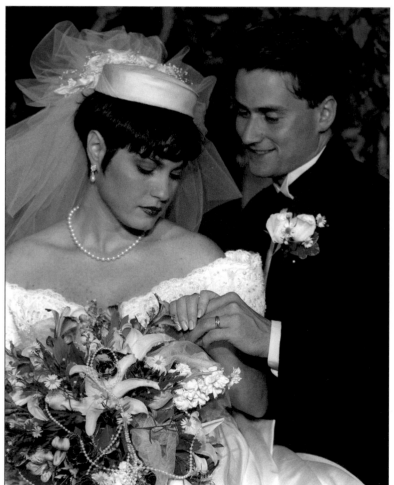

panic! A situation like this is not your fault. Just don't forget to take the missed shots later!

### Use an Assistant

At the beginning of your career, you may well be tempted to photograph weddings all by yourself, without the benefit of any help. If for no other reason, you may want to save money. However, to us, this is being penny wise and pound foolish, especially when it comes to the altar return phase. A good, well-trained, photographic assistant can make any photographer's job easier and faster.

For example, just prior to the altar returns, a capable assistant can be used to set up all of your equipment and lights while you are busy photographing the receiving line or other important matters. While you are photographing the altar returns, the assistant can make certain that all of your flashes are firing when you shoot; assist with the posing of people, and help keep the order and progression moving smoothly and quickly. While you are photographing one group, he or she can be assembling the next group for you to photograph.

A word of caution! The key words for any assistant are good, well-trained, and capable. Never rely upon any assistant unless that person knows exactly what to do and when to do it. It not only will be a waste of your efforts and money, it will usually cost you precious time. The site of an actual wedding should not be a training ground. 📷

### Working in the Presence of Other Photographers

Like it or not, there will be other photographers present at most all weddings: friends, relatives, and guests, all taking photographs. They'll be taking photos before, during and after you photograph, and often of the same people and from the same views; they'll often want to capture the poses you have worked so hard

to arrange. They will slow you down, get in your way, and increase the time you need for your photography. Sometimes they will even affect the quality of your images by having their flashes set off your slaved lights. Sometimes their shooting may also affect your sale of prints. After all, your photos will have to be paid for while theirs will usually be offered to the bride free of charge.

Whatever the case may be, if other photographers are shooting around you, attempt to have the bride restrain them from photographing until you have finished or try yourself, tactfully, to persuade them to wait. If these attempts fail, do your photography in spite of them. But, in no event, should you ever become involved in any open confrontation or altercation with these other photographers. Don't create any situation which could cause you, your studio, the bridal couple, or their families any embarrassment.

### LIGHTING

Almost all altar return photographs will be taken by using some sort of flash: flash as the main light, ambient light as a fill source or vice versa; flash on-camera as a fill light source with off-camera flash as the main light or vice versa; and so on. However, knowing that you will most often be using flash is only part of the solution to properly lighting altar returns. You must also have a knowledge of light control and lighting placement.

The results will be best if you use *dimensional lighting*: off-camera flash as a main light source with ambient light as a fill, or one or more off-camera flash units as the main source with an on-camera flash as a fill.

Once in a while, such as when you are photographing an outdoor wedding during daylight hours, you'll be able to get some additional pictorial variety by taking a few selected photographs illumi-

> "...IF OTHER PHOTOGRAPHERS ARE SHOOTING AROUND YOU, ATTEMPT TO HAVE THE BRIDE RESTRAIN THEM."

At our studio, we never pay any new assistant until that person is capable of taking on the total responsibility that is associated with the job. Our usual routine is to take a new assistant with us to a few weddings; we allow him or her to observe; we offer some on-the-job advice, and once in a while allow them to give some help. But, we never pay them nor rely upon their assistance until we feel that he or she is ready. After having observed three or four weddings, they should be ready to take on the total responsibility required of a wedding assistant; however, if, by this time, we think they're still not ready, we'll look for a new assistant.

nated only by natural light. A shot of the bridal couple, with the entire wedding party assembled in a lovely garden, would be just one example.

## Light Control

Simply stated, light control involves how one or more lights are used; it takes into account such things as the power of lights, light housings, and the affixing of lights.

Good, effective, light control is most important for altar returns. In fact, of the four major things which could ruin altar return photos, (i.e., improper posing, bad film exposure, improper light control, and improper light placement), poor light control usually heads the list; it's second only to improper light placement.

## The Power of Lights

Ideally, for altar return photography, especially when photographing large groups of people, a photographer should have as much power as possible for the flash units; more power gives more control over depth of field. Why? The general rule of thumb is simple: the more power from the output off your lights, the *higher* you can set your camera's f-stop; and, the higher the camera's f-stop setting, the greater the depth of field you will have.

When people are posed in lines, say one group of people behind another, you'll want the people in the foreground to be in sharp focus as well as the people behind them. To accomplish this, you really need to use a relatively high f-stop setting on the camera and this usually means that the photographer should use portable type-B or studio type lighting equipment. Equipment of these types usually produces more power than portable type-A equipment, and thus can yield stronger light. This equates to higher f-stop settings to work with.

For example, if you work with portable type-A equipment, you'll often find with large group photography that you'll be working at a relatively low f-stop setting, such as f-4.0 or lower. By switching to the more powerful, portable, type-B or studio equipment, you'll have more power and control. Depending upon the power of the equipment being used, it would not be unusual to find a photographer shooting large group altar returns at f-8, f-11, or even f-16.

Another general rule to know is: every time you double the power output of a light, you gain one whole f-stop. Thus, if a given flash has a power output rating of 100 watt-seconds, and at a given distance produces a power of light which would allow you to photograph at a lens setting of f-5.6, by doubling the power output to 200 watts, you would be able to photograph those same subjects, at that same distance, at a higher f-stop setting of f-8. Double the power again to 400 watt-seconds and you would be able to photograph that same situation, at the same distance, at a new, and even higher f-stop setting of f-11.

## Light housings

What you put a flash unit into is generally referred to as a light housing and the type of housing that you choose can not only have a decisive affect on power output but have an affect on light control as well.

A flash unit housed in a bowl, umbrella or softbox are examples of three different types of light housings; and, each type of housing can have a definite affect on the quality and quantity of light control.

*Quality:* As a general rule, the smaller the light source, the harder the light. Conversely, the larger the light source, the softer the light. Therefore, a flash unit which is housed in a bowl reflector will yield hard light, that same flash housed in an umbrella will yield less hard, or softer light, and one housed in a softbox will produce the softest light of all three. Since most people photograph best when soft

FOUR MAJOR THINGS WHICH COULD RUIN ALTAR RETURN PHOTOS:
1. Improper posing
2. Bad film exposure
3. Improper light control
4. Improper light placement

light is used, one would think that altar returns should be done with flash units housed only in softboxes. Unfortunately, this is not always practical.

Compared with bowl reflectors and umbrellas, softboxes are usually larger, more bulky, and more time consuming to set up and tear down.

This fact alone makes them less than desirable for altar return photography. However, there is a more compelling reason why they should not be used for altar return photography: softboxes are usually less light efficient than umbrellas or bowl reflectors.

*Quantity:* Generally, bowl reflectors are more light efficient than umbrellas or softboxes, while softboxes are the least light efficient of the three. As a result, a wedding photographer may not have enough power available to use softboxes for altar returns. And, the general rule is simple: the less light efficient a light (light housing) is, the more power you'll need to get that light to produce any given quantity or f-stop of light. Conversely, the more light efficient a light (light housing) is, the less power you'll need.

For example, assume that you want to photograph a group of eight people at the altar (four people standing in the foreground and four immediately behind); you only have 100 watt-second power sources for your flash units, and the lights are 10 feet from the subjects. If you put those lights into bowl reflectors, you might get an f-stop meter reading of say, f-5.6. Those same lights, at that same power output and distance, housed in umbrellas will yield less powerful and

efficient light, such as f-4.0 light and even less efficient light if they were housed in softboxes: f-2.8 light.

Therefore, if you wanted to work at a higher f-stop setting (and you should; a setting of f-2.8 or even f-4.0 are usually totally inappropriate camera f-stop settings to use when doing large group photography), you would need a lot more power or you would have to forgo the thought of using your lights housed in softboxes or umbrellas. How much more power would you need? (See table 6-1.)

By looking at the example table, you can quickly see that if we took our above example lights and doubled the power from 100 watt-seconds to 200 watts, we would gain one whole f-stop of light to use, but this would not be enough power to allow us to use softboxes. We would only be getting f-4.0 light out of them.

If we doubled this 200 watts to 400 watts, we would gain another f-stop of light to work with, but this would still not be enough; we'd only have f-5.6 light to work with, if we used softboxes.

By doubling the power again, to 800 watt-seconds, we would gain another whole f-stop of light to work with (f-8.0 light) and by doubling the power one more time, to 1600 watt-seconds, we would end up with a light output of f-11 for our softboxes.

However, 1600 watts of power is a lot of power, and is usually only available in heavy, bulky, studio-type equipment. This same amount of power (1600 watt-seconds), used on lights which were housed in umbrellas or bowl reflectors, would yield a lot more light: f-16 or f-22

*"COMPARED WITH BOWL REFLECTORS AND UMBRELLAS, SOFTBOXES ARE USUALLY LARGER, MORE BULKY AND MORE TIME CONSUMING TO SET UP AND TEAR DOWN."*

| Power Output in Watt-Seconds | F-Stops For Bowl Reflectors | F-Stops For Umbrellas | F-Stops For Softboxes |
|---|---|---|---|
| 100 watts of power | f-5.6 | f-4.0 | f-2.8 |
| 200 watts of power | f-8.0 | f-5.6 | f-4.0 |
| 400 watts of power | f-11 | f-8.0 | f-5.6 |
| 800 watts of power | f-16 | f-11 | f-8.0 |
| 1600 watts of power | f-22 | f-16 | f-11 |

Table 6-1: F-stops for light housings supplied by different power outputs.

light respectively; greater f-stops for greater depth of field.

The bottom line to all of this is simple. Because the light housing can affect light efficiency, it often becomes necessary for a photographer to compromise. In our above example, if the photographer abandoned the thought of using softboxes and used those same flash units, at the same distance, but powered by only 400 watt-seconds of power (portable type-B equipment), housed in umbrellas or bowl reflectors, he or she could still get a relatively high f-stop camera setting to work with: f-8.0 for the umbrellas or f-11 for the bowl reflectors. Either f-stop would give you a lot of depth of field for your altar return photography.

Which combination of light housings with what quantity of power sources should you use for altar returns? This will be a subjective decision which you must make on an individual basis. One thing we can tell you, we almost never use softboxes for large group altar return photography. It just takes too much power. Accordingly, we frequently opt for portable units, with less power, and then use our flashes housed either in bowl reflectors or umbrellas.

### Affixing lights

Although it may seem very basic, when doing altar returns, off-camera flash units should most always be mounted onto light stands rather than having them hand-held. This will help ensure more predictable results and better light control. Most portable flash units do not have modeling lights built into them. Modeling lights are tungsten lights that are built into flash units. They enable the photographer to see where the flash will strike the subject. Without these modeling lights, the photographer cannot see exactly where the light will fall; he has to "guesstimate". The condition worsens when off-camera lights are hand-held by an assistant.

When you put an off-camera light on a stand, you know the general direction the light is going to travel. Thus, you can control where the flash will strike the subject. Unless someone moves the light stand, the height, angle and distance of the flash from the subject will not vary. But if you place a light into the hands of your assistant, and take your eyes off him to take your photograph, you will not know whether the light was moved until you see the processed pictures, and then it will be too late.

Hand-holding a second, off-camera flash may be all right for a few head-and-shoulder photographs, but when you are engaged in 30 to 60 minutes of altar return photography, it's just too risky. The chances of getting bad light placement, and therefore bad lighting on the subjects, are great and far outweigh the slight inconvenience of putting your lights onto stands.

### Light Placement

Whether you are using studio or portable lighting equipment to light your altar returns, and regardless of the type of housing your lights might be in, you must pay critical attention to light placement. You must position your lights so that all of the subjects receive even illumination. You want light on every face, without the shadow from one person falling onto the face of another. To assist you with this, we suggest the following basic guidelines:

• If you want to see something, light it. If you don't, don't.

• For all of your off-camera lights, the midpoint of each flash should be at the height of the subject's face and angled slightly downward.

• For lighting individuals or couples, you have some quick choices. Use only one on-camera flash or, for better, more dimensional lighting, use two lights: an off-camera flash as a main light, and the on-camera flash as fill light. Place the off-camera light about 45 degrees to the right

**"...WE FREQUENTLY OPT FOR PORTABLE UNITS, WITH LESS POWER, AND THEN USE OUR FLASHES HOUSED EITHER IN BOWL REFLECTORS OR UMBRELLAS."**

or left of the camera-subject axis (see Diagram 6-A) and as close to the subjects as you can, without it being seen in your viewfinder.

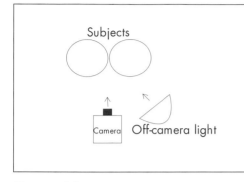

**Diagram 6-A**

• For groups of four or more people, use three flash units: one on-camera and two off camera. Adjust all three to emit the same quantity or power of light. Place one off-camera flash to the right of the camera-subject axis and one to the left, at the same distance from the camera.

The one on the left should be directed at the midpoint of the people standing to the right of the bride and groom. The flash to the right of the camera should be directed at the midpoint of the people standing to the left of the bride and groom.

The on-camera flash should be directed at the bride and groom (see Diagram 6-B). This will give you a bank of light for all the subjects, with even illumination on all the subjects' faces.

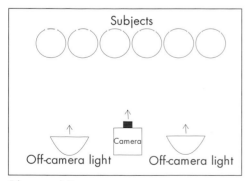

**Diagram 6-B**

• As the group of people to be photographed becomes larger, you'll need to become more critical about the placement of your lights and their direction. The lights should be closer to the camera-subject axis. When photographing one or two people, you can afford to have your off-camera flash as much as 45 degrees to the right or left of the camera-subject axis, pointing the light inward toward the person or couple. With a group of 10 or more people, the off-camera flashes should be closer to the camera (within 10 to 20 degrees of the camera-subject axis) and angled away from that axis (see Diagram 6-C) to ensure even illumination.

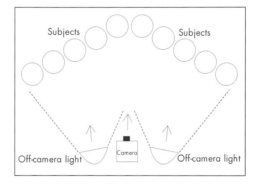

**Diagram 6-C**

It's helpful to think of a large group as several smaller groups combined. For example, Diagram 6-C shows a group of 10 people, positioned in a traditional pose, which we call an upside down "V" pose. We think of this combination of people, in this particular pose, as really being three small groups: the bride and groom in the center, four people to their right, and four people to their left.

Although each group is thought of as being lit separately, because all three flash units are of the same size and power output, the group will be lit very uniformly: all faces will be easily seen and lit.

There is a variation to this three light placement using the same upside-down V pose (see Diagram 6-D). It employs the same three lights, but placed differently. Because of this placement difference, the resulting photos will be a bit more dramatic than the photos taken with the lighting setup in Diagram 6-C, but a bit more space will be required.

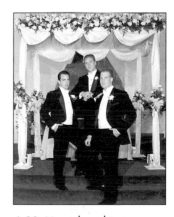

**6-20:** Here, the subjects are placed into an upside-down V pose. The lighting set-up is not difficult, especially if you follow the set-ups in Diagrams 6-C and 6-D.

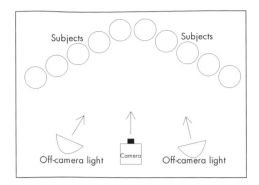

**Diagram 6-D**

Although this arrangement appears to contradict a general rule that you should not crisscross your lighting (crisscross lighting often produces conflicting shadows), for this application it'll be okay. As long as you don't allow the conflicting shadows to be seen in the final photo results, it's perfectly all right to crisscross your lighting.

In Diagram 6-D, you'll note that the slaved, off-camera lights to the right and left of the camera are directed inward, toward the center of each group of four persons. Your on-camera light, as before, will illuminate mainly the bride and groom and, just as before, all three flash units should be adjusted to emit the same amount of light, for even illumination. For even more variation, see diagram 6-E.

Diagram 6-E depicts a very different and contemporary pose which we call a split-T pose. Although this lighting placement is similar to that shown in 6-D, the pose allows you the opportunity to make the lighting a bit more versatile; you have some choices.

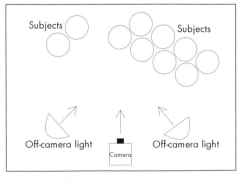

**Diagram 6-E**

You could have all three lights adjusted to emit the same amount of power (which will give even illumination); you could have the light to the right of camera (the one directed toward the bridal couple), and the one to the left of the camera (the one directed to the group) be of equal power, while the flash on-camera (adjusted for one whole f-stop of less light than the other two) acts as the fill light; or, you could have the light which is directed toward the bridal couple be the main light while the other two lights, set to one whole f-stop of less power, act as a fill light source.

Will one lighting placement be better than another? Usually not. For most photography, one lighting method will frequently be different from another, but not necessarily better.

However, there is a big exception to this: altar returns. Brides and their families most often want to see everyone's faces, and all evenly illuminated. Accordingly, we would initially light people set up in this pose with all three power sources adjusted to give even, equal illumination.

Then, if we had some spare time, we would use the light which was directed toward the bridal couple, as a main light, while the other two acted as a fill source. This would place more emphasis onto the bridal couple, and make the group a secondary, less prominent element in the photo composition.

## A Variation in Procedure

Even though it might be traditional and typical to do altar returns after the ceremony phase, this doesn't mean that it always happens this way.

The wishes of the wedding photographer, and the dictates of the bride and her parents, will often play a big part in the decision of whether the altar returns will be done before the ceremony or afterwards. One thing, however, is rather

> **"BRIDES AND THEIR FAMILIES MOST OFTEN WANT TO SEE EVERYONE'S FACES, AND ALL EVENLY ILLUMINATED."**

constant: the time factor. Whenever we have scheduled altar returns to be done before the ceremony, we usually attempt to have them start not less than one hour, nor longer than two hours, before the start of the ceremony phase. This amount of time gives us plenty of assurance that we will be able to take all the photos we need without rushing.

## The Wishes of the Wedding Photographer

Some photographers prefer to do altar returns well before the ceremony. In fact, some photographers feel so strongly about this point that many of them refuse to do altar returns unless they are done ahead of time and even refuse to book a wedding unless they can do it their way.

Although we would prefer to do them ahead of time too, we are not as dogmatic as others. At the time of booking, we'll try to convince a bride to do them ahead of time, but, we'll always accede to a bride's wishes if she is against it.

From a photographer's standpoint, and to assist you in making an informed decision about whether you should do altar returns ahead of time, consider the following positive points:

### It's Easier

When altar returns are done ahead of time, they are usually done about one to two hours before the ceremony phase starts. This means that the photographer often doesn't have to rush nor keep to a tight time schedule; he or she can work at a slower, more methodical pace. The photographer has plenty of time to pay attention to details: the lighting, the posing, film exposure and so on.

### People are More Relaxed

Immediately prior to the start of the actual wedding ceremony service, families of the bride and groom, and most of the bridal participants, will often be full of anxiety. Once the ceremony is over, and

it becomes time for the altar return phase, you'll usually find tensions lessening, but not eliminated; many will still feel rushed and anxious to get to the reception. And, subjects who are tense will often not photograph as well as those who are calm. By doing altar returns a couple of hours before a ceremony phase starts, you will often find most of the participants in a calmer state, much more cooperative and not rushed nor harried.

### Two Bites of the Apple

By doing altar returns well in advance of the actual ceremony, the photographer is really being given two chances to accomplish one result. If photos are taken in the usual course, after the ceremony, and some important shots are poorly or inadequately photographed, or are missed due to a photographer's negligence, he or she might face some dire consequences; there will be no other chance for a re-shoot. However, by doing altar returns before the ceremony, the photographer has a second chance.

Once the ceremony phase is over, he or she can go back to the altar and photograph those shots which were missed or which should be re-photographed. This is an extremely important benefit and, to us, the main reason why one should do this type of photography ahead of time.

### More Pictorial Variety

By doing altar returns ahead of time, you'll have more time to take more photos. Therefore, you'll often find that instead of taking photos of individuals, couples, and groups in just one or two poses, you'll often do three and four different poses. This additional work will create much more pictorial variety and equates to more photo sales and happier clients.

Although the above are all important and positive reasons for doing altar returns ahead of time, there are some very real negative considerations too:

> **"By doing altar returns a couple of hours before a ceremony phase starts, you will often find most of the participants in a calmer state..."**

**POSITIVE POINTS TO PHOTOGRAPHING THE ALTAR RETURNS BEFORE THE CEREMONY:**

1. It's easier
2. People are more relaxed
3. Two chances to capture altar return shots
4. More pictorial variety

### You'll Shoot More Film

By shooting altar returns ahead of time, we know we'll have some extra time to take all of our required shots. Because we are not rushed and have this additional time, we often shoot more film. Instead of taking doubles of each photo situation, as we normally would, we usually take three or four shots. Instead of taking shots of an individual, couple or group in just one or two different poses, we might take shots of them in three or four different poses.

All of this additional work requires the use of more film. In point of fact, and at our studio, whenever we do altar returns ahead of time, we often use 25 to 50 percent more film than we would have used had we done the altar returns after the actual ceremony. This, of course, drives our cost up; cost which we hope to retrieve through increased sales.

### You May Have to Work Harder

You may find yourself doing double work. For example, if the altar returns are to be done at the place where the ceremony is to take place, you'll first have to set up all of your equipment and lighting.

Once the photo session is over, you'll have to tear it all down so that the ceremony can proceed, then reposition all of your lighting and equipment again, to capture previously missed or poorly executed shots after the ceremony is over.

### You'll Often be Working Longer Hours

Assume that a bride has booked you for her wedding and has agreed to pay you $1,000 dollars; that this amount includes your services for five hours of time, a bridal album, some wedding proofs, and so on.

If you subsequently convince her to do altar returns ahead of time (say two hours before), something which she hadn't planned on anyway, you'll be doing this additional work without being able to charge her any more money. If you tried to charge her additional sums, it would not be unusual to find her balking and declining to do the altar returns in advance.

After all, the real benefit of doing altar returns ahead of time extends primarily to the wedding photographer and secondarily to the bride.

### Ceremony Site is Not Available

Even though you and the bride may agree to do altar returns ahead of time, this will be no guarantee that the ceremony site will be available to you when you need it.

If the ceremony is to take place at a church or temple, be prepared for some last minute changes; these institutions usually book a lot of weddings, some at the last minute.

Even though you might have checked with the wedding official in charge weeks or months in advance, this will be no assurance that the site will be available for the length of time you'll need it or even at all. If the wedding is to take place at a country club or hotel, you'll frequently face a different problem.

These institutions frequently do not have altars fully set up until minutes before a wedding ceremony is to begin, which, of course, will be of little value to you.

### People May Arrive Late or Not At All

If you are doing altar returns after a ceremony, it's often no problem getting all of the necessary people together, to return to the altar for photos; they are already on site anyway. However, if you are doing the photo session before the ceremony, be prepared for some delays and even "no-shows".

Whenever we have done altar returns ahead of time, it has been our experience that many of the required people, including the bride and groom, arrive late or not at all. Many people think that since

**"...THE REAL BENEFIT OF DOING ALTAR RETURNS AHEAD OF TIME EXTENDS PRIMARILY TO THE WEDDING PHOTOGRAPHER AND SECONDARILY TO THE BRIDE."**

**NEGATIVE POINTS TO PHOTOGRAPHING THE ALTAR RETURNS BEFORE THE CEREMONY:**

1. You'll shoot more film
2. You may have to work harder
3. You'll often be working longer hours
4. The ceremony site is not available
5. People may arrive late or not at all

"only photos are being taken," and the actual wedding is hours away, there is no sense of urgency to arrive early, timely, or even at all.

When this happens, we have no choice but to proceed with the photo session without them, and then go back to the altar and photograph these missed people after the ceremony has concluded.

## Dictates of The Bride and Her Family

When you are *hired* to photograph a wedding, there is a very simple rule to follow: Pay attention to and do what the person who has hired you, wants or asks you to do.

You really can't go wrong following this guideline. And, when it comes to doing altar returns ahead of time, following this rule isn't just good business, it's mandatory.

Although we usually suggest that altar returns be done ahead of time, if a bride, or her family doesn't want to do it, we would never pressure them into changing their minds.

If we did, and something went amiss during the photo session, we would surely be blamed; we might hear negative remarks such as, "...if you hadn't talked us into doing those photos ahead of time, this (accident or incident) might not have happened."

Although there are some real benefits which a bride and her family can derive from doing altar returns ahead of time, many times these positives go unappreciated, and the negative points influence their decision. Consider the following:

### More Time for Fun at the Reception

If altar returns are done ahead of time, once the actual ceremony is over, and barring having to return to the altar to take a few missed or better photos (which should only take about five or ten minutes), a bridal couple, their families and all the bridal participants can immediately leave for the reception; they can join their friends and have fun. This is a very positive benefit for all concerned.

### More Photos; More Pictorial Variety

By doing photos ahead of time, a bride will be able to get more photos and more variety, and this is a positive benefit to her and her family.

### Looking Better

The bride, groom, their families, and all of the participants will look their best and freshest immediately after they have dressed for the wedding. Clothing is not wrinkled nor soiled; makeup looks fresh; and so on. Photo results will look better since they will be at their best. This is a big benefit.

### The Site will Photograph Better

This positive benefit really applies only to brides who are having their weddings outdoors, such as on a boat or at a country club.

Many times they book such a location site because they think the grounds and surrounding area look beautiful and charming; they want this environment photographically captured. If they plan their wedding to start at dusk, they often don't realize that by the time the ceremony is over, the grounds and surrounding area will often be in total darkness and not capable of being perceived in the altar return photos.

By doing the photo session ahead of time, you be able to assure a bride that the environment will be captured and preserved in her photos.

### Brides Must Dress Earlier

Our experience has shown that most brides spend a lot of time (often hours) preparing themselves on the day of their wedding. They often have their hair and makeup professionally done, spend time primping, sorting out, and packing clothing and so on.

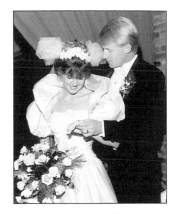

**6-21:** Whether the altar returns are done before or after the ceremony, it is important you have a list of shots you know you don't want to forget. Above, the bridal couple admire her ring.

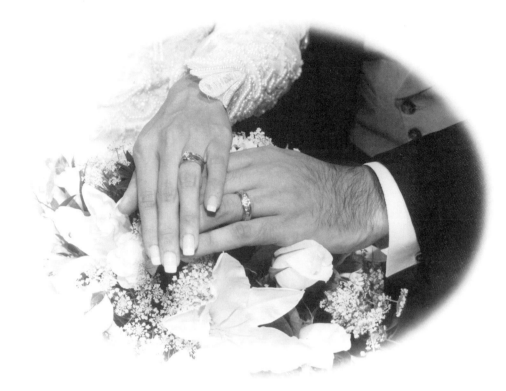

**6-22:** One of the last altar return shots we do is "the ring shot". We take photos of the actual exchanging of the rings, the couple admiring the rings, and a shot like the one above of the hands. This is a traditional shot and one that is expected by the bride.

Many brides hate to make a commitment to be readied earlier than anticipated; there are too many people and things that must be coordinated. They often fear that they will be rushed to much.

### It Violates Tradition

Taking photos ahead of time requires that the bride and groom see each other, in their wedding attire, before the ceremony. This violates tradition and causes most brides to reject doing altar returns ahead of time.

### Photos in this Chapter

All of the photographs in this chapter were taken with the following equipment and at the following exposure settings, unless otherwise noted:

Hasselblad camera; 60mm wide-angle lens; three portable flash units, one on-camera and two off-camera and slaved; exposure, f-8 at 1/60th second; metering for the ambient light was with a Minolta Auto 3F meter in incident-light mode. Flash meter reading was taken by using a Minolta Flash Meter.

# CHAPTER SEVEN

# AFTER THE ALTAR

Once the altar return phase is over, and before the cocktail hour and reception phase starts, typically two additional phases will occur: the romantic and the exit phase. Photographs taken during these phases help round out a bride's album while adding an element of warmth, romance, and sometimes, humor.

These two phases involve romance-type photos of the bride and groom, and photos of the bridal couple as they depart from the ceremony site, entering their limousine and leaving for their reception. Adequate photo coverage of each phase is extremely important since we, and most brides, usually consider images from both phases as must-get photos.

Unlike the exit phase, which usually only lasts a few minutes, the romantic phase can be a bit time consuming. This is because photos in the romantic phase are usually taken over a period of time and in more than one location. They usually start immediately after the altar return phase and continue, periodically, throughout the remainder of the day.

For example, a few of these photos could be taken in, or outside, the site where the ceremony took place.

Additional photos could be interspersed with the exit phase. More photos could be captured at a special location on the way to the reception, and some additional romantic photos could be taken of the bridal couple while at the reception.

Taken separately, neither the exit nor romantic phase is very complicated. The required equipment is minimal and you only need the bride and groom. However, because the two phases overlap each other, some confusion could develop.

## SEQUENCE OF EVENTS

The typical sequence of photographic events for both the exit and romantic phases are as follows:

1. Some romance photographs should be taken after all of the formal photographs at the altar have been concluded. These first shots will usually take place inside and/or outside the ceremony site.

2. Exit photographs of the couple leaving the ceremony site for their limousine and their reception.

3. Additional romantic photographs, from inside the limousine, then, a few minutes later, in a suitable,

## SEQUENCE OF EVENTS FOR THE EXIT AND ROMANTIC PHASES:

1. Some romance photos after the formal altar photos.

2. Exit photos of couple leaving ceremony site.

3. Additional romantic photos in limousine and/or other romantic spot.

4. Romantic photos throughout the reception.

meaningful environment en route to the reception area.

4. More romantic images taken periodically throughout the reception, both in and out of doors.

### The Sequence of Events Can Vary for the Exit Phase

Since all weddings are not the same, you may find a great variance with the exit phase. A bride may have planed two exits, one exit, or none at all. You might even find the exit phase being taken out of its typical sequential order.

#### Two Exits

Many weddings will have two exit scenarios. The first will usually occur after all of the photography at the ceremony site has concluded (after the altar returns and the first set of romantic photos have been taken). This first exit should entail photo coverage of the bridal couple as they prepare to leave for their reception.

The second exit phase will occur hours later, at the end of the reception, as the bridal couple prepare to leave for their honeymoon. (This second exit is also very important to photograph; it is discussed in Chapter 8.)

When there are two exits planned, romantic photos should be taken, typically between the two exit phases, however you might have to change the order of events.

For example, instead of following the typical sequence of events, where the exit phase comes second, you might find it necessary to have the exit phase first. In this case, and immediately after the altar return phase, you would photograph the bridal couple as they left the ceremony site, went through a rice-throwing event,

> "SINCE ALL WEDDINGS ARE NOT THE SAME, YOU MAY FIND A GREAT VARIANCE WITH THE EXIT PHASE."

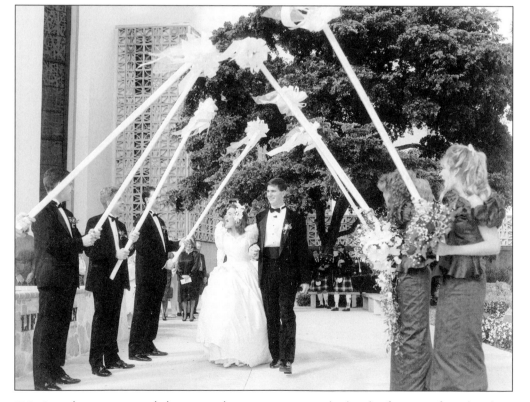

**7-1:** Once the ceremony and altar return phases are over, some brides plan for a very formal and structured exit scenario like the one above. Other brides plan for a more traditional exit, with the throwing of rice as the bridal couple make their way to the waiting limo. In either case, you must be prepared. A simple flash on-camera, with exposure balanced with daylight, will usually be all the equipment and technique you'll need to adequately cover the event.

entered their bridal limousine, and sipped some champagne while inside the car as they drove away. You, of course, would have had to instruct them in advance to only drive around the block. On their return, they would go back inside the building for the first round of romantic photographs.

Couples often want to take the first exit scenario out of its typical sequence for one major reason: people. If they were to follow the typical sequence and engage in the romantic photos first, and then the exit phase, there is often no one left at the ceremony site to observe them leaving for their reception, to throw rice or rose petals, and to wish them well. All of their guests, friends, and family will often have departed for the reception long before.

### One Exit

There will be some weddings at which there will only be one exit scene. This usually occurs when the ceremony and the reception are held at the same place, and most often occurs at the end of the reception. As before, you will be required to photograph this exit phase and capture all of your romantic photos well before this exit phase is upon you.

### No Exit

In a few cases, there may not be an exit phase planned at all. This generally happens when the ceremony and reception are held at the same place, such as at a hotel, and the bridal couple plan to stay overnight. In other situations, the bride may think of it as being too trivial or too showy. Whatever the case might be, if an exit phase has not been planned for, the experienced wedding photographer will create and stage at least one and record it.

### The Sequence of Events can Vary for the Romantic Phase

Just as the exit phase can vary, so can the romantic phase. It will help to understand the parts that comprise this phase

and what each part entails. Typically, this phase is composed of four separate but connected parts, unified by romance, the way a bride and groom look at each other, a meaningful environment, and the presence of both the bride and groom. These unifiers must be present for all of the parts if the photos from this phase are to be successful.

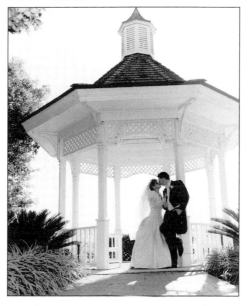

**7-2:** If time permits, take the bridal couple to a "special" area for some romantic shots. These will often be great photos for the bridal album and will sell.

For example, photograph the bride while she is seated elegantly in a very contemplative pose, amidst the lovely garden environment where she was married, during the beautiful last light of day, and you will often have a lovely photo. It will also be one that will usually sell and be a beautiful addition to her wedding album. However, you will not have created a romantic photo.

In order to have a photo of this type a romantic photo, the groom must be present somewhere in the photo composition. He might be positioned in the foreground as a primary element, in the background as a secondary element, or in the far distant background as a supporting element to the overall composition. He must be shown. This

"...IF AN EXIT PHASE HAS NOT BEEN PLANNED FOR, THE EXPERIENCED WEDDING PHOTOGRAPHER WILL CREATE AND STAGE AT LEAST ONE AND RECORD IT."

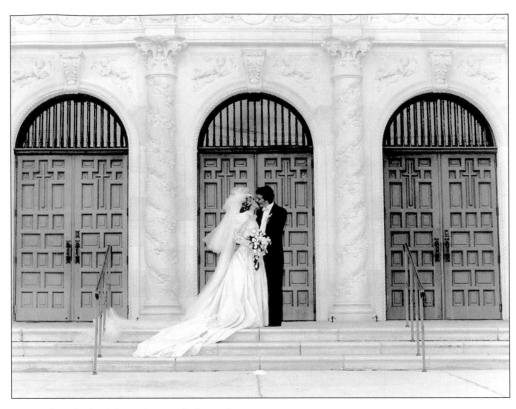

**7-4:** When you take romantic photos from inside the wedding site, most often you'll rely on ambient lighting. The exposure for the photo above was based primarily on the existing ambient light present in the room with flash as a secondary source. During the long exposure, a flash was fired; the flash was adjusted to emit power of one full f-stop of less light than the ambient. The flash acted only as a fill-light source.

**7-3:** Before the bridal couple actually leave the ceremony site, it's important to capture some romantic shots of them, incorporating some portion of the environment where they were married. The images should show the couple kissing, holding hands or looking tenderly into each other's eyes while the marital site acts as a secondary element.

also applies to photos of the groom. The bride must be somewhere in photo composition of him, otherwise it too will fail as a romantic photo.

### Part 1: Romantics at the Ceremony Site

Once the altar return phase is over, you will usually be given your first opportunity to take some romantic photos of the bridal couple. Plan to take photos both in and outside the ceremony site, if you have the time, if the bridal couple is cooperative, and if the weather permits.

Photos from these two distinctly different areas will have a great deal of appeal and meaning to the bridal couple. Pictorial variety, and thus, sales, will also increase. The following is a list of photos to take:

1. Take a shot of the bride seated on the steps of the altar, while the groom kneels by her side. He should be kissing her hand while she looks at him with a tender, loving expression.

2. Take a shot of a floral arrangement, candelabra or religious artifact. Have it be in sharp focus in the foreground of the composition, while the bridal couple stands close together in the background, looking lovingly at each other. Place the couple just beyond the depth of field so that they are slightly soft or out-of-focus.

3. The reverse of the above shot: the bridal couple in the foreground with the floral arrangement, candelabra or religious artifact in the background, and slightly out-of-focus.

4. Have the bridal couple stand in the middle of the aisle of the church or temple, facing each other, looking into each others eyes, then capture the shot. The altar or back of the ceremony site should act as the backdrop.

5. Take a shot of the bride and groom kissing, on the front steps of the church or

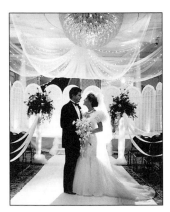

**7-5:** This photo was executed similarly to 7-4 with two notable exceptions: the flash-fill light source was adjusted to be two full f-stops of less light than the ambient light, while a back flash unit was adjusted to emit one full f-stop of more light than the ambient light.

temple. The front of the ceremony site should act as the backdrop.

6. Take a shot of the groom and bride, with her head nestled on his shoulder, standing on the front steps of the church or temple, facing the camera. The front of the ceremony site should act as the backdrop.

### Part 2: Romantics in the Limo

Once the couple has exited the ceremony site and entered their limo, there will be additional opportunities for romantic shots.

*Photos to take.* Take one or more of the following:

1. Once the bridal couple is inside their limo and before the car door is closed, have them both look out through the opening at you. Have them kiss and then capture the shot. Use a wide angle lens and flash on-camera; make certain that a portion of the car is in the photo composition. You want the viewer to be certain where the shot was taken.

2. Go inside the limo, in the front seat area, and take at least four different photos of the couple. Use flash on-camera and a wide angle lens for all the shots. The first photo should show the groom preparing to open a bottle of champagne. The second shot should show the groom pouring a drink for his bride into their special glasses, and the third as they toast each other's health and love. Take one final shot of the glasses raised while the couple kiss.

### Part 3: Romantics En Route to the Reception

Well before a bride's wedding day, you should check out the areas that lie between the ceremony site and the reception. Try to find a suitable or meaningful environmental site that might lend itself for romantic photos. A park, a waterfall, a small bridge spanning a brook and even the greens of a golf course could be likely spots. Then, on the day of the wedding,

and while the couple is en route to their reception, plan to stop at one of these sites and take a few more romantic photos.

For example, if you are photographing in a lovely park, you could have the couple walking, hand in hand, down a garden lane or through a field of flowers. If it is fall, you might photograph the couple as they playfully romp through a bed of leaves. The photo potentials are virtually endless if you have chosen the proper environment.

### Part 4: Romantics While at the Reception

If you are photographing a wedding reception at a hotel or country club, you should take some romantic photos both in and out of doors. However, since the bridal couple will not be at their reception to take photos, and to keep them from becoming bored, break this part down into smaller segments.

For example, take a few romantic shots (four to six shots) within the first hour of the couple's arrival at the reception site. Take a few more an hour or so later and some additional shots toward the reception's end.

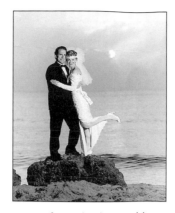

7-7: Before a bride's wedding day, check out the areas that lie between the ceremony site and reception. On the wedding day, stop at one of these sites and take a few more romantic photos like the one above.

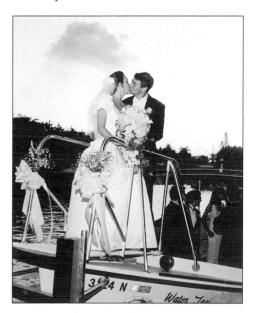

7-6: During the course of a reception, take the bridal couple aside and capture some additional romantic photos.

"WELL BEFORE A BRIDE'S WEDDING DAY, YOU SHOULD CHECK OUT THE AREAS THAT LIE BETWEEN THE CEREMONY SITE AND THE RECEPTION."

For the best photo results, attempt to incorporate props from the reception site. For example, if there is an attractive staircase, take advantage of it. Position the bridal couple on the stairs, have the groom take his bride tenderly into his arms, and take the shot.

For another shot, you could have the groom seat himself on a couch with the bride cuddled up next to him. Or, have the groom sit in an over-stuffed chair, with the bride seated on the arm of the chair, draped across the groom's shoulder. Any of these photos will have great appeal to the bridal couple and will usually sell.

For a cute, romantic-type, fun shot, you might try a piano shot. Have the groom seat himself at the keyboard of a baby grand piano and act as though he is playing. Close the lid of the piano, seat the bride on top, facing the groom, and have her lie on her side, in a stylish pose. Have her look with pride and love at the groom and take the shot.

This type of photo is easily made, using a simple flash on-camera and wide angle lens. Every time we have taken such a shot it has been well received and has sold.

## The Reasons for Variance

Although it's typical to have all four parts comprise a complete romantic phase, you might not have the opportunity to photograph them all, for all weddings. Three main reasons will control both the sequence and how many parts there will be. These are the time factor, the cooperation of the bridal couple, and the weather or time of day.

### The Time Factor

At the time of booking, it's standard procedure to ask a bride if she would like to have you photograph some romantics of her and the groom on the day of her wedding. Our experience has shown that most all brides profess to want romantic photos, provided not too much time is involved.

Some brides are initially very generous with the time factor and will grant us as much time as we need to accomplish the results. On the day of the actual wedding, however, many brides change their minds. Although they still want the romantic photos captured, most will not want to adhere to the times previously planned.

For example, initially a bride may be quick to agree to allow you 30 to 45 minutes to photograph parts 1,2, and 3 of the romantic phase. She might also agree to an additional 10 minutes for photographing each segment of part 4. However, if a bride feels rushed or harried, she might tell you that you only have about 20 minutes to photograph all of the romantics you intended to create.

This time reduction will shift the burden to you for picking and choosing which parts of the romantic phase are most important. It won't matter which sequence you follow, or which parts you eliminate, as long as you capture some romantics and offer as much pictorial and meaningful variety as possible.

### The Cooperation of the Bride and Groom

Even though a bride may have expressed a great desire to have romantic photos taken on the day of her wedding, the groom may not share those feelings. Some grooms think of this phase as being rather foolish; others might think that they will appear awkward or not masculine in romantic photos and hesitate to become involved.

Whatever the reasons are, some grooms may balk and refuse to become involved, while others may tolerate only a few romantic shots. It may take you some measure of time to persuade them to become involved to the extent that will allow you to take the romantic photos you need.

THREE MAIN REASONS FOR VARIANCE:

1. Time factor
2. Cooperation of the bridal couple
3. Weather conditions or time of day

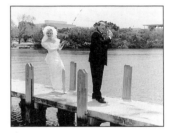

**7-8:** Here is an example of a cute, romantic-type fun shot. These type of photos are easy to set up, especially if you have some props available.

If the reception is held at a country club, and either the bride or groom is a golfer, you might try a different cute shot. Borrow a golf bag and some clubs from the pro shop, take the bridal couple onto the golf course and compose a photo around the bag and clubs. You could make the bag the focal and central point of the composition. First stand the bag between the couple. Then stand the groom on one side of the bag, with the bride on the other, and have them act as though they are both grabbing for the same club, while they kiss. A shot such as this will have great appeal and will sell.

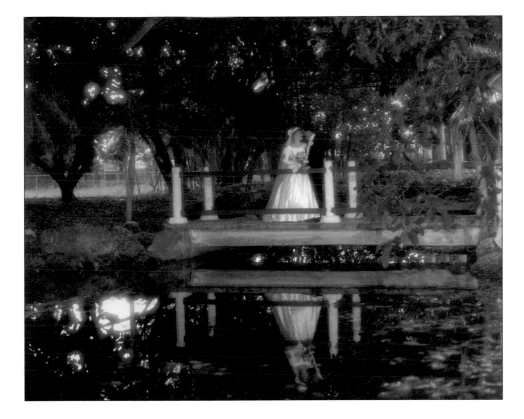

**Above:** Once you have left the ceremony site, and if time permits, plan to take the bridal couple to a "special" area for some romantic photos. A park, a grassy knoll, the beach, etc. can all be excellent locations for such photos.

**Right:** When you take romantic photos from inside the wedding site, most often you'll rely on ambient lighting. Exposure of this photo was based primarily on the existing ambient light present in the room with flash as a secondary source; exposure times were fairly lengthy, such as a 1/2 second. During long exposure, a flash was fired. The flash was adjusted to emit power of one full f-stop of less light than the ambient. The flash acted only as a fill-light source.
(*See Chapter Seven*)

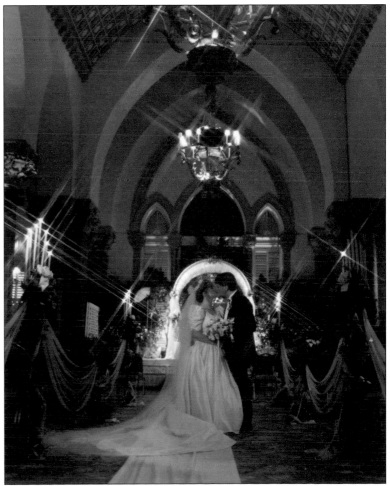

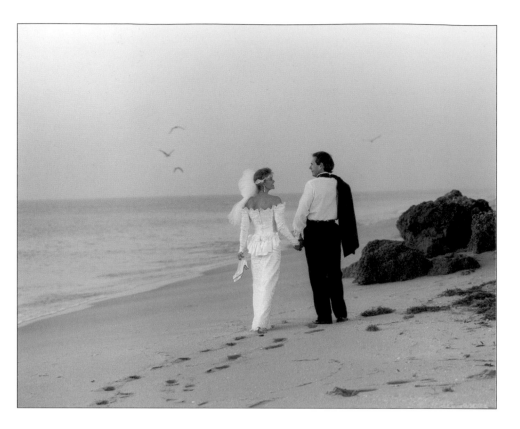

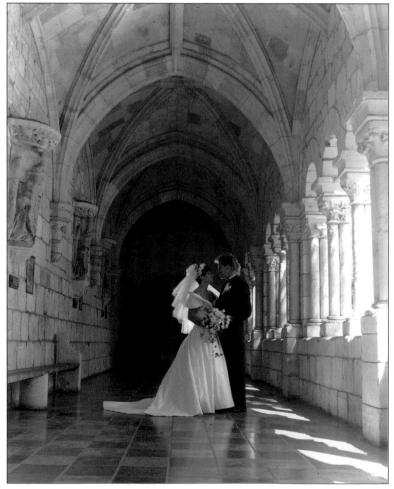

**Above and Left:** Keep in mind that not all romantic photos need to depict the bridal couple kissing. The key to romantic photos is to capture a feeling of togetherness, while at the same time offering the bridal couple pictorial variety. Since most all of our romantic photos are usually captured with a simple flash on-camera, paired with daylight to some extent, we are able to move from one photo situation to another with relative ease and dispatch. As a result, we can take a lot of different romantic photos in a short period of time.

These photos are good examples of romantic shots taken at a couple's "special" place.
(*See Chapter Seven*)

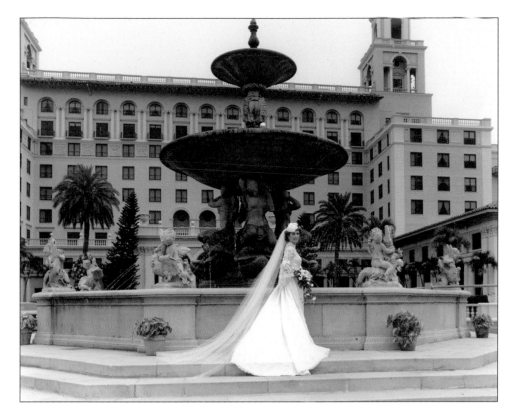

**Above:** At our studio, photos that depict an actual site of a wedding reception don't sell unless there is a very strong and essential element included: the presence of the bride, the bridal couple, or some important member of the bridal couple's family somewhere in the photo scene. When such an element is added to a reception site, the photo will likely sell.

**Right:** One of the first things that you should do upon arriving at a reception site is to photograph the room where the actual wedding reception is going to be held. Photograph the room just before the guests gather inside the room; before it has a chance to look cluttered and spoiled. Brides, and especially their families, expect to see such shots and want them for their wedding albums.

When photographing the room, use a wide angle lens, with a camera mounted onto a tripod, and slow shutter speeds with exposures by available light. For additional pictorial variety and a little added flair, like the one depicted, select one table to concentrate on and balance your ambient light film exposures with flash, while adding a star filter. (*See Chapter Eight*)

**Above:** During a high-energy, fast-paced wedding reception, there will be plenty of candid situations to photograph. And, if the party gets a little dull, don't hesitate to orchestrate a shot or two, or even three or more. Shots such as the one above are very simple to orchestrate, execute, and sell.

**Right:** An important event to adequately cover photographically is the cake-cutting event. To record it properly, there are several images that you should capture. Record the bridal couple standing at the cake table, photograph the groom feeding a piece of cake to his bride and vice-versa, and don't forget to get the photo of the couple as they kiss – with the cake in the photo composition. "Silly" photos usually become great sellers and are interesting and refreshing additions to a bride's album.
(*See Chapter Eight*)

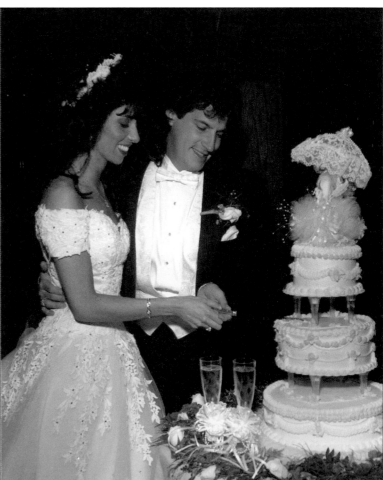

Once again the burden of choosing which parts of the romantic phase to capture will be put squarely onto your shoulders. You will have to be very selective and wisely choose which parts of the phase to capture and which order to follow.

One suggestion: When you come across a groom that is very negative about romantic photos, do not overdo photos from any one part of this phase. Take only photos that you think are absolutely necessary for the romantic phase.

Otherwise, the groom might become disgruntled and walk away from the photo session. Worse, his attitude will probably affect your rapport with him and this will affect the rest of the photos you have to capture.

### The Weather or Time of Day

Even though you might have planned to do romantic photos outdoors, this does not mean that weather nor time of day will cooperate.

If you had planned to do some romantics after the ceremony during the last light of day, but the wedding ran late, you might find yourself photographing in total darkness. If it's raining, or other poor weather conditions exist, you will usually find brides and grooms declining to do any outdoor photos for fear of ruining their wedding attire.

Whatever the reasons, you must be prepared to work around these conditions. With poor weather or bad light, you'll often be forced to eliminate all outdoor photos from this phase.

## PHOTOGRAPHING ROMANCE

In a previous chapter we discussed romantic photos of the bridal couple; photos taken in the studio and on location. Those differ from the ones presently under discussion. In order to be successful with this, you should know what's different about the romantic phase.

### What's Different

Compared with the romantic photos that you might take of the bridal couple before their wedding day, photos from the romantic phase differ in at least eight different ways: time; film; re-shoots; environment; variety; experimentation; equipment, and the capturing emotions.

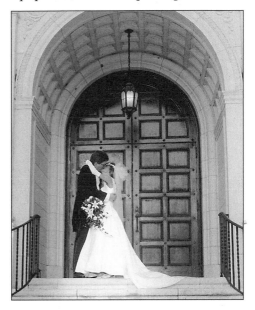

**7-9:** This romantic shot was taken outside of the wedding site. Remember to include much of the environment of the site as this will give the resulting photos an additional flair of interest for the bridal couple.

### Time

When you take romantic photos of the bridal couple before the wedding day, you will often have total control over the time factor. You will be making the decision as to how long it will take you to photograph the session, not the bride and groom. If you decide that it will take an hour or two to complete, then that is exactly what the bride and groom will have to abide by.

In contrast, when you engage in the romantic phase on the day of the wedding, you will be forced to work within the time structure that the bride has allotted you. Worse, you will have your shooting time interrupted.

> "ONE SUGGESTION: WHEN YOU COME ACROSS A GROOM THAT IS VERY NEGATIVE ABOUT ROMANTIC PHOTOS, DO NOT OVERDO PHOTOS FROM ANY ONE PART OF THIS PHASE."

For example, before the wedding, if you have decided to spend one full hour continuously engaging in romantic-type photos, then that is what will happen. During the wedding, you will constantly have your photography interrupted and spread out over a period of time. You will be photographing different parts, at different times, and you will be lucky to get 5 to 15 minutes worth of shooting accomplished during any one given part.

## Film

With photo sessions involving the bridal couple before the wedding day, you will have complete control over how much film you will shoot. It's not uncommon for us to shoot two to four rolls of 220 film during a casual photo session in the studio and on location. However, on the wedding day, you will often find a different situation. During the romantic phase, you will be very lucky if you have the opportunity to expose one to one and one half rolls of 220 film for all the parts that comprise the phase. You usually will not have the time to do more.

## Re-Shooting

Make every image you shoot count. They will all be important since your chances for a re-shoot will often be nil.

During romantic photos of the bridal couple before the wedding day, if you had an equipment failure or if your photo technique was poor, you will usually be able to persuade the couple to engage in a re-shoot.

However, if something goes wrong with your photography or equipment on the wedding day, during the romantic phase, you will frequently be stuck. The couple will be of a different frame of mind.

Their altar might not be available or even in existence since the flowers or other artifacts will not be the same or even present as they were on their day. The reception hall will usually not be at

your disposal, although the grounds of the reception site may be, if you can get permission to return.

As for the couple themselves, once the wedding day has come and gone, often the bride and groom will not want to dress in their formal attire in order to accommodate you for a re-shoot of mere romantic photos. They might feel it is not worth their time and trouble.

Consequently, you both may lose. You will suffer a loss of photo sales and possible future business referrals. They will lose having good and unique romantic photos for their wedding album.

## Environment

During the romantic phase, you will be photographing in environments selected by the bride. This is the opposite of romantic photos taken of the bridal couple before the wedding day, where you will usually be the sole person to choose where you will photograph.

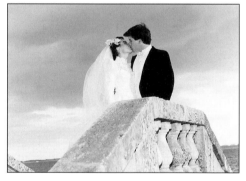

**7-10:** The bride will usually select the environments photographed on the day of the wedding. During these romantic photo sessions, the environment assumes a much greater role and significance.

During a location photo session before the wedding day, the environment will usually be only a secondary element in the overall photo compositions; it might become a mere supporting element. By contrast, during the romantic photo session on the wedding day, the environment assumes a much greater role and significance.

## "MAKE EVERY IMAGE YOU SHOOT COUNT."

Romantic photographs taken in and outside the ceremony site will have a very personal meaning and importance to the couple. The same is true with photos taken when they are in their limousine and while they are at the reception site. Consequently, it would not be unusual to sell more of these images than those taken from the casual photo session of the couple weeks before.

### Variety

You will usually have much more variety to offer a bride from the romantic phase than during other romantic photo sessions taken of the couple before their wedding day. From a business viewpoint, to take four photographs of the bride and groom kissing at the altar will probably result in their buying only one of the images. However, being able to take four photographs of them kissing at different places (the altar, in their limousine, beside a waterfall, and at their reception) could well mean selling all four.

### Experimentation

An actual wedding is absolutely no time to try new and different photo techniques or to experiment with new pieces of equipment. It is too risky, too much is at stake, and you frequently will not have the time.

By contrast, and during any other photo session involving the bridal couple before the wedding day, a wedding photographer may very well experiment with new and different poses, lighting, film or equipment. However, the prudent photographer will only experiment if he has first photographically captured all of the required photos that he had to take.

Secondly, he won't experiment until he has first cautioned the bridal couple that he is about to try something new and the photo results might be questionable or less than desirable. This procedure and warning gives him a viable excuse, just in case something goes awry.

### Equipment

Since you will spending a limited amount of time photographing each part of the romantic phase and moving about quite a bit, do not overload yourself with a lot of equipment. Usually all you will have time for and need are the following: a camera; a slightly wide-angle lens; a normal or portrait lens; a tripod; a cable release; an incident-flash light exposure meter; one on-camera flash; one off-camera flash that is slaved and on a light stand, and a soft-focus or diffusion filter.

When you do photography of the bridal couple before the day of their wedding, equipment choices can be very different. Whether it be in your studio or on location, you will often have the time and luxury to take and use whatever pieces of equipment you think will be needed.

### Capturing Emotions

Although the wise photographer will always attempt to capture a bridal couple's emotion on film when taking romantic photos before the wedding day, during the romantic phase it is a necessity! It is also easier to capture a bride and groom's emotions during the romantic phase than before their wedding.

**7-11:** Capturing moments of quiet interactions that reflect love and tenderness between the bridal couple is the key to excellent romantic shots. Be careful not to disturb the moment or feeling that the couple now have for each other.

There is an interesting phenomenon which happens to most bridal couples. The act of going through a ceremonial phase usually is enough to cause the

"AN ACTUAL WEDDING IS ABSOLUTELY NO TIME TO TRY NEW AND DIFFERENT PHOTO TECHNIQUES OR TO EXPERIMENT WITH NEW PIECES OF EQUIPMENT."

bride and groom to perceive each other somewhat differently than they had just before their ceremony, even if the couple had been living together for a period of time before the wedding day.

There often will be stronger emotions being exhibited after the ceremony. This will make any photographer's job easier. However, there are a few precautions you should take.

Do not rush things during the romantic phase, but work quickly and methodically. Be careful not to disturb the moment or feeling that the couple now have for each other. If you scurry about, they are likely to sense this, change their mood, and frustrate the effects you are after.

The first part of the romantic phase, after the wedding ceremony is over, is usually an ideal down time for the couple. It will be a chance for them to relax, making it easier for the couple to slip into the tender and loving mood you seek from them.

The bridal couple will have just been told by a wedding official that their lives, as individuals, are over; that they are one entity and united; that they are married forever.

These words often cause them to become more thoughtful, emotional, and sensitive than they had previously exhibited to you.

*Capture this unique moment in their lives with sensitivity; look for interactions that are quiet, yet reflect love and tenderness. Photograph emotions, not just people.*

## PHOTOGRAPHING THE EXIT

Whether the exit of the couple from the ceremony site is faked or is an actual departure, the wedding photographer must be assertive in directing the couple in order to record it well. And, to direct it well, he or she must know exactly what to photograph and what equipment is needed.

**7-12:** No matter what conveyance the bridal couple may choose to take them from the wedding site (car, boat, carriage, and so on), make certain to capture shots of them out and inside the vehicle. Such images will have particular appeal to the bridal couple and will sell.

### What to Photograph

Since it will only take a bridal couple three to five minutes to complete an exit scenario, there will not be a lot of time to think about what it is that you should do. All of your photos should be well planned and simple, keeping in mind that you will have little opportunity to orchestrate much of anything. There usually will be no time for frosting photographs, nor opportunities for a re-shoot.

For the most part, you will know you have done your job well if you are able to photograph at least the following situations, all of which are considered by us to be must-get photos.

1. The bridal couple standing in front of the ceremony site.

2. The bride and groom rushing or running to their bridal conveyance

**"DO NOT RUSH THINGS DURING THE ROMANTIC PHASE, BUT WORK QUICKLY AND METHODICALLY."**

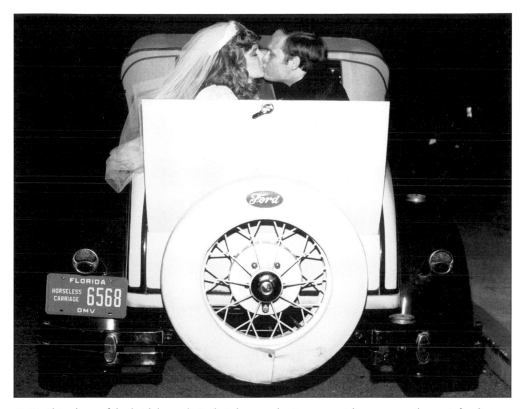

**7-13:** This photo of the bridal couple in their buggy, sharing a special moment as they exit for their reception, is a great shot and will probably sell. Make sure to capture these moments as they hold special meaning for the couple.

(be it a limousine, horse and buggy, yacht, or something else) amidst a barrage of rice or rose petals thrown by their guests.

3. The bride and groom standing next to their bridal conveyance, with the door open, preparing to enter.

4. The bride and groom actually entering the bridal conveyance.

5. A shot of the bridal couple waving to you as they drive off in the bridal conveyance for their reception.

If you do have the opportunity to improvise a variation of one of these five photo situations, do it, but be mindful of the time factor. Spending additional time with the exit phase could cost you time allotted for one or more parts of the romantic phase.

### Equipment Needed

Because of the short time available for the exit phase, it's advisable to limit equipment. We would suggest one camera with an attached flash. A standard lens could work, but a slight wide-angle lens will ensure more adequate inclusion of the environment.

### Photos in this Chapter

Unless otherwise indicated, all of the photos contained in this chapter were taken with the following equipment and at the following exposures: Hasselblad camera; standard (80mm) or slightly wide-angle (60mm) lens; one portable on-camera flash and one off-camera flash on a light stand and slaved; Minolta Auto 3F meter, used in incident-light mode.

When only the on-camera flash was used, it was adjusted to emit f-8 light; camera set at f-5.6. When both the on-camera and off-camera flashes were used, the off-camera unit was adjusted to emit f-8.0 light; the on-camera flash to emit f-5.6 light, and the camera set at f-5.6.

**MUST-GET PHOTOS OF THE EXIT PHASE:**

1. Bridal couple standing in front of ceremony site

2. Bridal couple running to conveyance

3. Bridal couple standing next to conveyance

4. Bridal couple entering conveyance

5. Bridal couple waving as they leave for reception in the conveyance

**"BECAUSE OF THE SHORT TIME AVAILABLE FOR THE EXIT PHASE, IT'S ADVISABLE TO LIMIT EQUIPMENT."**

## CHAPTER EIGHT

# THE COCKTAIL HOUR AND RECEPTION

The last two phases that comprise an entire wedding event, and that typically occur at most weddings, are the cocktail hour and the reception phases. Photographing a typical cocktail hour phase is simple and easy to do. Often, there will be very little action, few to no activities, and absolutely no major events that must be captured.

By contrast, a typical reception usually has a great deal of action and a lot of activities or events to photograph. Even the people attending a reception phase sometimes act differently than they had acted during the cocktail hour.

## THE OVERVIEW

The cocktail hour phase will usually occur after the ceremony and before the reception. It, as its name implies, will last about one hour. Its primary purpose is to afford the guests some free time to mix and to relax after the ceremony.

Secondarily, its purpose is to afford the bridal couple and party a chance to relax and compose themselves prior to the start of the reception.

It is customary to have both the cocktail hour and reception at the same location. It will also not be difficult to tell when one phase has ended and the other one started. You will usually be given some strong clues.

For example, there might be some type of announcement made to all concerned that the cocktail hour is ending and the reception is about to start. Or, you will see all of the guests leaving the cocktail area for the reception hall.

The cocktail phase will offer liquid refreshment along with some form of snack, or light buffet. Things will usually be much different at a reception.

Customarily there will be a more elaborate meal, a three to a seven course dinner if it's an evening affair, a full lunch if it's an early affair, or an expanded buffet table. You will often find the music more elaborate than during the cocktail hour and sometimes there will be other forms of entertainment as well: professional dancers; a magician; a professional singer, or the like. Although not all weddings include a cocktail hour, almost all of them do have a reception. And, as all weddings differ, so will the receptions.

Some receptions will be exciting, some less than exuberant, and a few downright dull. It's a lot of fun and much easier

For example, during the cocktail hour phase, you may find many of the guests acting very prim, proper and sedate, hesitating to pose for mere candid photos. More often than not, this condition has prevailed at many of the weddings that we have photographed, especially at the more elaborate and posh affairs.

However, during the reception phase, we have often found these same people acting quite differently. Everyone will be having fun, with a few of them even throwing caution to the wind; most will not hesitate to pose for whatever photos you need to take.

to photograph an exciting reception than one that is dull and boring. However, exciting or dull, the trained photographer must get all of the required images.

## THE COCKTAIL HOUR

At the time of booking a bride's wedding, ask the bride if she plans on having a cocktail hour. If none is planned, there will be no need to worry about staging any part of it. But, if one is planned, there are two things to watch for: attendance and promises!

### Attendance

At the time of booking, ask the bride if she and the groom plan to attend their own cocktail hour phase.

If they do not, this will be great news for you. Their lack of attendance will almost ensure that you will have plenty of time for photos. You will have at least one whole hour between the time the ceremony ends and the reception starts to do all of the required photos: altar returns, romantics, exit scenario, and at least a part of the cocktail hour phase.

If they do plan to attend, then you know that you will have to work very quickly and might have to eliminate some of the photos that you planned to take after the altar returns.

### Promises

At the time you book a bride's wedding, avoid promising her that you will photographically cover any part of the cocktail hour phase. Time will not permit you to be in two places at once. If you have not promised her that you will cover this phase, she will not expect to see any photos from it. When the wedding day arrives, whatever photos you were able to capture of the cocktail hour will thus be a bonus to her.

In actual practice, the wedding photographer will be busy with other situations during most of the cocktail hour phase. Once the photos from these phases are taken, whatever time is left will usually be spent photographing the end of the cocktail hour phase. However, things can be different if you plan on having an assistant help you. Once the altar return phase has concluded, you could then send your assistant on to the reception location to photograph the cocktail hour phase. He or she would be in on the event almost from its inception.

If you do not have an assistant and the bridal couple plan to attend the phase, you will be arriving at the cocktail site whenever they do. Consequently, you will be able to capture at least some part of the cocktail phase with few problems.

**8-1:** Often there will be an ice sculpture on display in the room where the cocktail hour is being held. The sculpture may be a swan, a heart, the bride and groom's initials, and so on. By positioning the flash obliquely, more detail is rendered in the ice sculpture.

### Value of the Cocktail Hour Phase

In our experience, brides rarely buy photographs of this phase. There are just too many other images from before and after this event that are more important and more representative of the wedding day than this phase.

Even if you have the opportunity to photograph the cocktail hour, from beginning to end, we recommend that you do not spend much time or film recording it. Ten minutes with a single on-camera flash will generally suffice. Use any remaining time to ready yourself for the reception.

### What to Shoot

There are no must-get shots in the cocktail-hour phase. However, if you have the time and opportunity, the following frosting shots will help to round out any bridal album. Most can be easily made with a simple flash on-camera and a standard lens.

1. The Ice Sculpture: If there is an ice sculpture, it will generally be carved in the shape of the bridal couples initials or some other symbol that has some special meaning to them.

2. A General View: A general, wide-angle view of the entire room in which the cocktail hour is held. A timed exposure, with camera mounted onto a tripod, is often ideal.

3. Bridal Couple and Guests: Take a few photographs of selected guests with the bridal couple or the parents and grandparents of the couple.

4. The Buffet Table: Take a general, wide-angle view of the buffet table, preferably before the guests have had an opportunity to partake of the food. The food will look and present better photographically.

## THE RECEPTION PHASE

How long will a reception last? It will depend! Although religious considerations or the elaborateness of the reception can play a part in the time factor, usually it will be another criteria: action! Usually, the less the action, activities, and fun, the shorter the reception will be; the more action, activities, and fun, the longer the reception will be. A short reception will usually last about two to three hours. A

**SHOTS OF THE COCKTAIL-HOUR PHASE:**

1. Ice Sculpture
2. A general view
3. Bridal couple and guests
4. The buffet table

8-2 In this shot, "the boys" toast the groom. There are no must-get shots of cocktail hour, but be on the lookout for candid opportunities such as this one.

lengthy reception will usually last six or more hours. However, the typical reception will last anywhere from four to five hours.

## The Photographer's Role

Any wedding reception must be structured. If it isn't, it will be over soon after it starts. The guests will become bored by the lack of festivities and organization and they will leave.

The bride and groom will look around for guidance and that guidance should come from you. Primarily, you want them to rely upon you. Not only will you be helping them through unsure moments, but you will also be setting up the photographic situations you need to record.

If the reception has been well structured and the activities come about as expected, a photographer's job is made easier. He or she might have to make an adjustment or two, so that any given activity is photographically presented at its best; however, apart from this, the photographer will simply record what is happening. However, our experience has shown that this state of affairs is the exception and not the rule. If nothing is planned, if some activities are happening but are not structured well, or if there is structure, but it's not in a manner that is conducive for good photos, the photographer will have to take charge.

The experienced photographer will make things happen by improvising and photographing activities and situations that are representative of a typical reception and that simulate a fun atmosphere. Otherwise, the only thing you will have to show is one exposed roll of boring images with people eating and drinking.

In addition, to ensure that you are able to adequately photograph all of the situations you should capture during a typical reception, we offer two areas of caution: protect your equipment and do not rely on the wedding consultant, caterer, or bandleader.

## Protect Your Equipment

During the course of any wedding, you and your equipment will be mostly in the company of strangers. Whether the reception is modest or elaborate, the possibility of theft of, or tampering with, your equipment is great.

Even the best photographers can not photograph a reception without the basic equipment. Therefore, good practice dictates that you keep enough equipment and film on or near your person during the course of an entire reception. Keep at least one camera, with a standard or wide-angle lens, an attached on-camera flash and enough film that would allow you to finish an entire reception, if you had to, on hand.

It will be no consolation to the bride or her family to hear that you can not finish your photos because some major piece of your equipment was stolen or damaged. You and you alone will be responsible for its care and protection during the course of an entire wedding.

## The Wedding Consultant

Sometimes, especially for the more elaborate affairs, a bride will hire a special wedding consultant. A consultant's sole job is to coordinate all things associated with the wedding: the flowers; the food; the decorations; the music, and the like. One would think that having such a person present during a wedding would make a photographer's job easier. It won't. Our experience has shown that having a wedding consultant, present at a wedding is more hindrance than help. Unless you personally know the wedding consultant and are familiar with his or her work, never rely on any such person to be of any assistance or to orchestrate any of your photos.

If a wedding consultant is present, be polite, offer your cooperation and assistance, then do what you have to do. Don't wait for him or her to help you, and

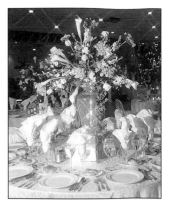

**8-3:** One of the first shots you should get at the reception is a photo recording the site itself. The photo above shows a table at the reception. It was taken before the guests arrived. A star filter was used to add interest to the shot.

*"OUR EXPERIENCE HAS SHOWN THAT HAVING A WEDDING CONSULTANT PRESENT AT A WEDDING IS MORE HINDRANCE THAN HELP."*

above all, do not let the consultant orchestrate your photography. On most occasions, the consultant will not have the faintest idea of what will look good photographically, or how to arrange for the photographs you need to capture. Use diplomacy to work around any problems you may encounter. If the problem becomes unbearable, take the matter up with the bride or her family.

## The Wedding Caterer

At all the receptions we have attended where food was served, there has been a caterer. Most of the time the caterer will present no problems for you; however, there are two exceptions: the bridal cake, and the table shots.

### Situation #1: The Bridal Cake

When you first arrive at the site of the reception, one of the first photographs you should take is of the bridal cake. The reason we always do the cake first is insurance!

When a bridal cake is first put out into the reception area, which is usually one to two hours before the cake-cutting ceremony, it looks its best and will photograph well. Between the time it is displayed and it's cut, a number of things could happen to the cake, including collapsing. We have attended a number of receptions where large, ornate, freshly made cakes have collapsed and sunken almost into oblivion due to their sheer size and weight.

Another reason that we photograph the bridal cake early is we can control our lighting and the placement of the cake.

*Control:* Ideally the cake should be lit with dimensional lighting: an on-camera flash to act as the fill light, with one, off-camera light acting as the main light. This type of lighting will give the cake much more dimension and character. During the course of an actual cake-cutting ceremony, you will usually not have the time nor the space to use dimensional lighting.

Most of your photos will be taken with just flash on-camera.

*Placement:* Here is the first of three problems with the caterer.

1. When the cake is brought into the reception area, the caterer will usually have the cake placed on a large table, off in a side area of the reception room, and out of harms way. By placing the cake in such an out-of-the-way area, it is implied: Look, but don't touch.

In addition, the area where the cake will typically be placed will be a poor one, photographically speaking. The background will often be less than desirable: clutter; dirty dishes; and the like. This type of background will not lend itself well. Therefore, you have two choices: take photos of the cake as it stands, working around the bad background if you can, or move the cake table to a better location, where the background is more suitable.

We would absolutely not take it upon ourselves to move any cake table. We always seek the help of the caterer; we ask him or her (or the employees) to move it to a more suitable location (generally, a few feet, one way or the other, will do it). If the cake is a small one, with not too many tiers, they will usually agree and move the cake table to a spot we choose.

However, if the cake is large and ornate, with a number of tiers, most of the time they will refuse. In such a case, we do not argue. We leave the cake where it is and work around the condition, choosing the best camera angle we can.

2. The second problem with the cake comes about during the cake-cutting ceremony.

Ideally, at the time the bridal couple is to cut the cake, the cake table should be moved from its sideline position to the center of the dance floor, which will allow all of the guests to watch the cake ceremony with relative ease.

However, our experience has shown that if the cake is large, with a number of

If a consultant advises you to take a certain photograph, and you do, and the results are poor, you will be the one blamed. If the results are good, the praise will go to the consultant. Your subjects may well wonder how much better your other photographs might have been had you had the consultant's help for all of your photos. If the consultant's advice was sound, store it in your memory and use it for your next affair, when it will be your idea.

**"WHEN YOU FIRST ARRIVE AT THE SITE OF THE RECEPTION, ONE OF THE FIRST PHOTOGRAPHS YOU SHOULD TAKE IS OF THE BRIDAL CAKE.."**

tiers, the caterer will usually object to having the cake moved anywhere, fearful that the cake will tumble or break apart. In this case, we have little choice. We try to work around the situation, choosing the best camera angle that we can.

Even on the dance floor, the cake might be placed in a spot that is not good for photos. You will often find that the background behind the bridal couple will be less than great: waiters standing idly by; dirty dishes; an exit sign, and the like.

Ideally, the cake table should be positioned so that a photo composition includes a portion of the cake in the foreground, a clear view of the bridal couple in the mid-ground, and a background showing guests or parents of the couple, looking on.

Obviously, if the cake is positioned poorly for photos, it should be moved. We would first ask the caterer. If he refused, we would tell the couple what we wanted to do and enlist their aid in moving the table. If worst comes to worst, and the table can not be positioned to incorporate a good background, then choose your camera angles carefully. Avoid having a blank wall or clutter in the background. If you have the time, you might even try to orchestrate the shot; place some of the guests or family members behind the couple. This would be ideal.

3. The third problem will also come about during the cake-cutting ceremony. The caterer may wish to assist with the cutting of the cake. Ask him to move off to one side, just for a moment, so that you can take your shots. If the caterer refuses your request, you will be forced to work in front of or around him.

### Situation #2: Table Shots

Our experience has again shown that most brides want photos taken of all of the guests who attend their receptions. If the reception you are attending features a sit-down meal, capturing such photos is usually simple.

During the reception, the band will take a number of breaks. During a band-break, it is usual to serve a course of food. This is a good time to take photos of guests since they will usually be seated at their tables, waiting to be served. Photographing a group of guests seated or standing next to their tables is called a table shot.

8-4: Most often, you'll be engaged in candid photography when photographing a wedding reception. Candids usually involve flash on-camera for lighting and photos that fall into one of three categories: posed, prompted, or photojournalistic photos. This photo is a posed table shot candid.

If the reception you are doing is large, with 150 to 200 people or more, it will not be uncommon to have 15 to 20 table shots to take. Usually band-breaks are 15 to 20 minutes long between minor food courses, and about 30 minutes long when the entree is served. This is not a lot of time to do table shots, especially if there are not a lot of courses to be served.

*Table shots are usually broken up:* A few table shots are taken during the first band-break, some more are taken during the second band-break, and so on, until all the table shots have been photographed. Obviously, you will have to work quickly to get all of the table shots concluded before the main entree is served. If you wait too long, two things happen: the tables will be messy and not photograph well, and the guests may no longer be at their tables. They may be dancing, visiting people at other tables or

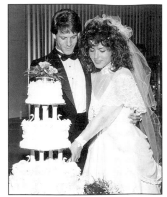

8-5: During the cake-cutting ceremony, try to position the cake table so that a photo composition includes the cake, the bridal couple, and if possible, guests looking on. The photo above is a good close-up shot of the cake and bridal couple during the cake-cutting. Even though it doesn't include any guests looking on, it's a good shot and will be a good photo for the bridal album.

"OBVIOUSLY, YOU WILL HAVE TO WORK QUICKLY TO GET ALL OF THE TABLE SHOTS CONCLUDED BEFORE THE MAIN ENTREE IS SERVED."

they might even have left the reception for the evening. Time will be working against you, as well as the caterer.

At large receptions, a caterer will typically be under-staffed in order to save money. Consequently, a limited number will have to serve a large group in a short period of time. Wedding photographers are usually perceived as being a threat to their time schedule if table shots are being taken during the serving of any food course.

Caterers are so adamant about this that many will not hesitate to speak out. At one reception, while we were photographing a table shot, the caterer approached and addressed the guests: "I will not have my people work under these conditions. I refuse to have anything served at this table so long as the photographer is interfering with my helpers." When this happens to you, we advise you to attempt to placate the caterer. Tell him that you will only be a minute and that you will not interfere. If that fails, ignore him. Take the shots that you have been commanded to take by the bride. However, if the bride tells you to stop, then you must. You will then be off the proverbial hook.

### The Bandleader

At most receptions, music will be provided. It may be furnished by a disk jockey, a band, an orchestra, or various other combinations. In any case, there will be someone in charge (the bandleader) who will usually have the additional job of controlling when certain events are to happen: bride and groom's first dance; the bride's dance with her father; the cake-cutting, and so on.

Soon after your arrival at the reception site, approach the bandleader, introduce yourself, and ask him to keep you informed, in advance, of all the events. But do not rely on his fulfilling your request, unless he has worked dependably with you before.

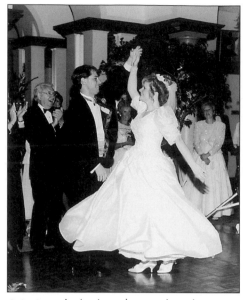

**8-6:** Once the bride and groom have been announced into the reception room, typically they will be invited to start their first dance. It is important you capture photos from the first dance. Next, the parents of the bridal couple will be invited to dance and they will be followed by all the members of the bridal party.

If the bandleader forgets to have the first dance for the bridal couple, or if he forgets the bridal bouquet toss, you must arrange it. If, during the removal of the bride's garter, he places the chair at a bad angle, you must move it. Also, if the bandleader announces some major event but forgets to tell you in advance and you are unavailable or unprepared, it will be your fault for not getting the photographs, not his.

## SEQUENCE OF EVENTS

The list below comprises the typical events that occur at most receptions, as well as their order. Because the events can vary, the thing to remember is that all of the events should happen, and in this order, unless the bride, or some other party in charge, has specifically informed you otherwise.

The following events will not happen immediately after each other. There will be band-breaks in between a number of the events. For example, there might be a

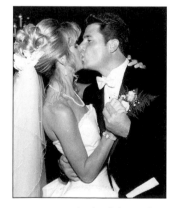

**8-7:** During the bridal couple's first dance, watch for the couple's kiss. This is usually a great shot to get and one that should be captured.

band-break between event number 1 and 2, or the first break may not occur until event number 3 has finished.

How many band-breaks there will be and when they occur will vary with each wedding you do. A lot will depend on the instructions that the bandleader has received from the bride, her family, the caterer, or wedding consultant.

1. Entrance. Usually the entire bridal party and the parents of the bridal couple will be announced by the bandleader as each couple walks into the reception room area. The bride and groom will always be announced last.

2. The bride and groom will then have their first dance.

3. The bridal party will then be invited to dance by the bandleader.

4. The parents of the bridal couple are next to be invited to dance.

Immediately following this, all of the guests will be invited to dance.

5. Bride will dance with her father-in-law and then with her father.

6. Groom will dance with his mother-in-law and then with his mother.

7. There will be a prayer or blessing which will usually be given from the dance floor by a priest, rabbi, minister, or family member.

8. Toast to the bridal couple.

9. Main meal.

10. Cake-cutting ceremony.

11. Bouquet toss by the bride.

12. Groom's removal of the bride's garter.

13. Garter toss by the groom.

14. Garter placed on the woman who caught the bouquet, by the man who caught the garter.

## SEQUENCE OF EVENTS FOR THE RECEPTION PHASE:

1. Entrance of the bridal party into the reception room
2. Bride and groom will have first dance
3. Bridal party will be invited to dance
4. Parents of the bridal couple will be invited to dance
5. Bride will dance with her father-in-law and then with her father
6. Groom will dance with his mother-in-law and then with his mother
7. Prayer or blessing
8. Toast to the bridal couple
9. Main meal
10. Cake-cutting ceremony
11. Bouquet toss by the bride
12. Groom's removal of the bride's garter
13. Garter toss by the groom
14. Garter placed on woman who caught bouquet by the man who caught the garter
15. Bridal couple leaves reception for honeymoon

**8-8:** The toast to the bridal couple is another must-get photo situation. Ideally, the bridal couple should be up on the dance floor, standing next to the person giving the toast. Once the toast has concluded, have all three people stand next to each other with their glasses raised. In the event that you can not get the bridal couple to go onto the dance floor during the giving of the toast, then photograph the toast-person as he or she gives the toast, then go over to the bridal couple and "stage" some action as those they are acknowledging are being toasted.

15. Bridal couple leaves the reception for the honeymoon.

## MUST-GET PHOTOGRAPHS OF THE RECEPTION

There are certain photographs that must be taken for adequate coverage of the reception phase. We have listed the minimum here. In addition, we have included some tips for the photos. Use these tips as a guide to follow when composing your photos

1. Entrance of the bridal couple into the reception room.

*Tip:* This should be a full-length shot. Show the bride's entire gown; show guests applauding and cheering in the background of your photo composition.

2. Bridal couple's first dance.

*Tip:* Take at least three shots of the bride and groom dancing: one head-and-shoulder view; one three-quarter length view; one full length view. Sometime during the dance the couple will kiss. Capture this shot too!

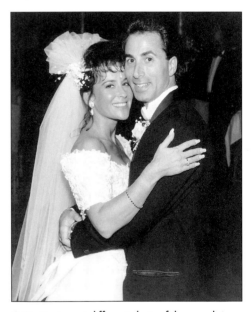

8-9 : Try to get different shots of the couple's first dance. Take at least three shots of the bride and groom dancing.

3. Bride dancing with her father.

*Tip:* Take at least three shots: one head-and-shoulder view; one three-quarter

length view; one full length view. Make certain that at least one of the photos shows the bride and father hugging.

4. Groom dancing with his mother.

*Tip:* Take the same type and number of shots for this situation as you did for the bride when she was dancing with her father.

5. Toast to the bride and groom by the best man.

*Tip:* Ideally, all three people should be on the dance floor and standing next to each other. Take at least one full-length view of all three people when the speech is first started. Take a second shot but this time, only a three-quarter view. Finally, take a three-quarter shot as the best man toasts the couple.

Make certain that all three have wine glasses in their hands and that the glasses are raised; you want the photo to clearly show a toast is being made. Also make certain that their arms and glasses do not block their faces from the camera's view when you take your shots.

6. The bridal cake by itself.

*Tip:* Never shoot down on a cake. A high camera angle will tend to make most any cake look smaller in resulting photos. Ideally you should shoot from a low camera angle, or, at least, from eye-level. Keep backgrounds uncluttered; use dimensional lighting if you can.

7. Bridal couple cutting the cake.

*Tip:* Do mostly three-quarter length views. Place a portion of the bridal cake in the foreground, off to one side of the photo composition in at least one of the shots. Have the bridal couple prominently shown in the center of the images.

The groom should be on the bride's far side, and slightly in front of her so that you can see both of their faces from your camera angle. If the bride is unusually heavy, reverse this order; have the groom stand closer to your camera.

This will help minimize the bride's weight and size. Take at least two shots of the couple cutting the cake, the bride

## MUST-GET PHOTOS OF THE RECEPTION PHASE:

1. Entrance of the bridal couple into the reception room
2. Bridal couple's first dance
3. Bride dancing with her father
4. Groom dancing with his mother
5. Toast to the bride and groom by best man
6. The bridal cake
7. Bridal couple cutting the cake
8. Table shots of selected tables
9. Bouquet toss by the bride
10. Brides garter being removed by groom
11. Garter toss by groom
12. Replacing the garter
13. The exit

## Shooter's Log: The Customer is Always Right!

One of our clients has five daughters. We have photographed the weddings for four of these women, and a few months from now, we will photograph the fifth's. The family is very religious.

As a result, all of their receptions have no smoking, no music, no dancing, no alcoholic drinking, no garter removal, no bouquet toss, no entertainment; almost nothing happening. However, they like it this way and refuse to do anything differently. Usually 10 or so family members will each give a 10 to 15 minute religion-oriented speech, followed by a very modest cake-cutting ceremony. In between speeches, and after the cake-cutting event, the guests merely mill about, discussing various and sundry topics of the day.

Under these circumstances, we have few choices. We photograph what happens and we take a lot of shots of the bridal couple with almost everyone at the site. This is what the customers want, so this is what we give them.

feeding a piece of cake to the groom, and the groom feeding a piece to the bride. Have the couple kiss and capture the shot. Be prepared for some spontaneous action. The groom may well shove a piece of cake into his bride's face and vice versa. These images will sell well.

8. Table shots of selected tables.

*Tip:* Take some shots of the bridal table and some additional ones of the parent's table. Make certain that all persons are present when you take the photos, other-wise the photos will not sell.

9. Bouquet toss by the bride.

*Tip:* Have the bride stand on the dance floor with the single women lined-up behind her. Stand in front of the bride, on the side opposite her throwing arm, so that her arm will not block her face from the camera.

Make certain that you compose the shot to show the bride (in a three-quarter view) in the foreground with the single women lined-up in the background. Just

as the bouquet is about to leave her hand, take your shot.

8-10: Toward the end of any given reception there will be some additional events taking place. One such event is the bouquet toss. Capture a shot of the bride as the bouquet just leaves her finger tips. Then orchestrate a shot of the bride going over to the girl who just caught the flowers and have the bride pose for a photo with her.

Ideally, you should have an assistant focusing on the single women. The assistant should be prepared to photograph the one who catches the bouquet. If you have no assistant, after the toss have the bride walk over to the woman who caught the bouquet and give her a hug. Even though this is a frosting photo, you should photograph this action.

10. Brides garter being removed by the groom.

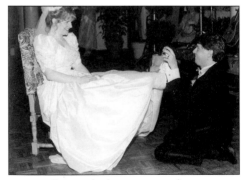

8-11: Following the bouquet toss, the groom will be expected to remove his wife's garter from her leg. Make sure you shoot from a low camera angle. Once the bride's garter has been removed, you should orchestrate one more shot – the bridal couple kissing.

*Tip:* In advance of this event, ask the bride which leg she is wearing her garter on. You should always be on that side when you photograph this event to get a better shot of the garter being removed. Use a standard or wide-angle lens to always include both the bride and groom in full-length views.

Further, you will usually find it preferable to shoot from a low camera angle. Your shots of this event should include the groom starting to remove the garter; the garter half-way off the bride's leg; after the garter has been removed, and finally, the couple, as the groom leans over to kiss his bride.

11. Garter toss by the groom.

*Tip:* Follow the same procedure as in tip number 9 above; it will work for the groom and his garter-toss as well. The only difference will be at the end. Instead of having the groom hug the man who caught the garter, have him shake his hand.

8-12: Once the groom has his bride's garter in hand, he will then be expected to toss it into the crowd of single men. Photograph the groom just as he has tossed the garter.

12. Replacing the garter.

*Tip:* The woman who caught the bride's bouquet and the man who caught the garter will be invited up to the dance floor. He will be instructed to place the garter onto this woman's leg. You should set this shot up exactly as you did for the garter removal on the bride. (See tip number 10 above.)

The bridal couple should be standing directly opposite you, in the middle, just behind the seated woman and kneeling man, observing the action.

Even if the event came about successfully, sometimes the bandleader will announce that the man has put the garter onto the wrong leg. He will often do this just to promote more excitement and fun. The man will remove the garter and start all over, placing the garter onto the woman's other leg.

If this event comes about, keep the same position you originally had, even though you will be on the wrong side. Just be prepared to take a few more photos. When the event is finally over, have all four people pose for a shot. The photo will usually sell.

13. The exit.

*Tip:* Any wedding album must show a logical ending to the events of the day. Photos of the exit event usually serve this purpose. A flash on-camera and a wide angle lens will record such events nicely.

Whether you take traditional exit photos or more fun and cutesy shots is not the important fact. What is important is that you record some sort of exit event. A bride's wedding album is really not complete without it.

### Frosting Photographs

If time and the bridal package selected permit, a reception is usually a great place to capture frosting photos. This will be especially true at receptions that are elaborate and fun-filled. The photo opportunities will usually abound.

Some frosting photo opportunities will occur by themselves; others will have to be orchestrated. For example, a bride may well dance with her father-in-law during the course of her reception and you will have to do nothing other than record it when it happens.

However, sometime during the reception, you may have to suggest and set-up a group shot of the bride with her sorority sisters because the bride may not have thought of it. (Note! If these shots are requested by the bride at the time of booking, they will not be frosting shots, but command photos.)

1. Wide-angle, time exposure views of the entire reception room. Take these shots before any guests get into the room. If candles adorn the various tables, consider using a 4-point star filter on your lens.

2. Group photographs of various family members with the bridal couple.

3. Group photographs of the groom with his friends.

4. Group photographs of the bride with her friends.

5. Bride with her mother.

6. Bride with her father.

7. Bride with both of her parents.

8. Groom with his mother.

9. Groom with his father.

10. Groom with both of his parents.

11. Bride dancing with her father-in-law.

12. Groom dancing with his mother-in-law.

13. Table shots.

14. The girl who caught the bridal bouquet, with the bouquet.

15. The bride hugging the girl who caught her bouquet.

16. The man who caught the garter, with the garter.

17. The groom shaking hands with the man who caught the garter.

18. The bride dancing with each of her brothers and the groom dancing with each of his sisters.

19. The sweet trolley.

20. The bride's parents as they watch their little girl driving off in the bridal limousine. In addition, photograph the bridal couple's friends as they wave good-bye.

21. The bridal car alone, if it is decorated.

**8-13:** There are three general categories of candids: posed, prompted, or photojournalistic. The above shot is a photojournalistic candid. This type of candid involves just one thing: great timing. Be prepared at all times to capture spontaneous moments filled with feeling and emotions. This shot is an example of being in the right spot at the right time when the shutter was snapped.

**8-14:** This is an example of a posed candid. It may look like it "just happened", but it is in fact contrived. For this type of candids, the photographer pays attention to details including clothing, facial expression, and directing the action.

## Variances

Poor or improper planning, religious considerations, and even the wishes of the bride, groom, and the bride's family will all play a part in the success of a reception. As a result, you may find yourself not being able to photograph all the events that we have recommended in this chapter.

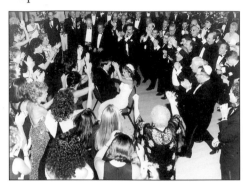

8-15: Typically, at most Jewish wedding receptions (and at many non-Jewish receptions too) there will be an event called "The Horah." Two chairs will be placed onto the dance floor and the bridal couple will be asked to sit as the crowd gathers around, singing and dancing. It is important that this event be thoroughly covered.

They will either be forbidden, impossible, impractical, or inappropriate to capture. In such a case, we can only offer you a few recommendations: do the best you can; suggest taking as many photos as you can; take a lot of photos of family and friends, and absolutely thoroughly cover the events that do occur.

## The Reception is Over

Once the bride and groom have left the reception site for their honeymoon, your job and the affair are basically over. If you have done your job well, you should be tired and ready to leave.

However, before you do, approach the bride's parents to extend your congratulations and thank them for allowing you to participate and be of service in their daughter's wedding. In addition to being a normal gesture of goodwill and good

manners, it will go a long way in promoting you with the bride's family.

One final word: be certain you take all of your equipment and film! Do not leave valuable gear or film you have just exposed back at the reception area.

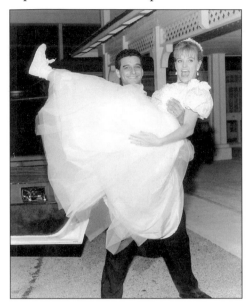

8-16: And they're off...wedding tennis shoes and all. This is a "cute" good-bye shot and shows the couple in more of a "fun theme".

## Photos in this Chapter

Unless otherwise noted, all the photographs in this chapter were taken with the following equipment and at the following exposures: Hasselblad camera; standard or wide-angle lens; single, portable, on-camera flash; flash adjusted to emit f-8 light, and the camera set at f-5.6 and 1/60th second.

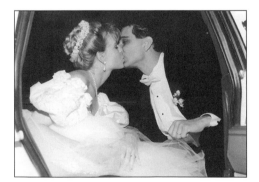

8-17: The final shot for the wedding. We call this shot a good-bye shot.

"...APPROACH THE BRIDE'S PARENTS TO EXTEND YOUR CONGRATULATIONS AND THANK THEM FOR ALLOWING YOU TO PARTICIPATE AND BE OF SERVICE IN THEIR DAUGHTER'S WEDDING."

## CHAPTER NINE

# THE BUSINESS OF WEDDING PHOTOGRAPHY

Wedding photography can be fun. However, to be successful, you must treat wedding photography as a business.

Prior to going into photography on a full-time basis, I practiced law for about 19 years and was very successful. When I changed careers, friends and family members thought I was crazy. How could I possibly give up a lucrative law practice just to become a photographer? I began to question my own judgment. Photography was fun and I enjoyed it immensely; however, if I couldn't make at least the same type of living from it as I had from law; it would be foolhardy to change lifestyles.

## GOOD BUSINESS SENSE

Consequently, I started looking around to see how other photographers in our area were faring. I was shocked at what I learned. A few were making a nice living, a lot had failed, and most were just getting by financially. Not content with this information, I pursued the matter further. I remember thinking that this condition must surely only exist in our area; that it could not be the state of affairs nationally. I was wrong!

I recall speaking with a number of representatives from leading film and equipment manufacturers, and posing the same question to all: Can one go into photography and make an outstanding living from it? Most were quick to answer no! When I questioned them as to why, most of these representatives thought that the lack of business sense and inability to run a photography business as a business were the main reasons for the downfall of most photographers. One representative who frequently deals with professional photographers from all over the country told me that ten percent of the photographers make ninety percent of the money.

It's not that good, solid, photographic work is unimportant. It most assuredly is. However, show us a photographer who does outstanding photos, but who also runs a poor business operation, and we will show you a photographer who has probably failed, or is doomed to failure. By contrast, show me a photographer who does just competent work, but is excellent in business, and we'll bet you that he is financially successful.

There is no single factor that will make one a good business person in the photographic field. There are no shortcuts or get-rich-quick schemes. Among other things, the ingredients are hard work,

**"THERE IS NO SINGLE FACTOR THAT WILL MAKE ONE A GOOD BUSINESS PERSON IN THE PHOTOGRAPHIC FIELD. "**

practice, careful preparation, maintaining good equipment, using informed judgment, and good business sense.

The result can not only lead to the production of good photographic products, but great financial rewards. If you take the business aspect of photography seriously, your only limitations will be self-imposed.Whether you are already in wedding photography professionally, or are intending to enter it as a new career, we would like to help make your journey down the business path a little easier.

In this chapter, we will discuss four major and important business-parts of wedding photography: how to attract business, book weddings, present previews or proofs, and get the order.

## HOW TO ATTRACT WEDDING BUSINESS

There is a customary sequence of events that precedes most weddings. First, a bride becomes engaged, which usually means that a jeweler has been consulted. Second, the bride shops for her bridal gown, the groom, for his tuxedo, and two more businesses have been contacted. Third, a bride will choose a wedding date and then seek a ceremony and reception site. Fourth, she'll choose engagement and wedding announcements from a stationery shop.

Next, she will hire a band, a florist, and a caterer. Lastly, she'll hire a photographer. Although the order for these events can vary, our experience has been that before a bride hires us, she has planned for everything else, and she has had contact with a number of different business establishments.

It is important, therefore, to make contact with owners of the businesses brides go to. Get to know them; let them know you want to do wedding photography. Do not hesitate to tell them that you would appreciate any referrals from them, and, in turn, you will refer customers to them. It definitely helps to get you business.

Before you make your first business contact, you must first build a portfolio. You must have photos to demonstrate your talent, expertise and ability to photograph a wedding. Without photos, you have little to sell.

## Build a Portfolio

In the beginning, you may not be armed with many samples of wedding pictures to show to prospective customers. In fact, you may not even have any to show. That, of course, will be a great drawback. Therefore, one of your first tasks must be to build a sample book of wedding photographs: a portfolio.

A portfolio for a wedding photographer, at the minimum, is nothing more than a sample wedding album. The sample should contain at least 30 to 40 photos and be representative of an entire wedding day, showing photos from all the wedding phases.

1. You may have to talk friends, family and acquaintances into allowing you to photograph their weddings. Offer to photograph these weddings at no charge, or for the cost of the film and processing.

The main purpose will be to build up a portfolio. By the time you have photographed three or four weddings, you should have enough good photos to put together a sample wedding album.

2. As an alternative, you might have to hire yourself out as an assistant to a wedding professional. You should have an understanding with the professional that you want to receive no money for your help, but wish to be paid in prints-reproductions of photographs you have taken at each affair. However, if this is the way you choose to build your portfolio, be careful of plagiarism!

### Don't Use Someone Else's Work

When you work closely with a professional photographer, you might be tempted to borrow one or more of the better wedding photos, place it in your

> **"BEFORE YOU MAKE YOUR FIRST BUSINESS CONTACT, YOU MUST FIRST BUILD A PORTFOLIO."**

> **"IT IS IMPORTANT, THEREFORE, TO MAKE CONTACT WITH OWNERS OF THE BUSINESSES BRIDES GO TO."**

portfolio, and claim it as your work. Don't. Eventually, touting someone else's work as your own will have a detrimental effect on your business.

### Critiquing Your Own Portfolio

After amassing 30 or 40 wedding prints that are versatile and representative of a typical wedding including all the wedding phases, put them all into a sample bridal book, in logical order. Show the book to no one!

Put the book away for a few days ignoring the photos during this time. After a few days have passed, retrieve the book and scrutinize each photo, looking at them carefully from both a photographer's and customer's viewpoints.

As you look at each photo, ask yourself as many questions as you can. Is the exposure good? Is it printed well? Is the shot composed well? Is it representative of the action I was trying to capture? Is my subject in sharp focus?

As you re-examine all of your photos, judge them carefully. If there are any shots that you think are questionable or that you must explain to a viewer in order to excuse the way in which it appears, then omit it. Replace it with a better photo.

There are a lot of differences between an amateur and a professional photographer. One of these differences is showing photos. Typically, an amateur will show you all the photos he has ever shot, making an excuse for almost each and every one he shows.

The professional shows you the ones he thinks are the best, and most likely represent the style and type of photographic work executed. Once you are thoroughly satisfied with all of your photos, put them into the sample album and then show it to a person whose judgment you trust.

Do not show it to a relative, spouse or companion. They might be too biased in your favor and lack objectivity. If your friend does not question anything about the photos, then you should be ready to show your work to a prospective customer.

However, if the friend has to ask any questions about the photos, consider replacing them. If your friend says, this is a great shot of the bride and groom, but, who is this other guy standing next to them? If that other guy was the caterer and not a family member, get rid of the shot from your sample album.

Most of your prospective customers will know little to nothing about photography. But, they will know what they like. Ideally, the friend you have examine your sample book will be of this frame of mind, so his or her typical responses might be the same as prospective customers when viewing your portfolio.

*It is often very difficult to critique one's own work. By putting a photo away for a period of time, we found that we became more objective. Once reviewed, if we still liked the shot, we kept it; if we still had doubts, we omitted it from our portfolio.*

### Presenting Your Portfolio

Once you have samples of your work to show, be sure to display them in the best album that you intend to sell. In addition, before you put your photos into a book, make certain that all of them have been retouched, spotted, sprayed, and are in chronological order.

Do not go cheaply: If you do not think highly enough of your work to show it to its best advantage, you cannot expect prospective customers to be impressed.

### CRITIQUING EACH PORTFOLIO PHOTOGRAPH:

1. Is the exposure good?
2. Is it printed well?
3. Is the shot composed well?
4. Is it representative of the action I was trying to capture?
5. Is my subject in sharp focus?

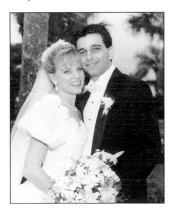

**9-2 and 9-3:** You must carefully critique your portfolio. Ask yourself the following questions about each shot: Is the exposure good; are they printed well; do they represent the action taking place; and are the subjects in focus?

## Business Cards

Business cards are extremely important: they represent you. And, like a tie or a purse, a photographer's card should be especially distinctive. People should be able to remember you by your card. Therefore, think of a new, fresh way of presenting yourself. If you cannot do it, hire someone else to design a card for you; one that is representative of what you do and which reflects your artistry.

Business cards are a personal item, and because they should be personally distinctive, we really can not tell you what to do. However, we can give some suggestions as to what not to do.

1. Do not buy the cheapest cards in town. If customers think the card is cheap, they will think you and your work are too. There are many business items you will be able to save on, but your business cards should not be one of them.

2. Do not use a cheap stock of paper. We would suggest you pay attention to the grade of paper your cards are printed on. A good paper stock feels good to the touch, and many people will remember you simply by the quality of paper your cards are printed on.

3. Do not become trite. Over the years, in our travels around the country teaching and lecturing, we have accumulated hundreds of photographer's cards.

Most fall into one of three categories: either the photographer's face is prominently displayed; there is a portrait of the photographer standing next to or with a camera or there is a lovely scenic occupying the entire front of the card. Printing is customarily overlaid on or next to these images. These are all overused. Many years ago such business cards may have been a good marketing tool. However, today you should use a newer approach.

4. Do not rely solely on a printer to guide you. Unless they have an art department, a printer will not be able to help you design your business cards. You are better off seeking a design-person first to have a drawing made, and then showing this to the printer.

5. Do not rush your selection. Once you have gone to the time, trouble, and expense of having your business cards designed, and a sample has been given to you, do not hastily accept it, even if you love the way it looks.

*Spend a couple of days thinking about you business card. Show it to friends and family and get their opinions. Avoid the expense of designing a card, having a thousand made, and then realizing that you do not like it.*

## Talk Shop

A successful business person is not faint of heart. When at the barber shop, gas station, cleaners, clothing store, or wherever, strike up conversations with most anyone who will listen. Let people know what you do and how good you are.

You may be hesitant at first to shout your own praises, but, until you have a clientele to do it for you, you must be your own public relations agent. Be enthusiastic: it's contagious. People will remember how thrilled you were when talking about what you do.

## Enter Bridal Shows

In our area, bridal shows are conducted several times during the course of each year. A bridal show is a gathering of selected business people who service weddings: caterers; florists; bands, and the like. All of these people get together and display their respective wares, or tout

> "PEOPLE SHOULD BE ABLE TO REMEMBER YOU BY YOUR CARD. THEREFORE, THINK OF A NEW, FRESH WAY OF PRESENTING YOURSELF."

> "...UNTIL YOU HAVE A CLIENTELE TO DO IT FOR YOU, YOU MUST BE YOUR OWN PUBLIC RELATIONS AGENT."

their services to prospective brides, their families, and friends. Such shows are typically non-exclusive.

They will usually have at least two or more of each type of business represented, with one main exception: usually there will be only one of the host business. Bridal shows can be great sources for future wedding business, but there are some drawbacks.

## Cost

The cost to participate in a bridal show will depend upon two things: the amount of space you need to set up your display booth, and the quality of the bridal show.

Typically, space is sold on the basis of booth size. Depending on how much space you plan to take for any given bridal show, the cost can vary between $200 and $1,500 per show, per booth.

Low cost bridal shows usually serve inexpensive wine and cheeses to the guests.

More elaborate ones offer champagne, hors d'oeuvres, and sometimes music or other entertainment. Budget bridal shows often have three or more of the same type of business represented.

The more extravagant shows will usually allow only one, or two at the most, of any given business.

In addition, bargain bridal shows are often located in less affluent sites. More elaborate ones select posh locations. As a result, the poorer quality shows will be less expensive than the elaborate ones, often by many hundreds of dollars. However, you get what you pay for. Poor quality shows often draw less than an affluent crowd of people. Since we seek the more affluent customer, we usually avoid these shows.

## Length

A show can last anywhere from three to five hours, to two full eight to ten hour days. You, or one of your representatives, should plan to attend the entire bridal show. If you don't, you will miss speaking with a lot of potential customers.

## The Value to You

During the course of one evening, you might see several hundred prospective customers at a bridal show. This exposure can prove invaluable to you. However, you will be lucky to see a handful if the weather is poor, or if the event occurs during a major holiday, even if it's a high quality show. In this case, the show will have been a total waste of your time and money.

If there has been a good turnout at a given show, one of the side benefits will be a mailing list. The sponsoring host puts together a list of all the people who attended the show, which will usually be a great source for your future advertising and promotions.

You also will get the chance to meet and fraternize with representatives of related businesses and let them know of your work. The better businesses are often at all of the better wedding affairs. At bridal shows, you can become known among this group of caterers, florists, bands, and bridal shops.

Soon you will start to get business from them, just because you are always around and seen.

## How to Enter a Show

Watch your local newspaper to see when the next show is coming to your area, and contact the person in charge to find out how to participate.

If you do not want to wait, call the better bridal and tuxedo shops. Inquire of them when the next show is to occur, and whom to contact.

They will generally have advance information as to when shows are to occur, and will usually be responsive to your requests.

> "AT BRIDAL SHOWS, YOU CAN BECOME KNOWN AMONG THIS GROUP OF CATERERS, FLORISTS, BANDS AND BRIDAL SHOPS."

## Bridal And Tuxedo Shops

Do not hesitate to visit each of the better bridal and tuxedo specialty shops in your area to show the owners or managers samples of your work.

Offer to photograph anyone they choose, attired in one of their gowns or tuxedos, for free, in exchange for permission to display the photo results in their shop. (Make certain that the prints you offer to display are 16x20, 20x24 or 24x30-inch prints; the larger the better.) At the time you deliver the prints to them, which should be on loan, leave some business cards so that they can recommend you to prospective customers.

In addition, the people whom you photographed may purchase one or more of the photos, or might even book you for some other form of photography.

## Yellow Pages

This form of advertising has proved to be one of the most successful forms of advertising that we employ, not only bringing in business, but keeping our name before the public. It allows us the luxury of touting not only our wedding photography, but the other forms of photography that we do as well: family; boudoir; children, and the like.

However, yellow page advertising can be expensive, especially when you run quarter or half-page ads in color. If you advertise in this manner, study your competition's ads carefully and make yours different. An ad similar to your competitor's is likely to be ineffective and wasteful.

## Public Displays

Another great form of advertising is to display your photographic work at local banks, good restaurants, your city hall, your local theater, and other public places.

Not only can displays bring you business, it will be business that you will not have to pay for. public places usually allow a photographer to display for free.

When negotiating for a display, ask to have your work displayed for a minimum of one weekend, but preferably for one to two full weeks at a time. A number of places are sure to turn you down, however, a few will agree.

Once you have your foot in the door, your work will keep you there, season after season. A couple times a year, try to show 10 to 20 pieces of your work; impressive, attractively framed, enlargements, 16x20-inches and larger.

## Radio, Newspaper, Television and Direct Mail Advertising

Many years ago, one of our mentors told us something very interesting: When a photographer is first starting out in business, he can least afford to spend money on everything that is important: rent; advertising; equipment, and so on. But he has to do it. Years later, once he is successful and can afford to spend whatever sums are needed to be spent on such things, he often will not have to; he'll be well established. Unfortunately, there is a measure of truth in that.

Like it or not, there is a certain amount a photographer must spend to establish him or herself in business. However, how you spend your money is something that you can control. Obviously, you should spend it in the most effective way you can. When it comes to advertising, this means selecting the form of advertising which is best for you: radio; newspaper; television, or direct mail.

### Radio Advertising

We have never been successful with this form of advertising. Over the last 12 years, we have advertised a number of times on radio. Each time, we are lucky if we get enough business from it to pay for the cost of the commercials. Most of the time we have lost money.

> Every time we display at a local bank, we book a number of portrait and family sittings, and a few weddings. It has always been well worth the effort and time.

> "LIKE IT OR NOT, THERE IS A CERTAIN AMOUNT A PHOTOGRAPHER MUST SPEND TO ESTABLISH HIM OR HERSELF IN BUSINESS."

### Shooter's Log: On the Air

We were approached by officers of two local AM radio stations. Both wanted photos of people on their staffs. However, they wanted to exchange free radio advertising for our work. One of the stations has been on the air for about 75 years. It has a music-news-format and caters to thousands of 25 to 55 year olds. The other station, a sports-talk-format, has been in existence for about 40 years, and has the same type and size of audience.

In exchange for the two thousand dollars worth of work we were to do, each station said that they would air a 30 second commercial 15 times per day for one month. That is a total of 450 spots or commercials per station. To be more effective, we choose to have our commercials divided: one station was to run all of our commercials during one given month, the other station, during the following month.

They produced two dynamite commercials for us. We were convinced that both commercials were winners. But, in the two months that our ads ran on the radio, we did not get any form of business from them whatsoever. It was a total waste of time, effort, and money.

### Newspaper Advertising

Ads in newspapers have been of questionable value for us. A few ads have worked well; most have not worked at all.

For an ad to be effective, it should be large (at least two to four columns wide), have some distinction which separates it from other ads, and should be repeated two or three times a week for a couple of weeks. This can be quite expensive.

Whenever we have run a standard or regular type ad, one with a photo and a simple message as copy, it has been of minor success. However, there are two other types of ads that have been very successful for us: paid-for editorials and editorials written by the newspaper.

*Paid-for editorials:* A couple of times a year, our local papers run a special deal for advertisers. They allow an advertiser

to write a story about themselves and include any photo they wish. They also allow the ad to be quite large: about 4 or 5 column inches long by 3 or 4 columns wide. This has a number of benefits. We can write it in the third person, as though it had been written by a reporter. This gives us the chance to promote ourselves without it appearing as such. This is a distinct advantage.

At the bottom of such an ad, in very small type, are the words paid-for advertisement, which most people don't notice.

The other two advantages are cost and placement. Unlike standard weekly ads, which often cost $500 to $750, a paid-for editorial usually costs about $350 to $400. In addition, paid for-editorials are usually run in the TV guide section, the women's section, or the social section; all good places. And every time we run a paid-for editorial ad, we get business.

*Editorials written by the newspaper:* Sometimes, you can get a newspaper to write a story about your studio free of charge. These are human interest editorials. If you approach your local newspapers, you will often find that they will write an editorial about you and run it during a special time of the year: sometime during the month of June; Easter week, and so on.

Every time we have had a newspaper write an editorial about us, we get a lot of new business. However, even though the editorial will be written and run free of charge, the paper may want you to buy a small ad. We typically take out a $200 ad.

## Television

This is an expensive way to get new business, but it is effective. You must, however, advertise a lot. Ads must run at least two or three times a day, several days a week, for at least two months.

The repetition is essential if you are going to get your message across to the general public. We usually run our ads just prior to major holiday events:

Christmas, Thanksgiving, Easter, Labor Day, and the like.

## Bridal Magazines

We have mixed emotions about this form of advertising. Sometimes ads in bridal magazines work for us and attract new business, but most times they have been a bust.

In our area, the larger specialty bridal shops publish, or have published, bridal magazines, which usually contain time and money saving tips. Some brides find these tips invaluable. There are tips on honeymoon locations, how to shop for a florist and photographer, how to prepare for the wedding day, how to choose a band and so on.

They also contain advertisements from businesses that cater to weddings. Although we cannot directly attribute a lot of our wedding business to such ads, we continue to advertise in such publications because they help keep our name before the public.

## Direct mail

Of all the mediums that we have discussed in this section, direct mail works best for us. We use direct mail in two ways: our customer list and a target market list.

*Our customer list:* At least once per month, we mail something out to all of our past customers. Typically it will be in the form of a one-page newsletter containing three columns of typed copy along with at least one black and white photo. It covers what we are doing that's new and different, what we are planning to do, and so on. We slant our newsletter toward the business that we are seeking. Our newsletters serve as a subtle reminder that we are still here, alive and well, and eager to be of service.

*Target market list:* There are companies that sell mailing lists; the better ones have mailing lists that will meet almost any criteria. If we wanted a list of women who

**"OF ALL THE MEDIUMS THAT WE HAVE DISCUSSED IN THIS SECTION, DIRECT MAIL WORKS BEST FOR US. "**

have given birth within the last three months, we could buy it. If we wanted a list of women who have announced their engagement within the last 30 days, we could buy that as well.

Every time we have used a mailing list we have gotten business: weddings; portraits; family portraits, and the like. But when we first started, we did not know the better companies that provided mailing lists. We wasted a lot of time and money learning who the good ones were. Bad companies will give you a list of old names and addresses. Many will not even pay attention to the criteria that you have asked for.

For example, if you want a mailing list of pregnant woman in your area, don't be surprised if you get names of women who are not pregnant. Weeding out the bad companies will be on a trial-and-error basis. Eventually you will find a good company to deal with.

### Caterers, Bakers, Florists, and Bands

All of these are good sources for new business. While at a reception, take a few minutes for some photographs of the buffet or sweet table, the floral centerpiece or other arrangement, and group shots of the band. When you print the photos, print them as 8x10s to send to these people, at no charge. Include a note to say how nice their displays were.

In the case of a band, say how well they looked and sounded at the wedding. Your note should say that you thought they might like the enclosed photographs for their portfolios. They will love you for it and remember you. Your foot will be in the door for referral business.

Eventually, once you start to book weddings, you will have a number of brides ask you for a referral. Those people will usually want to reciprocate, even offer you money. Don't take it! Tell them that you would much rather have them refer new brides to you instead. They will, and you will prosper even more.

### Word of Mouth

Customer referrals are the best form of advertising any business can have. More than 80 percent of all of the weddings we booked during a six month period recently came to us through recommendations by former bridal clients.

Customers obtained in this way are sold on you and your photography in advance. However, it takes time to build up a clientele, but don't despair. If you do consistently good work and engage in good business practices, the word-of-mouth method of getting business tends to snowball.

## What Not To Do

So-called get-rich schemes are everywhere, and the wedding business is no exception. They are likely to lead you to disaster.

### Exchanging Referrals

There is nothing wrong with exchanging referrals. It's done all the time. If you find a florist in your area who does exceptional work, do not hesitate to let him know that you are often asked to recommend a good florist. Let him know that you would like to refer the business to him. Not only will he be greatly appreciative, but he will also respond by referring bridal business to you.

Usually people who refer business expect something in return. Many will accept a written thank you note. Others may expect a small token of appreciation: flowers, a bottle of liquor, and the like. A few will expect referrals back from you.

However, there will be people that will not be content with any of these things. These people will expect to be paid in hard cash. The florist may want to refer business to you, but only if you pay him a fee.

(The typical referral fee is between $100 and $200 per wedding and becomes due and payable once a wedding is booked. )

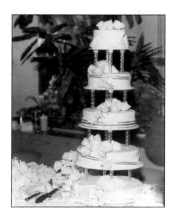

**9-4:** Take some photos of other people's work at the wedding (like the baker's cake, the band playing, or the buffet table) and send them an 8x10 at no charge. Now your foot will be in the door for referral business.

You might initially balk at such a concept, but don't. Photography is a business and paying a referral fee is another way of attracting business; you just need to be careful and use good business sense. [1]

## BOOKING A WEDDING

Attracting wedding photography business is just part of the cycle. To be successful, you must be able to close the deal, to convince the bride to book or hire you as her official photographer. At the beginning of your endeavors, it will not be uncommon to find yourself talking with 10 or 20 potential bridal customers, yet only booking one or two. Eventually, as your reputation grows and your skills become better, you'll start booking a greater percentage of the people that you come into contact with.

### Choose a Good Lab

We have the luxury of being a full service studio. We process our own film, enlarge our own prints, spot and retouch our photos on site, and even mount and frame our photos, all in-house. This gives us almost total control over our results. However, most of you will have to consult a professional laboratory. You will literally be putting the financial outcome of each wedding you do into a third party's hands. Consequently, choose a lab carefully. A lab can make or break the best of photographers.

Talk with other photographers and get their recommendations. Visit the lab, examine the facilities, and determine the quality of work done there; take some of your work and see how they handle it.

In addition, get a detailed list of their services, rates, costs, and delivery times. You will need all of this information before you can accurately quote a fee for a wedding. [2]

### Price List

Before you book a wedding, you should have a printed price list of the various bridal packages and photographic services you intend to offer. We suggest you visit other photographers in your area and see what they are offering and use this information as a guide. In the beginning, you may elect to charge less than they do. However, as your work and experience improve, so can your prices. Be cautious about the prices you set, however, because your prices could set a trend for you which might take months, if not years, to overcome.

### Level of Clientele

Like it or not, a price list can determine the level of your clientele, just as it does for so many other types of businesses. Usually, if your fees are low, you will entice a larger clientele, who will hire you not because of your work, skill, or talent, but simply because you are the cheapest photographer in town. This is not flattering, and is an awkward position to be in.

Once you gain the reputation of being the cheapest in town, more affluent customers will hesitate to use your services. Many of these people will fear that your work will be less than good. If your prices are too high, you may get some affluent customers to start with, but it will be at the risk of losing all others. The less affluent clients will simply not be able to afford you.

We suggest that you start conservatively and set your prices very competitively. Then, as your skills, talent and reputation grow, so can your prices.

### An Attractive and Informative Price List

Regardless of what your pricing structure is, we recommend that you have your price list prepared by a good printer, on a good stock of paper. Like your business cards, it should be distinctive and informative. It should include your business name, address and phone number, as well as a list of the wedding services you offer.

1  Several years ago, when first starting our business, we were approached by the general manager of a very large restaurant and reception hall. His proposition was simple. He told us that if we paid him $10,000 (up front), he would guarantee, in writing, to refer a minimum of 10 bridal customers to us, per week. We declined. Eight months later we heard that he had skipped town and the restaurant-reception hall had gone into bankruptcy.

2  For example, if you think that you will spend $400 on film, processing and proofs, it would not make much sense to only charge $500 for the wedding. On the other hand, if your total lab cost will be about $700 to $800, and you are charging $2,000, this would be a nice profit if other factors (such as an assistant's fee) are minimal.

### Pass Your Price List Out Freely

Don't be afraid to hand out your price list to prospective customers. We know a few photographers who have a deep-seated fear about a price list. They think that if they allow a customer to take a price list home, they she will take the list to other photographers and attempt to get a better price for similar services.

We do not share their fears. If a customer is going to shop, she is going to whether you have given her a price list or not. That's what price conscious customers do. What the photographer attempts to do is to sell a prospective bride on his or her quality and creativity of work, the studio, and the services offered, and not on price.

## The Telephone: A Strong Tool

Most successful photographers agree their telephone is one of their most important business tools. As such, you should entrust your telephone only to people who are truly familiar with your work, your price structure, and who are friendly, courteous, and enthusiastic. This person can be very instrumental in getting the customer into your studio.

Most of our customers call the studio, checking our prices and availability before coming in. We do not consider an untrained person, an answering machine, or a telephone answering service acceptable during usual business hours.

### Go After Information

When you have a prospective bride on the phone, get as much information about her and her wedding as you can. Don't just respond to her questions. Be interested in what she is saying and try to be of assistance.

Most prospective brides do not know what questions to ask and what information they should get, so help by volunteering as much as you can. If you have done your job well, they will think of you as a friend and want to book their wedding with you.

### Your Prices and Your Work

While someone can ask how much your wedding prices are and then compare them with another photographer's packages, it is the wrong approach. A print from you is different from anyone else's. You are engaged in an art form as well as a business, and thus your finished product becomes the main consideration.

One of the first questions you should ask callers is: Are you familiar with our work? If they are, you have half the battle won. If they are not, inform the callers that what they are paying for is not pieces of photographic paper, which cost only a few dollars, but your service, style and imagery. Invite them to come to your studio to see your work, all, of course, without any obligation.

## Your First Meeting

Since people judge others by their first impression, you should make your first meeting with your prospect an impressive one. From the moment a customer comes into your studio, she will be evaluating you and your work. Be prepared for this. Here are some things which you should know and do.

### Demeanor, Attire and Atmosphere

Whoever books the weddings must be neat, clean, personable, well-dressed, well-spoken, well-mannered, knowledgeable about you, your work, your pricing, your services and is anxious to serve the needs of the prospective bride. Never compromise.

*Serve refreshments.* Make the bride feel comfortable and relaxed. You want her to stay to hear what you have to say and to see your work. You will have a willing audience, so capitalize on her attentiveness.

*Physical surroundings.* Whether you are operating from your home or from a

Many years ago, we studied with a top photographer. We had occasion to leave his studio for a location photo session and were gone four hours. Upon our return to his studio, the photographer asked his receptionist, "Did I get any phone calls?" "Yes," she replied, "six from new clients." "Great! Are they coming in to see me?" he asked. "No," she responded. "I just told them you were out and they said they would call back."

studio, set apart an area for interviewing prospective customers. It should be clean, neat, and very professional looking. Have samples of your work on the walls and one or more bridal albums lying about and available for inspection.

*Interruptions.* In the beginning of your career you may not be troubled with your phone ringing off the wall, or customers frequently coming in and out, however positive problems like these tend to grow with a business. When they do happen, you should arrange not to be interrupted for anything other than an emergency once you begin to talk with a prospective customer. The bride-to-be deserves your full attention.

If you are interrupted too often during your first meeting, a prospective customer might get the impression that you are not interested in her business. In either case, she will politely make some excuse to leave, advising you that she will call you at a later time. That will often be the last you see of her.

## Other Photographers

During your first meeting, attempt to learn whether you are the first photographer the bride has seen. If you are one of many, try to learn what it is she likes and does not like about the competition's work. Listen to what she has to say and address yourself specifically to those areas. Tell her how your work differs without putting another photographer down. You can distinguish yourself and your operation from others without such measures.

If you are the first photographer she has seen and she intends to see others, don't lose your enthusiasm. By the session's end, she might have changed her mind and decided to book you before even seeing other photographers.

In any case, make certain that she leaves on a positive note. Your parting words will be the ones she will remember above all else.

## Go After Information Again

Even though you may have had a previous telephone contact with the prospective bride and amassed a lot of information about her wedding during the call, make certain you review all of it with her at your first meeting. The essential information you should get from her is as follows:

1. Bride's full name, address, work and home phone numbers.

2. Groom's full name, address and phone numbers.

3. Names and addresses of the bride's and groom's parents.

4. The number and names of the bride's and groom's brothers and sisters.

5. Date of the wedding.

6. Exact time of the ceremony and reception, and the exact location of each.

7. Bride's address after the wedding date.

8. Where the bride will be dressing for her wedding and the exact time.

9. Number of bridesmaids and ushers.

10. Whether there will be a flower girl and a ring bearer.

11. The number of invited guests.

12. Special problems. For example, her parents may be divorced and do not wish to be photographed together.

13. Special requests. For example, romantic photographs taken only with soft focus or very few posed photographs and mostly candids, special family members who plan to attend and so on. Heed these requests well.

14. Ascertain what is really important to her regarding her wedding photography. For example, she may consider photographs of her entire family the most important; or walking down the aisle with her

> "IF YOU ARE INTERRUPTED TOO OFTEN DURING YOUR FIRST MEETING, A PROSPECTIVE CUSTOMER MIGHT GET THE IMPRESSION THAT YOU ARE NOT INTERESTED IN HER BUSINESS."

father the most important. Whatever situation she describes, make certain that it is adequately covered photographically.

### Enlist Cooperation

Once you find out how important the wedding photographs will be to her and her family, you should ask for her cooperation. Convey to the bride that competently executed wedding photography does not just happen, but is created. Such photos take time and preparation on your part, and cooperation and time on hers.

Ascertain how much time and cooperation she is willing to give you on her wedding day. Outline the photographs you will do and how long it will take you to accomplish each phase of photography. Getting a commitment from a bride to cooperate makes her feel involved and this will make you job much easier.

### Who's the Boss

Stress to the bride that if she hires you, you will work around almost any schedule. In addition, acknowledge that you will attempt to adhere to almost any photographic request she might have. This gesture will make her feel more important and involved in the services you are to perform for her.

### Getting Down to Specifics

During your first meeting, offer the bride your printed price list for her review. Point out what each of your bridal packages includes, and how each of your bridal packages differs.

Inform her that there are no hidden charges, gimmicks, or surprises. Let her know that if none of your bridal packages meets her needs, you will tailor a package to accommodate her and her budget.

### Personally Show Your Work

Never simply place a sample wedding book in front of the customer and allow her to thumb through it, looking at all the pretty pictures. Usually, she will not know what to look for other than to see whether, in general, she likes them or not. Go through the book with her and point out the reason for each photograph, what each is conveying or demonstrating.

### Ask for the Business

After you have finished covering the above areas, do not hesitate to ask for the business. Use whatever words you wish, but ask for the opportunity to be the official photographer at the bride's wedding.

If she wants to think about it, attempt to find out what is causing her indecision and specifically address it. Remove as many obstacles as you can. If she still will not commit herself, offer to reserve her wedding date and time. Advise her that you will pencil her name into your appointment book and hold her wedding date open for a period of five days, at no obligation to her. During this five day period, if she books with you, fine; if she does not, and if another person wants to book you for that same date and time, extend the courtesy of calling her first. This will give her one last chance to book you before you commit to someone else.

If she acknowledges that she does want to book you, but is not then prepared to give you a deposit, advise her that you can tentatively reserve the date and time for her. As before, you would pencil the date and time into your book, and hold this time-slot open for a period of five days.

No matter what the case might be, the main point to remember is a wedding is not officially booked until you actually get a deposit. The amount is not as important as the financial commitment.

### Deposit and Balance Due

We require a $200 deposit with all but one of our bridal packages. With our most expensive bridal package, we require a $500 deposit. Our policy is simple and

> "GO THROUGH THE BOOK WITH HER AND POINT OUT THE REASON FOR EACH PHOTOGRAPH, WHAT EACH IS CONVEYING OR DEMONSTRATING."

> "NO MATTER WHAT THE CASE MIGHT BE, THE MAIN POINT TO REMEMBER IS A WEDDING IS NOT OFFICIALLY BOOKED UNTIL YOU ACTUALLY GET A DEPOSIT."

always explained, in detail, to new bridal customers. We want no confusion at a later time. Our basic policy is:

1. A deposit must be paid at the time of booking. There are no exceptions.

2. The balance of the bridal package selected is due and payable at the time of the pre-wedding portrait photography session, or two weeks prior to the wedding date, whichever comes first.

For example, if the package selected is $1,500, a deposit of $200 is initially collected, with the $1,300 balance being due and payable no later than two weeks prior to the bride's wedding date.

3. Deposits are non-refundable. If a bride books us, pays a deposit and then changes the date of her wedding, and if we are still available on this new date and time, there is no problem.

However, if we are unavailable, her deposit is lost. If we have no wedding on the date in question (because of her change of plans), as well as no money from a deposit (if we give the deposit back), we will have defeated our purpose for taking a deposit in the first place.

4. Re-scheduling or canceling after the balance is paid. Once the deposit has been paid and the total balance due has been collected, if the bride changes the date of her wedding, we do not financially penalize her, if we are still available. If we are unavailable, we keep 50 percent of the money paid and credit her with the balance.

This credit can be taken out at any time in other photographic services that we offer; family portraits, individual portraits, and so on. This apparently rigid policy decision does have one exception: re-booking.

5. Money is fully refunded if we re-book. For example, a bride books us on February 1, for a wedding scheduled for November 15. At the booking she pays the deposit.

Sometime during the month of April, she pays her balance in full. She then calls our studio and advises that her wedding is off. If we can book someone else's wedding for that same date, we will refund all of her money to her.

6. Payment of the balance. In the event that a bride has not paid the balance of her bridal package prior to the wedding date, we will not photograph her wedding. This point is made to the customer at the booking. The deposit is only to secure the date. Only payment in full will guarantee that we will attend her wedding.

7. Partial and late payment of the balance. Sometime after you have booked a bride's wedding, she might offer to make a partial payment, with the balance paid at a later time or to defer paying the whole balance until the day of her wedding. Here is how we handle both situations.

*Partial payment:* If we know the bride or her family, know that they have deep roots in the community and are very responsible, we have, on rare occasions, allowed a bride to make a partial payment before her wedding date.

However, the amount we ask and the terms we set never vary: we ask for 60 percent of the balance due before the wedding date, with the remaining 40 percent paid within two weeks after the wedding. In addition, we inform her that we shall not be processing any of the film until the balance has been paid in full. About 90 percent of the time when we have extended a bride this courtesy, we have been paid.

*Deferred payment:* Even though our policy calls for a bride to pay in full, at least two weeks prior to her wedding, sometimes a bride will ask to pay the balance in full on the day of her wedding. We never agree. There is too much chaos on the day of the wedding to try collecting money.

What happens on the day of the wedding if the bride again says she will pay you later? If you have only received a

deposit, do you stay and photograph the wedding or do you leave? Almost without exception, every time we have deferred payment until the day of a wedding, we have never received our money.

### The Contract

Sometimes a bride will want a written contract to be signed by both you and her. She will want this document to set forth the entire understanding, including all of the terms and conditions regarding money, your photography and the like. We use standard contract forms.

If you are interested in using a standard contract, we would suggest that you use either the one from the Nebs Co. or from the Professional Photographers of America. The Nebs Co., in Groton, Massachusetts, has a standard photographic contract that they offer for sale; it is Form 136-3. You can call them at 1-800-225-6380.

If you wish further information on photography contracts, we suggest you contact the Professional Photographers of America, Inc., 57 Forsyth St. NW #1500, Atlanta, GA 30303.

### The Appointment Book

Once you have booked a wedding, be certain you immediately record the wedding date and all pertinent information in your appointment book. It would be a disaster if you booked a wedding, collected all of your money in full, and failed to attend. More than likely, you would be sued and lose far more than she had paid to you.

*Once booked, stay booked.* We have heard about photographers who accept bookings, collect deposits and even full payments, only to cancel because they book another, more expensive, wedding instead.

This procedure is unprofessional and should be avoided at all costs. You should assure a bride that once you have accepted her deposit, you will stay booked, even if she does not bring the subject up herself.

### PREVIEWS

After you have photographed the wedding, the couple will be anxious to see the results. Your first step will be to take all of your film to the lab for processing. Once the film has been processed, you should have the lab make previews or printed proofs of all the photographs you took at the wedding. These are often called paper proofs or, more simply, proofs.

### The Traditional Way

Once you have instructed your lab to make previews, it will usually take between one and three weeks to have a finished product. The reason for this is due to the lab's production capabilities. But you should not choose a lab simply because they are able to fill your orders quickly. Speed should be secondary to the quality of work.

Once your proofs are in hand, you should screen them carefully. The photographically poor ones should be discarded. Those poor from a printing standpoint should be sent back to the lab for correction. Detailed comments on why they are unacceptable should accompany each returned proof.

### The Wedding Proof Book

When all proofs have been assembled, numbered and arranged in a logical order, they should be placed in some form of preview book or binder (the wedding proof book.) The book can then be presented to the bridal couple. Brides, grooms, and their families will then select photos they want for their wedding album.

A number of photographers prepare a combination preview book. Some pages in this book will sport only 4x5-inch prints; others will show only 5x7s, some

> "YOU SHOULD ASSURE A BRIDE THAT, ONCE YOU HAVE ACCEPTED HER DEPOSIT, YOU WILL STAY BOOKED..."

> "ONCE YOUR PROOFS ARE IN HAND, YOU SHOULD SCREEN THEM CAREFULLY. THE PHOTOGRAPHICALLY POOR ONES SHOULD BE DISCARDED."

additional pages will show only 8x10s. Some pages will have a mix of sizes. Our books are completely comprised of 8x10s.

Some photographers will not permit a proof book to be taken off their premises insisting that the bridal couple (and their families) make their final selection at the time it is presented to them. The two main reasons why are emotions and copying.

*Emotions:* Many photographers rely on emotions to help sell their prints. Photographers often think that if they are able to capitalize on the emotions of the bridal couple and their families when a wedding proof book is first reviewed they will have a better chance at selling more prints. If the book is allowed to leave with the bride to be reviewed elsewhere, these photographers believe print sales are greatly lessened.

*Copying:* Many photographers also don't let a proof book leave their sight for fear of it being copied.

Assume you presented a bride a proof book containing 100 proofs and allowed her to take it home with her. Her pre-selected bridal package only entitles her to 30 prints. By allowing her to review 100 photos, you hope to sell more than the prints initially bargained for.

Also assume that the value of the wedding proof book that you gave to the bride is $1,300, plus the cost of the album. Assume the bride decides that your prices are too high, and takes the entire book to a local lab to have 70 prints copied (she has already paid for 30 prints), thus saving herself several hundred dollars. You will have lost a great deal of business and money. Some of you might say that copying a photographer's work cannot happen if a copyright seal, the photographer's name and address, and the date are clearly marked on the back of each print.

Technically, once a copyright seal is affixed on the back of any print and assuming it contains the required information, it becomes a warning: look but do not copy! As a result, most reputable labs will not copy a print clearly copyrighted. But the operative word here is reputable. It has been our experience that many labs will copy anything, properly marked or not, just to get the business.

On the other side of the coin, there are other photographers who do freely allow their proof books to be checked out by the bridal couple under certain conditions. Typically, a proof book will be checked out to a bride for a two, three, or four week period of time. However, before it is checked out, it is common to secure an additional deposit. This deposit is to ensure that the book will be returned intact and undamaged.

Whichever method you follow, or even if you choose a different one, you should have a definite policy about wedding proof books, and stick to it.

### How We Previously Dealt With Proofs

For a while, we used the following procedure: we developed the film and then did a contact sheet of each roll. We would examine each frame of film and select the ones that we thought looked the best.

We would print 8x10s of those, usually 100 to 200 percent more photographs than the bride had requested, and create the preview book for the bride to take home.

By following this procedure, we lost the great advantage of impact. Allowing a proof book to be taken home by a bride permits emotion and impact to dissipate and this can cause sales to suffer.

### How We Now Show Proofs

We have adopted a totally different way of showing proofs: electronic proofing. This method required purchasing a machine called an optilyser ( an electronic film viewer) and some video equipment.

We place each negative into the optilyser and view it on a television, while

**"...YOU SHOULD HAVE A DEFINITE POLICY ABOUT WEDDING PROOF BOOKS, AND STICK TO IT. "**

recording all onto a video tape. After all the images have been put onto the tape, we overlay appropriate, often romantic, music for background.

The bride, groom, and their guests are then invited to our studio for a showing of their day, on a 24 inch monitor. At the conclusion of the show, when emotions are at their peak, an order is taken.

We employ this for most of our previews. We would like to use it for all of our proofing, however, there are still times when a bride wants to take home paper proofs. In these cases, we revert back to the old way.

The cost of the optilyser and the video equipment is several thousand dollars, but since we have been using it, our wedding orders have increased dramatically. Should you want additional information about the optilyser, we suggest you contact Lucht Engineering Corp., Bloomington, Minnesota. The machine is available through them. There are other ways to show wedding previews other than those we have described. One of them involves a slide show.

A number of labs throughout the country will, for a fee, also make 35mm slides of every photograph you took at the wedding. You simply organize the slides into a logical order and prepare them to be shown on two or more slide projectors. Once the show, along with music, is prepared, you simply invite the bride, her husband, and their guests to see their wedding photos. After the show, the order for prints is taken.

### Newer Ways

As we move into the 21st century, things that we have reported here about wedding proofs will probably be of no value. We can tell you electronic imaging is here to stay, and as time progresses, there will be new and different ways to do almost everything photographically. Photographers must keep up with the changing times.

## What You Should Do

In the beginning of your career, walk before you run. Don't invest in a lot of expensive equipment until you get a taste for the market and business starts rolling in. You can always expand. We suggest that you start with paper proofs and consider the following:

### Numbering

No matter what size proofs you decide to present, choose a lab that will number all of your proofs and negatives. Numbering will prevent having to match proofs with negatives, and make ordering easier. A bride will be able to order by referring to each print by number.

### Don't Show it All

Do not make the mistake of showing every photograph you took during her wedding. Poor work, even just a few bad prints, leaves a lasting impression that all of your work is of poor caliber. Show only your better images in the preview book.

### How Many Preview Books?

It is typical to prepare and show only one preview book. A bride and groom will decide which prints they wish to order, and when they are done, they will pass the book on to their parents.

### The Orders to Expect

If you have done your job correctly, you should expect to sell at least three wedding albums: a bridal album and two parents' albums. At our studio, a bride's album typically contains only 8x10-inch prints. Her parent's album contains only 8x10s too, but sometimes 5x7-inch prints, and the groom's parents typically order only 5x7-inch prints.

Typically a bride's album and her parent's album will contain approximately the same number of prints. The groom's parent's album will typically contain about 60 to 75 percent of the photos that the bridal album contains.

**"DO NOT MAKE THE MISTAKE OF SHOWING EVERY PHOTOGRAPH YOU TOOK DURING HER WEDDING."**

### Reserve Enough Time

However you present your proofs, set aside adequate time for reviewing them with the bride. You will usually require at least an hour or more, but it will be time well spent. You will be laying a foundation for the final order.

### Have a Deadline

Once you have reviewed all of the preview book with the bride, she'll often be eager to take the book home so that she can show it to her family and friends. Do not let her leave your studio without telling her when you expect to have the preview book brought back. Give her a date and have her sign a receipt to this effect.

Since you are collecting a deposit for the preview book, make certain she understands that if the book is not brought back on or before the agreed upon date, the security deposit will be used to pay for the cost of the book and all the prints in it. Of course, call the bride to remind her if the date passes and you have yet to hear from her.

## GETTING THE ORDER

Of all the business dealings you will have with a bride, before, during, and after her wedding, getting the order is one of the most critical. Your financial well-being is at stake.

No matter how good your photographic work might be, without orders (and the money that comes from them) you cannot stay in business.

Some photographers use a soft-sell approach when it comes to their work: whatever a customer wants to buy, they'll buy.

Others use a hard-sell approach: whatever a customer wants to buy, they buy; what they don't want is sold to them anyway. To us, both approaches are wrong; they are too extreme.

When it is time to sit with a bride and take her order, we allow her to make her own decisions about which photos and sizes she wants to buy, with little to no intervention from us.

However, if she chooses images which we think are really wrong for her, or of the wrong size, or if she neglects to choose images which we think will be great for her album, we are not shy. We jump right in and make suggestions.

## Make an Appointment

At the time a bride picks up her preview book, you should lay some ground work about placing her order. Tell her that when she is ready to place her order, she should call you and make an appointment. An appointment will guarantee that you will be able to devote your full time and attention to her.

Make certain that you reserve enough time for her; at least one and one half to two hours. Ideally, you would like to sit with the bride during her entire appointment without being interrupted.

### Who Should Be Present

At the time a bride makes an appointment, you should advise her to bring her husband, as well as their parents. Although this many people will add confusion, it's well worth it. You will save a great deal of time in the long run by having all of them present at the same time.

## Samples of Sizes

Brides, and their families, often aren't sure what size prints to order for a wedding album. Therefore, be certain you have samples of all print sizes that you intend to offer. Not only will this make your job easier, but you may be able to encourage the large-size sales which will look better.

There is an old adage which is quite true: if you don't show it, you can't sell it. It would not hurt to have even larger print sizes readily available such as 11x14, 16x20, 20x24, and so on. Such large size

**9-5 and 9-6:** The more pictorial variety you can offer a bride, the higher your sales will be.

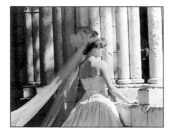

"OF ALL THE BUSINESS DEALINGS YOU WILL HAVE WITH A BRIDE, BEFORE, DURING, AND AFTER HER WEDDING, GETTING THE ORDER IS ONE OF THE MOST CRITICAL. "

prints will not go into her wedding album. However, she might choose such prints as extras. Almost without exception, every time we take a bride's order, we sell a number of large-size prints, too.

## Samples of Bridal Books

Make certain that you have samples of all the wedding books you sell, as well as swatches of all of the colors and fabrics the books come in.

You cannot expect a bride to become enthused about buying a wedding book if you have to say to her, "I don't have a sample of the book you want, but it will be like this, only instead of being white, with square corners and a plain front cover, it will be blue, with round corners and an oval cut-out for a photo on the front cover." Saying this could cause her to shop elsewhere for an album.

There are a number of reputable wedding book companies throughout the country offering a variety of looks, styles, finishes, and prices.

We use books from Art Leather Manufacturing Co., in Elmhurst, New York, and Leather Craftsman Inc., in Farmingdale, New York. The books from Leather Craftsman are more elaborate and expensive.

*No matter which wedding books you decide to have and sell, we suggest that you offer at least two grades, styles, and prices to give the bride a choice.*

## Selling Negatives and Proofs

Sometimes a bride will ask to buy all her wedding negatives, as well as all the proofs, from the wedding preview book.

### Selling Negatives

The act of hiring you to photograph a bride's wedding entitles her to: you photographing her wedding; your expertise while at the wedding; a certain agreed upon number of prints when the wedding is over, and a wedding album. The act of hiring never includes any of the film you will use to take the wedding photos. The negatives are the sole and separate property of the photographer.

By agreeing to sell her your negatives you will be cutting a great portion of your livelihood. She will place an order with you, but it will be minimal. Then, with negatives in hand, she will take them to a lab and have prints made for herself and both sets of parents. You will have lost a great deal of money as a result.

We never sell a bride the wedding negatives, with one exception. After her wedding, at the time the bride places her order, we advise her that we shall maintain her file in an open status for approximately three years. This gives her plenty of time in case she wishes to place an additional order for prints.

We also inform her that at the end of this time we shall be destroying all of the negatives. Before they are destroyed, she will be notified of this fact and given an opportunity to purchase them. Depending upon the quantity of film shot during the course of her wedding, this would cost between $100 and $200.

The typical question asked then is, if you're going to destroy the negatives anyway, why not just give them to me? It really doesn't matter what words you choose so long as you convey the idea to the bride that you are in business to do business and your negatives, from any photo session, are part of your stock-in-trade.

> **"MAKE CERTAIN THAT YOU HAVE SAMPLES OF ALL THE WEDDING BOOKS YOU SELL, AS WELL AS SWATCHES OF ALL OF THE COLORS AND FABRICS THE BOOKS COME IN."**

> **"THE NEGATIVES ARE THE SOLE AND SEPARATE PROPERTY OF THE PHOTOGRAPHER."**

**9-7:** Wedding photography is a very involved profession. Not only must you be a competent photographer, but you must also have good business sense. We have covered both of these sides to a wedding photographer. Both professional and personally speaking, being a wedding photographer is a rewarding experience.

### Selling Proofs

We never sell wedding proofs. When we started out, we used to. However, we quickly learned that when we did, our wedding sales diminished.

When we refused, our sale of prints increased. As a result, we stick to our strict, no-sell policy regarding our proofs. We do have one exception.

When a couple and their families have placed a very substantial order, many times they will expect or request some sort of discount. Since we have a strict policy of never discounting anything, we usually give the bride most, if not all, of her proofs, all at no charge. This policy has always worked for us.

### Get a Deposit

Always get an additional deposit whenever taking a wedding order. Absolutely every time we haven't, we have been stuck: people have moved out of town; no longer have the money to spare; the couple separated, etc.

Let's say that a bride books us to do her wedding and initially selects a $1,000 wedding package which includes 30 8x10 prints, housed in an album. We would initially collect a $200 deposit and then collect the balance of $800 at least within two weeks prior to her wedding.

Later, after her wedding, when she comes back into our studio to place her order, we collect more money.

When she places her order for $800, and more prints than originally agreed upon, she also places one for her family and the groom's family, that total $1250: a total of $2,050 worth of additional prints. We would thereupon require a 50 percent deposit of $1,025.

At the time we collect this deposit, we tell her that the balance for the entire

*"**ALWAYS GET AN ADDITIONAL DEPOSIT WHENEVER TAKING A WEDDING ORDER.**"*

order becomes due and payable at the time the entire order is ready for delivery. We will not let her pick up her bridal book and pay only for that. Otherwise, we may be stuck with those extra prints and parents' albums, with no one claiming them, even though we have gotten a deposit.

## Preventing Problems

At the end of taking a wedding order, allow the bride to review your notes. Quickly go back over the order and have her initial and date it. This will prevent a later problem if she forgets she ordered one or more particular prints, or if the sizes of prints are not as she remembered.

When the bride comes in to claim her final order, once again go over it with her in detail, examining every print. If everything meets with her satisfaction, have her sign a receipt acknowledging she received the wedding album, that all the prints she had ordered are there, and everything is satisfactory to her. This, too, will prevent future problems.

Despite this attention to business safeguards, what you seek is a happy customer. Do what you have to, within reason and good business practices, to accomplish this.

## A FINAL WORD

We have covered a lot of information in this book. We trust that we have entertained you, but above all, we hope that you have learned from what we have written. That was our goal.

Don't be discouraged by those who may tell you not to go forward with your photographic career. If you believe in what you are doing, and have the toughness to stick with it, go for it!

The world is full of people who never got anywhere because they were afraid of failure. Just remember, there is no such thing as success without the occasional failures.

Should you have any questions or comments about this book, or, should you want information about the other books we have written, or the videos we have produced, we welcome your call. You may reach us at 1-800-237-9876 or 305-764-0662. Or, you could contact our publisher, Amherst Media, Inc., by writing to: P.O. Box 586, Amherst, NY, 14226; telephone, 1-716-874-4450.

*With these thoughts in mind, we wish you much luck and success!*

**"...WHAT YOU SEEK IS A HAPPY CUSTOMER. DO WHAT YOU HAVE TO, WITHIN REASON AND GOOD BUSINESS PRACTICES, TO ACCOMPLISH THIS."**

# INDEX

# Other Books from Amherst Media

## Basic 35mm Photo Guide
*Craig Alesse*

For the beginning photographer! Designed to teach 35mm basics step-by-step—completely illustrated. Features the latest cameras. Includes: 35mm automatic and semi-automatic cameras, camera handling, f-stops, shutter speeds, composition, and lens & camera care. $12.95 list, 9 x 8, 112 p, 178 photos, order no. 1051.

## Build Your Own Home Darkroom
*Lista Duren & Will McDonald*

This classic book shows how to build a high quality, inexpensive darkroom in your basement, spare room, closet, bathroom, garage, attic or almost anywhere. Full information on: darkroom design, woodworking, tools, building techniques, lightproofing, ventilation, work tables, enlargers, lightboxes, darkroom sinks, water supply panels & print drying racks. $17.95 list, 8 1/2 x 11, 160 p, order no. 1092.

## Into Your Darkroom Step-by-Step
*Dennis P. Curtin*

The ideal beginning darkroom guide. Easy to follow and fully illustrated each step of the way. From developing black & white negatives to making your own enlargements. Full information on: equipment you'll need, setting up the darkroom, making proof sheets & enlargements, and special techniques for fine prints. $17.95 list, 8 1/2 x 11, 90 p, hundreds of photos, order no. 1093.

## Camera Maintenance & Repair
*Thomas Tomosy*

A step-by-step, fully illustrated guide by a master camera repair technician. Sections include: general maintenance, testing camera functions, basic tools needed and where to get them, basic repairs for accessories, camera electronics, plus "quick tips" for maintenance and repair of specific models. $24.95 list, 8 1/2 x 11, 176 p, order no. 1158.

## Make Fantastic Home Videos
*John Fuller*

All the information beginning and veteran camcorder owners need to create videos that friends and relatives will actually want to watch. After reviewing the basic equipment and parts of the camcorder, this book tells how to get a steady image, how to edit while shooting, and the basics of good lighting and sound. Sample story boards and storytelling tips help show how to shoot any event right. $12.95 list, 7 x 10, 128 p, fully illustrated, order no. 1382.

## Camcorder Tricks & Special Effects
*Michael Stavros*

Turn you camcorder into a toy! Over 40 tricks and effects show you how. With only a camcorder and simple props, you can simulate effects used by Hollywood pros. Each trick tells what you'll need, and shows the simple steps to getting the effects you should. It's so easy, the whole family can join in the fun — even Rover! Enjoy creating video fun, and make your videos an adventure to watch. $12.95 list, 7x10, 128 p, order no. 1482.

## Basic Camcorder Guide/ Revised Edition
*Steve Bryant*

For everyone with a camcorder, or those who want one. Easy and fun to read. Packed with up-to-date info you need to know. Includes: selecting a camcorder, how to give your videos a professional look, camcorder care tips, advanced video shooting techniques, and more. $12.95 list, 6 x 9, 96 p, order no. 1239.

## Infrared Photography Handbook
*Laurie White*

Totally covers infrared photography: focus, lenses, film loading, film speed rating, heat sensitivity, batch testing, paper stocks, and filters. Black & white and duotone photos illustrate how IR film reacts in portrait, landscape, and architectural photography, and how IR can create a dreamlike quality. Includes technical and artistic critiques of selected images. $24.95 list, 8 1/2 x 11, 104 p, 50 B&W photos, charts & diagrams, order no. 1383.

## The Wildlife Photographer's Field Manual
### Joe McDonald

The classic reference for the wildlife photographer. This complete how-to includes: lenses, lighting, building blinds, exposure, focusing techniques, and more. Special sections on: sneaking up on animals, close-up macro photography, studio and aquarium shots, photographing insects, birds, reptiles, amphibians and mammals., and more. Joe McDonald is one of the world's most accomplished wildlife photographers and a trained biologist. $14.95 list, 6 x 9, 208 p. order no. 1005.

## The Freelance Photographer's Handbook
### Fredrik D. Bodin

A complete and comprehensive handbook for the working freelancer (or anyone who wants to become one). Full of how-to info & examples, along with tips, techniques and strategies both tried & true and new & innovative. Chapters on marketing, customer relations, inventory systems and procedures for stock photography, portfolios, plus special camera techniques to increase the marketability of your work. $19.95 list, 8 1/2 x 11, 160 p, order no. 1075.

## Underwater Videographer's Handbook
### Lynn Laymon

Accomplished diver, instructor and underwater videographer, Lynn Laymon, shows how to get started and have fun shooting underwater videos. Fully illustrated, with step-by-step instruction on: purchasing equipment, basic & advanced underwater technique, dive planning, composition & lighting, editing & post production, shooting underwater at night, marketing your new video skills, and much more. $19.95 list, 8 1/2 x 11, 128 p, over 100 photos, order no. 1266.

## The Art of Infrared Photography
### Joseph Paduano

A complete, straightforward approach to B&W infrared photography for the beginner and professional. Includes a beautifully printed portfolio. Features: infrared theory, precautions, use of filters, focusing, film speed, exposure, night & flash photography, developing, printing and toning. $17.95 list, 9 x 9, 76 p, 50 duotone prints, order no. 1052.

## Big Bucks Selling Your Photography
*Cliff Hollenbeck*

A strategy to make big bucks selling photos! This book explains what sells, how to produce it, and HOW TO SELL IT! Paves the way for business success. Renowned West Coast photographer Cliff Hollenbeck teaches his successful photo business plan! Features setting financial, marketing, and creative goals. Helps organize business planning, bookkeeping, and taxes. It's all here! $15.95 list, 6x9, 336 p, Hollenbeck, order no. 1177.

## McBroom's Camera Bluebook
*Mike McBroom*

Totally comprehensive, fully illustrated, with price information on: 35mm cameras, medium & large format cameras, exposure meters, strobes, and accessories. Pricing info based on the condition of the equipment. Designed for quick & easy reference; includes the history of many camera systems. A must for any camera buyer, dealer or collector! $24.95 list, 8x11, 224 p, 75+ photos, order no. 1263.

## Guide to Photographing California
*Al Guiteras*

100's of the best photo opportunities in California! Listings rated with from 1 to 5 film canisters, signifying the overall image potential and the amount of film needed. Covers climate, local photo retailers & tips on shooting in difficult lighting conditions. $9.95 list, 6x9, 144 p, order no. 1291.

## Write or fax for a *FREE* catalog
AMHERST MEDIA, INC.
PO Box 586
Amherst, NY 14226 USA
Fax: 716-874-4508

### Ordering & Sales Information:

*Individuals:* If possible, purchase books from an Amherst Media retailer. Write to us for the dealer nearest you. To order direct, send a check or money order with a note listing the books you want and your shipping address. U.S. & overseas freight charges are $3.00 first book and $1.00 for each additional book. Visa and Master Card accepted. New York state residents add 8% sales tax.

*Dealers, distributors & colleges:* Write, call or fax to place orders. For price information, contact Amherst Media or an Amherst Media sales representative. Net 30 days.

*Prices are in U.S. dollars. Payment in U.S. funds only.*

Name_____
Address_____
City_____State_____
Zip_____ — _____

**Amherst Media, Inc.
PO Box 586
Amherst, NY 14226**